"Does the invisible hand of the art market deliver on Adam Smith's promise that it will promote the public interest? Hagtvedt, who conducts cutting-edge research in marketing, dissects the art market, showing that although both the quality of conception and the quality of execution matter for success, marketing can overshadow both."

Paul Romer, Boston College professor,
Nobel Prize winner in Economic Sciences,
and former Chief Economist of the World Bank

"This book tackles an interesting and timely topic. Henrik Hagtvedt draws on decades of relevant experience when illustrating the roles of money and marketing in the art world."

Steven Pinker, Harvard professor and bestselling author
of *How the Mind Works*, *The Blank Slate*,
and *The Better Angels of Our Nature*

"Many of us have appreciated art at one time or another, but few of us truly understand the business behind the market. Henrik Hagtvedt provides a fascinating tour of what goes on behind the scenes, and the result is both revelatory and enlightening. A fascinating read."

Jonah Berger, Wharton professor and bestselling
author of *Contagious* and *The Catalyst*

"Henrik Hagtvedt brings a diverse set of backgrounds to his discussion of money and marketing in the art world. Fascinating reading."

Don Thompson, author of *The $12 Million Stuffed Shark:
The Curious Economics of Contemporary Art*,
The Supermodel and the Brillo Box, and
The Orange Balloon Dog

MONEY AND MARKETING IN THE ART WORLD

How does the art market choose its winners, thereby also deciding what millions of visitors to galleries and museums will view, year after year? Whereas art historical writing and contemporary commentary tend to highlight the efforts of specific artists, this book illustrates how money and marketing, in combination with general trends, play decisive roles in shaping the art world and in propelling specific artists and artworks to positions of prominence.

Today, perhaps more than ever before, the high-profile art world is primarily shaped by buyers and those who cater to buyers. The actual artists, although most visible to the public, tend to play a secondary role. The time seems particularly ripe for transparency about how the art world works, given the growth in the art market, media attention on—and popular interest in—high-priced art, and controversy surrounding public funding for art and the value of art for contemporary society. With a combination of marketplace observations, marketing insights, and relevant research findings, this book contributes to increased transparency while providing thought-provoking digressions and anecdotes along the way.

Money and Marketing in the Art World offers an accessible analysis of the art market for scholars and graduate students across arts marketing and management, as well as for those more broadly interested in art and business.

Henrik Hagtvedt studied at art schools in Norway, Denmark, and Italy before enjoying an international career as a visual artist, exhibiting in galleries and museums in Europe and Asia. He was thereby exposed to the inner sanctums of the art world, which sparked his curiosity about how the art market really works, eventually prompting him to return to school. After completing a

degree in art history, he went on to earn an MBA and a PhD, both with a major in marketing. He is now a marketing professor at Boston College, and much of his research is focused on art and aesthetics. He has published a number of scholarly articles in top journals in the fields of marketing, psychology, and neuroscience, and his research has been featured in dozens of major news outlets around the world. He has presented this work at national and international conferences and has been invited to speak at diverse venues, ranging from the Western States Arts Federation to the Federal Reserve Bank. He has been designated an MSI Scholar by the Marketing Science Institute, which recognizes internationally leading marketing scholars. His interests also tend to reflect an international perspective, as he has lived in diverse countries in Europe, Asia, Africa, and North America, in addition to traveling extensively throughout his life.

Routledge Studies in Marketing

This series welcomes proposals for original research projects that are either single or multi-authored or an edited collection from both established and emerging scholars working on any aspect of marketing theory and practice and provides an outlet for studies dealing with elements of marketing theory, thought, pedagogy and practice.

It aims to reflect the evolving role of marketing and bring together the most innovative work across all aspects of the marketing 'mix' – from product development, consumer behaviour, marketing analysis, branding, and customer relationships, to sustainability, ethics and the new opportunities and challenges presented by digital and online marketing.

43. **Marketing and Gamification**
 Edited by Sahil Gupta, Razia Nagina, Mandakini Paruthi and Gaurav Gupta

44. **Marketing in Developing Nations**
 Contemporary Developments, Cases and Problems in Africa, Asia and the Middle East
 Edited by Ayodele C. Oniku

45. **Money and Marketing in the Art World**
 Henrik Hagtvedt

For more information about this series, please visit: www.routledge.com/Routledge-Studies-in-Marketing/book-series/RMKT

MONEY AND MARKETING IN THE ART WORLD

Henrik Hagtvedt

LONDON AND NEW YORK

Cover image: Yuji Sakai, Getty Images

First published 2025
by Routledge
4 Park Square, Milton Park, Abingdon, Oxon OX14 4RN

and by Routledge
605 Third Avenue, New York, NY 10158

Routledge is an imprint of the Taylor & Francis Group, an informa business

© 2025 Henrik Hagtvedt

The right of Henrik Hagtvedt to be identified as author of this work has been asserted in accordance with sections 77 and 78 of the Copyright, Designs and Patents Act 1988.

All rights reserved. No part of this book may be reprinted or reproduced or utilised in any form or by any electronic, mechanical, or other means, now known or hereafter invented, including photocopying and recording, or in any information storage or retrieval system, without permission in writing from the publishers.

Trademark notice: Product or corporate names may be trademarks or registered trademarks, and are used only for identification and explanation without intent to infringe.

British Library Cataloguing-in-Publication Data
A catalogue record for this book is available from the British Library

Library of Congress Cataloging-in-Publication Data
Names: Hagtvedt, Henrik, author.
Description: Abingdon, Oxon : Routledge, 2025. |
Series: Routledge studies in marketing |
Includes bibliographical references and index.
Identifiers: LCCN 2024025935 (print) | LCCN 2024025936 (ebook) |
ISBN 9781032832975 (hardback) | ISBN 9781032871899 (paperback) |
ISBN 9781003531340 (ebook)
Subjects: LCSH: Art–Economic aspects. | Art and society.
Classification: LCC N8600 .H34 2025 (print) | LCC N8600 (ebook) |
DDC 701/.03–dc23/eng/20240722
LC record available at https://lccn.loc.gov/2024025935
LC ebook record available at https://lccn.loc.gov/2024025936

ISBN: 9781032832975 (hbk)
ISBN: 9781032871899 (pbk)
ISBN: 9781003531340 (ebk)

DOI: 10.4324/9781003531340

Typeset in Sabon
by Newgen Publishing UK

CONTENTS

Acknowledgments *x*

1 Introduction: A Clash of Muses 1

2 A Few Marketing Principles: Past and Present Practices in the Art Market 7

3 The Contemporary Art Market: The Cogs and Wheels of Today's Marketplace 39

4 Trends, Fashions, and Social Influence: How Popular Patterns Emerge in Art and Elsewhere 62

5 Disentangling the Muses: Some Simple Steps Forward 90

6 Afterword: Some Additional Reflections on Art Theory 105

Notes *115*
References *134*
Index *149*

ACKNOWLEDGMENTS

A big thanks to my brother, Ray (Reidar), for inspiring me to pursue scholarship; to my wife, Lydia, and daughter, Elana, for all the wonder they bring to my life; and to Vanessa Patrick and other friends and colleagues around the world, including the ones at Boston College.

1
INTRODUCTION

A Clash of Muses

> O for a Muse of fire, that would ascend the brightest heaven of invention.[1]
> William Shakespeare

As Douglas Adams so aptly put it, "In the beginning the Universe was created. This has made a lot of people very angry and been widely regarded as a bad move."[2] Nonetheless, myths and legends laud creativity, whether human or divine. According to the ancient Greek poet Hesiod, for instance, the Muses were the nine daughters of Zeus, the ruler of the gods, and Mnemosyne, Titan goddess of memory. These nine sister deities personified knowledge and the arts. They inspired creativity, and today the term *muse* may connote anyone or anything that does so. Artists in the 21st century do not necessarily believe that nine goddesses inspire their work, but the muses serve as a metaphor for the impetus to create art. The word *museum* also stems from the muses and reflects the special status of work inspired by them.

Judging by the disparate array of works currently exhibited as art, the muses appear to disagree on the kinds of creativity they should inspire. To some extent, this situation is neither new nor surprising; from the outset, the muses have been locked in a perpetual struggle to set the course for new developments in the arts. The conflict evolves over time but is never resolved. Creativity often implies change, and because artists do not all march in lockstep, change entails multiplicity. One might indeed be thankful for mixed signals from competing muses, if the result is a diverse cornucopia of human creations, rather than an endless supply of similar commodities. Alongside the muses that inspire art, however, the art *market* has its own muse: money.

DOI: 10.4324/9781003531340-1

The most critical struggle in much of today's art world is arguably the one between the muses of art and the muse of the art market.

The main objective of this book is therefore to shed light on the roles of money and marketing in the art world—especially in the higher-end contemporary art market. These roles are also reflected in the endeavors of artists and marketers; regardless of what artists create, marketing often underlies the success or failure of their work, in terms of attention, monetary value, and even critical acclaim. Given this situation, it is also my view that much of the current high-profile art world is primarily shaped by buyers and those who cater to buyers. The actual artists, although most visible to the public, tend to play a secondary role—aside, that is, from those who are also proficient marketers.

I am currently a marketing professor, but my curiosity about the role of marketing in the art world was initially sparked three decades ago, when I was working as a painter in Europe. At the time, I had no formal education outside the sphere of art. After stints at art schools in Denmark and Norway, I had studied painting at the Academy of Fine Arts in Florence, Italy—the cradle of the Renaissance. This background fit well with a philosophy of optimistic humanism, but it contributed little to my grasp of business. Nevertheless, I was lucky as an artist. I was exposed to the inner workings of the art world in a way for which I was, and still am, grateful to my benefactors. Thanks to the efforts of patrons and curators, large exhibitions were organized for my work in galleries and museums in various countries. The first time I had a solo exhibition in a museum and saw the oversized posters with my name on them, I would have liked to believe that it all had resulted exclusively from my own work. But I had ample reason to doubt it. I had studied art from various times and places, and I had traveled all over the world, immersing myself in art on the street, in galleries and museums, and wherever else I could find it. This diversity of experience enhanced my appreciation for various art forms, but it also made it evident to me that something other than exceptional artistry was driving success in the marketplace.

Over the years, I met several artists who in my opinion produced masterpieces but who never received any positive feedback. Some of them exhibited techniques that I admired, in part because I would have had trouble emulating them, even if I had spent years trying. On the other hand, I also came to know artists whose abilities appeared much less impressive but who nonetheless made millions of dollars on their work. Having said this, it might also be a good time to acknowledge the subjectivity of art appreciation. Though I strive to maintain a scientifically minded impartiality, I cannot entirely avoid the realm of opinion without making this book exceedingly dull and dry. My views are informed by experience in both the art world and the world of marketing, but although I presumably can maintain objectivity regarding marketing, I cannot be entirely objective regarding art. The latter is

replete with subjective components, and my opinions are affected by personal tastes and frames of reference.

One afternoon in New York, for example, an art dealer took me out to lunch and showed me some local exhibitions. At one point, she showed me paintings by her favorite artist, whose work she, at other times, had exhibited in her own gallery. These were large, white canvases with white and off-white paint on them. Although I was inclined to appreciate explorations into subtle nuances and combinations of color and shape, I found this exhibition to be a little underwhelming. The dealer explained that these works, by an artist named Robert Ryman, were priced at close to half a million dollars apiece. These kinds of experiences gave me pause to think. I was getting to know all the right people in the art world, but the art market seemed virtually independent of what I considered art. Why was some white paint on canvas worth hundreds of thousands of dollars, when work by other artists was difficult to sell for a pittance? A popular view held that technical mastery of a medium was no longer a prerequisite for excellence because conceptual creativity and originality of artistic vision were what really mattered. However, not only was I skeptical to that view, but I also could not see an extraordinary level of conceptual creativity in the repeated application of white paint on canvas after canvas—at least not to the extent that it should command hundreds of thousands of dollars per canvas. The situation made me feel conflicted. On the one hand, I was fortunate that my career as an artist looked so promising at a young age. There apparently lay a bright future ahead of me. On the other hand, my values and philosophy of art were mismatched with the prevailing contemporary trends.

I do not mean to oversimplify or overgeneralize. Even during my early years in Scandinavia, I had met skillful, commercially successful painters, ranging from figurative ones, such as Odd Nerdrum, to abstract ones, such as Per Kirkeby. They had invited me into their homes, where we had talked about painting and related topics. These were friendly, thoughtful, and earnest people, and their commercial success was apparently just a fortunate side effect.

Nonetheless, several events showed me that I had trouble navigating tensions between art and money. In 1999, for instance, I had two exhibitions in the United Arab Emirates (facilitated by my friend Heidi Skjeggestad): one at the Green Art Gallery in Dubai, and the other at the Cultural Foundation in Abu Dhabi, which was the closest thing the UAE had to a national gallery in the Western sense of the word. The latter opening was a festive event, with the ribbon cut jointly by Undersecretary Ahmed Abdulla Al Mansoor and Norwegian ambassador Stein Vegard Hagen. Over the next several days, I was chauffeured around in a fancy car and went to dinners with movie producers and business executives. It was a change of pace for someone who was used to pairing cheap wine with $3 meals. I was also invited to a party

at a polo club in the desert between Abu Dhabi and Dubai. As a kid, I had lived a few years in Libya, so I had spent some time in the Sahara Desert, and being out in a different desert after so many years felt oddly familiar. The polo club, however, felt less so. I was not used to seeing that kind of high-end, solitary structure in the middle of nowhere, with elegant guests and fancy dining. Perhaps the most conspicuous display of all was a group of European models—all of them tall, all of them with long, silky hair, and all of them wearing identical red dresses—whose only task was to hand out cigarettes to those of us who wanted to smoke.

While I was standing on the balcony, after a seven-course meal, an associate of the sheikh who owned the polo club approached me. He explained that the sheikh was very fond of his horses. He had a large stable of them, and he was wondering if I would be interested in painting them. I had never made much money—in the art world or elsewhere—and numerous paintings commissioned by the sheikh sounded like a good opportunity. After mulling it over, however, I politely declined, probably in part because I was not very good at painting horses, but also because I did not want to. My reluctance was not due to a lack of appreciation; the prior few days had been fun, the organizers had been generous, and there was nothing wrong with commissions. But it felt like art and opulence were two worlds colliding. Being aware of the historical ties between art and wealth is not the same as wanting profit to be the main motivation for creating something. I believe my stance was similar to that of many artists who rely on marketing and sales to make a living but do not want these considerations to guide their art.

To cut a long story short: After much contemplation, I decided to refrain from participating in the art market at all. (As much as my ego would have liked to think otherwise, the art world did not exactly protest or take much notice. In terms appropriate to this book, my brand equity as an artist merely vanished into a forgotten past.) Instead, I wanted to learn more about the marketing activities that appeared essential to the realities of the art world. So I went back to school and continued my formal education, leading to degrees in business as well as art history, and to my current job as a marketing professor. Now, I spend most of my time doing scientific research, and the intersection of marketing and visual art remains a central focus. So far, that research has included topics such as consumers' evaluations of artworks, the impact of art on psychological variables such as meaning and happiness in life, and the role of art in the marketing of ordinary consumer products. My research methods have ranged from laboratory experiments to field studies to neuroimaging.[3] This book draws on some of that research, on general knowledge about art and marketing, and on personal experiences in the art world.

Despite its pervasive influence, marketing is rarely mentioned in discussions about art, whether in critical commentary or in mainstream articles in the

popular press. Perhaps the reason for this omission is that many art pundits, including critics, journalists, and philosophers of art, are unaware of the influence of marketing. Or perhaps they are fully aware of it but believe that acknowledging it somehow belittles art. Or perhaps, somewhat ironically, a narrative about marketing is not very marketable—which, incidentally, would also be a bit unfortunate for this book, given its topic.

As a caveat, I should mention that much of this book's emphasis is skewed toward Western art. As measured in monetary value, the United States and Europe have long represented the bulk of the art market, notwithstanding recent growth in markets such as China (which overtook the UK as the second-largest market in 2023[4]), India, Russia, Brazil, and the Middle East. In terms of contemporary art, New York and London are still the best-known hot spots, and Germany remains a center of activity as well.[5] Technological innovation and financial prosperity have also been prevalent in the West during much of the past couple of millennia. Rather than embarking on a discussion of why this is the case, I will refer readers to Jared Diamond's popular book titled *Guns, Germs, and Steel*, which might serve as a starting point for readings on that topic.[6] Either way, it is my opinion that the fundamentals of the creation and appreciation of art are similar across cultures, despite differences in specific practices, so a Western bias does not necessarily preclude a global relevance. Other apparent biases, such as ones tied to the gender or ethnicity of artists serving as examples, may stem from the unequal distribution of famous individuals within this predominantly Western context. At the risk of stating the obvious (and to head off any related objections from the outset), that distribution does not necessarily reflect underlying differences in artistic aspirations or abilities among specific demographic segments, but may result from the prevailing culture and power structure of the relevant time and place. The role of marketing in these latter contexts, however, is a topic for another book.

To note another caveat, work created for commercial purposes may dominate parts of the current focus, especially when that work generates attention because of factors such as high sales prices and representation in important galleries, fairs, and auctions. That work is also central in shaping popular conceptions of what art is and how it should be evaluated. However, the art world comprises a great deal more than headline-grabbing commercial work. Further, commercially successful work is not necessarily made for commercial purposes. Money and marketing may exert their influence regardless of explicit commercial intent, but I do not mean to mischaracterize or deny the multiplicity of the art world; in a broad sense, that world comprises everyone who engages in art. On a related note, my intention is not to demonize money or marketing either. Anti-commerce sentiment was certainly not what motivated me to get a PhD in business administration.

Some of the notions raised in this book may be familiar to marketers and marketing scholars, whereas other notions may be familiar to art professionals and aficionados. Different readers may desire a deeper or shallower treatment of different topics, depending on their own background and knowledge. Some compromises have therefore been made, to accommodate a diverse readership. Presumably, some of the ideas may also meet with disagreement; people have a variety of vested interests, and the topics discussed can be contentious. But reasonable people can disagree and nonetheless engage in a worthwhile discussion. Art is a unique source of meaningful experience, whereas money and marketing are essential business tools. Both art and business contribute positively to humankind, but their capacity to do so may decrease when their respective roles are obfuscated. I believe the art world could benefit from more transparency in general and from greater awareness of the roles played by money and marketing in particular, and I hope this book can contribute to that awareness.

The four main chapters are organized at differing levels of focus. The first chapter views practices in the art world through the lens of a few key marketing concepts. Historical and contemporary examples highlight the general roles of these marketing principles, as well as compare past and present practices. The second chapter zooms in on the cogs and wheels of the contemporary art market in specific, discussing how central players in this market operate. The third chapter then zooms out to consider the broader context in which these players operate. Drawing on examples from various areas, rather than exclusively from the art world, this chapter illustrates how social influences combine with targeted marketing efforts to create trends (i.e., vogues or prevailing tendencies) in the art world and elsewhere. Finally, the fourth chapter discusses some implications of the topics covered in the prior three chapters and suggests a few simple steps for disentangling the roles of art, money, and marketing.

2
A FEW MARKETING PRINCIPLES
Past and Present Practices in the Art Market

It would be difficult to exaggerate the role of marketing in modern society. As the evolutionary psychologist, Geoffrey Miller, puts it, "marketing underlies everything in modern human culture in the same way that evolution underlies everything in human nature."[1] This might sound like an exaggeration to the layman who equates marketing with advertising, but marketing embraces a broad spectrum of activities through which one can influence consumers and other entities, build relationships with them, understand their needs and desires, and provide products that ultimately serve purposes such as profit.

The current conception of marketing is in fact relatively new. In the past, marketing was largely viewed as a way to convince buyers to purchase whatever products a given firm happened to produce. Since then, marketers have come to understand that the development, promotion, distribution, and sales of products should be based on a match between the capabilities of the provider and the needs and desires of prospective customers.[2] Today, products tend to be conceived, designed, promoted, and distributed based on the preferences of buyers, not on the convenience of producers and sellers. While this shift in focus places more power in the hands of consumers, it also gives rise to a more central and influential role for marketing.

Miller goes on to note:

> Ecologists estimate that humans now consume more than half our planet's "net primary productivity" – more than half the biomass grown each year on earth. One lucky species, out of 20 million, sucks up half of the biosphere's annual output, and transforms it into work roles and leisure activities that are structured mainly by marketing. Marketing does not just dominate human culture; since human culture dominates the matter

and energy flows that constitute terrestrial life, it also, at this historical moment, dominates life on earth.

Perhaps Miller has thus succeeded in the difficult task of exaggerating the role of marketing after all. Or perhaps even this is no exaggeration. Either way, the centrality of marketing has some notable consequences. One of these is tied to the common observation that perception matters more than reality. Whether or not a product actually fulfills needs and desires via its quality or performance, the perception that it does drives success. A great deal of marketing is concerned with encouraging this perception, regardless of its basis in reality. This is perhaps most obvious in areas such as astrology or homeopathy, where many consumers can identify sellers as charlatans, but it can be equally true for any conceivable product.

For most sustainable business models, however, reality is in the ballpark of perception. Good marketers do not usually rely on their customers' stupidity; they aim to provide products that actually satisfy needs and desires. Many of the recent advances in marketing have been all about uncovering and understanding those needs, to better serve customers.[3] The most successful marketing efforts are frequently the ones that provide most value to consumers, because customer satisfaction and firm profitability go hand-in-hand.[4] Further, consumers have needs and desires outside of pure product functionality. Many of these are psychological in nature and provide part of the explanation for the effectiveness of branding.[5] It would be difficult to justify the price difference between a Gucci handbag and a generic one based on functionality alone.[6] It would also be difficult to explain why consumers are willing to pay such different prices for different bottles of water, not to mention that these bottles are hundreds of times more expensive than readily available tap water, which is sometimes virtually identical. Water may represent more of a gray zone than handbags, because it is difficult for consumers to gauge the quality of—or their need for—a brand of bottled water. This inability on the part of the consumer is one of the reasons why advertising for products such as pharmaceuticals is regulated.

As we shall consider in a later chapter, marketing can encourage peculiar behavior in all sorts of areas. There is little reason to suspect that the art world is somehow immune to those influences. Nonetheless, commentary on art tends to disregard the role of marketing, even when the quality and value provided by individual artworks are notoriously difficult to gauge. Further, some of this commentary relies on vague arguments, abstruse technical jargon, and convoluted sentences that might be interpreted in any number of ways. One reason for that might be postmodernism's effects on writing. Another reason could be the codependency between artist and critic, both of whom are trying to make careers for themselves. Perhaps another reason is that art invites us to be exploratory and open-minded, and we therefore use

poetic license when discussing it. But disregarding the role of marketing does not open the mind; it just distorts reality.

The following sections illustrate the past and present relevance of some key marketing concepts. The aim is not to give a comprehensive overview of marketing practices or provide a how-to-market recipe, but to highlight a handful of principles that are central to the art world, as well as compare their past and present roles. A typical marketing textbook might present a marketing-mix framework that is broadly applicable to a variety of contexts.[7] For example, the 4-P framework comprises decisions regarding product (e.g., design, features, benefits), price (e.g., pricing strategy, payment terms), place (e.g., distribution channels, market coverage, customer access), and promotion (e.g., advertising, public relations). Although these types of frameworks are applicable to the context of artworks, we shall not adhere closely to them here, in part because some of the distinctions are less clear in the art market than they are elsewhere; for example, promotional aspects sometimes blend into aspects pertaining to product design and other times blend into aspects pertaining to distribution channels. Instead, we will highlight a few relevant concepts, beginning with ones pertaining to the product itself, followed by a brief discussion of promotional aspects, and ending with some observations about consumers. As a starting point, it behooves us to specify what art and the art market are in the first place; in this market, even the product category is difficult to define.

Art: A Nebulous Product Category

Certain aspects of marketing take on a particularly central role when there is little clarity about what art is, which benefits we should expect to derive from artworks, and how we can evaluate their quality. For better or worse, this murkiness is highly characteristic of the art world, and especially the contemporary art world. When visiting a gallery or museum, or when observing works of art in any other kind of context, people may find themselves wondering why a particular work is classified as art, let alone why that artwork has been brought to their attention. Perhaps they take for granted that it is famous or has been deemed attention-worthy for some other reason. But if so, why is it famous, and who has deemed it worthy of attention? Presumably, it must be attention-worthy because it meets or exceeds some standard of excellence, and those responsible for evaluating it must be critics, curators, and others with relevant expertise. But what standard should we apply to measure excellence in artworks, when we cannot even agree on what art is?

What do Paleolithic cave paintings have in common with Leonardo's *Mona Lisa*, Artemisia Gentileschi's *Annunciation*, or Frank Auerbach's *Head of J.Y.M. I*? Do these commonalities extend beyond painting, to

sculptures such as Myron's *Discobolus*, Camille Claudel's *The Mature Age*, or Constantin Brancusi's *Bird in Space*, and perhaps to music, dance, and poetry? What about purely conceptual work of more recent origin? In this case, the substantive similarities appear to be rare. Any given individual may certainly appreciate both classical sculpture and contemporary conceptual art; the two modes of expression are in no way mutually exclusive. But despite the ability to appreciate them both, we might acknowledge their stark differences, although we lump them together in an amorphous overarching category called *art*. We might also acknowledge that it can be difficult to make sense of categories that comprise disparate exemplars.[8]

This difficulty—this amorphousness—makes art unique from a marketing perspective. Most product categories are comparatively clear and comprehensible. Consumers can typically identify a car, a book, or a cup. They may disagree about the merits of various product attributes, but they understand what a cup is. Art, on the other hand, is something about which millions of people around the world are passionate—often even more so than they are passionate about cups—yet they may disagree on what art is.

One cannot fully separate a discussion about the role of marketing in the art world from a discussion about what that world comprises, and there no longer appear to be restrictions on what may be presented and marketed as art. Perhaps Marcel Duchamp's *Fountain*, the ordinary urinal—albeit tilted at a 90-degree angle—famously presented for consideration at the New York Society of Independent Artists exhibition in 1917, should be viewed as a marker in time. The show was touted as the largest exhibition of modern art ever to take place on American soil, and the rules stipulated that all works presented by fee-paying artists would be accepted. *Fountain* was therefore not rejected, but nor was it placed in the show area, because the committee did not consider it a work of art. At the time, Duchamp was actually a board member of the Society of Independent Artists, but the committee members did not know that he was the one who had submitted the urinal, which he had signed "R. Mutt 1917." A subsequent editorial in the publication *The Blind Man* argued: "Whether Mr. Mutt with his own hands made the fountain or not has no importance. He CHOSE it. He took an ordinary article of life, placed it so that its useful significance disappeared under the new title and point of view—created a new thought for that object."[9] This shift from physical craft to conceptual thought heralded the ascendancy of conceptual art, and *Fountain* eventually became one of the most famous artworks in history. In 2004, a poll of 500 art experts pronounced it the most influential modern artwork of all time.[10]

This characterization is especially notable given an unclear basis for classifying it as an artwork at all. Indeed, if we accept an ordinary urinal as an artwork, then anything can arguably be classified as art. If so, one might also say that no artist since then has really expanded the conception of what

art is. When the parameters for this distinction have been eradicated, there are no longer any barriers through which to push. Nonetheless, not everyone accepts such a broad definition of art, so similar types of works continue to provoke controversy and debate.

Some of these works are on the macabre side, such as Damien Hirst's dead animals in formaldehyde. Others are on the more whimsical side, such as many of Jeff Koons' shiny, cartoonish objects. An oft-mentioned example, which is arguably representative of Duchamp's legacy, is Piero Manzoni's *Merda d'Artista* (*Artist's Shit*). This work from 1961 consisted of 90 hermetically sealed cans containing Manzoni's own feces, with no added preservatives. Unlike the above-mentioned works by Hirst and Koons, Manzoni at least produced the work himself. There were 30 grams per can, to be exact, priced at the weight of gold (i.e., $37 each in 1961). A spokesman for the Tate Gallery in London, who in 2000 acquired a specimen for £22,300, described it as a seminal work and a significant purchase for a trifling sum of money.[11] In 2015, one of the cans sold at Christie's for £182,500. In 2016, another one sold at auction in Milan for €275,000.[12] In a letter to a friend, Manzoni himself had explained that his reason for tinning his feces was to expose the gullible nature of the art-buying public, which makes this a particularly apt example for our purposes. In addition to the Tate, other institutions like the Pompidou Museum in Paris and the Museum of Modern Art in New York acquired their own 30 g specimens. As the proud creator would have stated it, they joined the ranks of the gullible art-buying public. Soon after creating the cans, Manzoni also explained to a friend that he hoped they would explode in the collectors' vitrines. Apparently, this is exactly what has happened to several cans.

When a prankster like Manzoni creates something to parody the art market, effectively mocking the art world for taking that kind of work seriously, and the art world responds not only by taking it seriously, but by enshrining it in some of the most important art collections in existence, it highlights the difficulty of defining what art is. For the current purposes, a market-centric definition may be the best alternative: Art is that which is marketed and/or sold as such, via channels or institutions typically thought to partake in the art world. This is not an entirely clear or satisfying definition, and some readers may note similarities with perspectives such as those proposed by Arthur Danto and George Dickie.[13] We shall consider implications of these and other perspectives in a later chapter. In the meantime, this market-centric perspective seems expedient when analyzing the art market, and it obviates the need to stop and question the art status of each example discussed.

The Art Market

In monetary terms, the art market is far from negligible. To give a rough idea by comparing with the film industry, the art market is larger than the

global box office, but smaller than the combined value of box office and home entertainment.[14] Of course, this comparison could immediately get me in trouble with some readers, as many would argue that movies are also art. Let me therefore reiterate that for the current purposes, the art market is restricted to works that are typically described as fine art and exchanged as such via sales channels such as galleries, agents, and auction houses. Despite this focus, however, it remains difficult to accurately quantify the art market. Complications arise both in tracking sales and in identifying exactly which products qualify as art. Therefore, estimates could legitimately vary by tens of billions of US dollars per year, depending on the parameters adopted.[15] The numbers supplied by The Art Basel and UBS Global Art Market Report are broadly applied, and the 2024 report sets the 2023 market at about $65 billion in sales.[16]

Most of the works pertaining to this market fall within the category of visual art. Many of them are original, unique, non-reproducible pieces. Common exemplars, recognizable by most people as art, include items such as sculptures and paintings. Blake Gopnik, described as the Chief Art Critic for the Washington Post, has been quoted as saying "painting is dead and has been dead for 40 years."[17] Given that the quote is 20 years old, painting has apparently now been dead for 60 years. Nonetheless, paintings still represent a major portion of today's art market, although they were not necessarily painted during the past 60 years.

The monetary value of these types of works is relatively easy to establish, whether or not it is difficult to understand why a specific piece has been is bought and sold at a specific price level; the value is simply the amount that someone is willing to pay. Relatedly, as the painter Robert Motherwell put it, "Any picture is fairly priced, if its subsequent value is greater."[18] Valuation becomes more complicated for contemporary works such as performances and installations. Whether or not they are sold, they can stimulate publicity, and few marketers would question the value of publicity.[19] For instance, when Christo and Jeanne-Claude wrapped the German Reichstag in Berlin in polypropylene fabric, casual observers may not immediately consider the monetary value of this spectacle. However, the publicity ensuing from these types of stunts might allow Christo to wrap a typewriter in plastic and sell it as art for large sums of money. If somebody else wrapped a typewriter in plastic and expected to reap substantial profits from the endeavor, they would probably be disappointed and possibly be politely referred to the nearest mental health institution. Publicity, however, makes almost anything possible. As the powerful art patron Charles Saatchi put it, lots of ambitious artworks end up in a dumpster, but only "until the artist becomes a star. Then he can sell anything he touches."[20]

So are publicity and marketing the only factors determining the value of artworks? Clearly, art is not reducible to the market.[21] Some would argue

that a distinguishing factor between artists and manufacturers of other marketable products is that artists create primarily to express their subjective visions, concepts, or experiences, irrespective of consumer demands.[22] Others would respond that this truism is assailed by an increasing multitude of exceptions to the rule.

As a case in point, it is difficult to refute the commercial acumen of entrepreneurs such as Andy Warhol or Jeff Koons. In fact, Warhol was openly proud of his commercial aspirations, emphasizing that "Being good in business is the most fascinating kind of art."[23] Koons seems equally unapologetic in his commercial approach. He is often described as a marketing phenomenon, and he appears to be well aware of the prospective buyers for whom he makes and sells luxury objects—that is to say, the objects that he has other people make for him.[24] Do commercial aspirations disqualify these individuals as artists? Certainly not, if the art market is any indication; they are among the most famous artists of the past century, and they achieve some of the highest prices.

Warhol and Koons may be said to exemplify commercial enterprise that is nonetheless classified as art, and observers who take a step back and think about it may be confused as to how they have reached consideration, let alone prominence, in the art community. But consider this: Even Michelangelo responded to consumer demand when he undertook commissions. Although he fiercely defended his right to rely on his own artistic vision and style, and despite his immense creativity and skill, it is far from certain that he would have become famous without the backing of his sponsors, who not only provided funding but who also decided much of his subject matter for him. This observation does not imply that Michelangelo's works are similar to, or belong in the same category as, the works of Warhol and Koons. These examples are fitting precisely because of the stark contrasts between them. The same market mechanisms can push markedly different products to prominence.

Regardless of questions pertaining to artistic or commercial aspirations, the success or failure of artists often has little to do with the artists themselves. Collectors, sponsors, dealers, auction houses, and critics have decisive influences, and thus the above-mentioned distinction between artists and other manufacturers of marketable products can become a moot point. This blurring of the line between art and marketing may seem like a recent development, a trend that has become especially salient since the center of the contemporary art world shifted from Paris to New York after the Second World War. However, the line has been blurred for a long time. As I will argue in the pages ahead, the needs of buyers have merely evolved along with social, economic, and technological changes, and this development is reflected in the types of artworks that are marketed to meet the changing

needs. That reality is no different for art than it is for other products in the marketplace.

The following sections consider some past and present roles of a few marketing principles, as applied to the art market. Doing so serves at least two purposes: First, it illustrates ways in which marketing in the art world has changed over the years and ways in which it has remained the same. Second, it shows how we can understand past and present art markets by viewing them through the same lenses that we use to analyze other markets and products.

Identifying useful, objective criteria for gauging quality is difficult in a number of product categories. However, it is especially difficult for contemporary art, for at least three reasons: First, so many barriers have been pushed through by now that the category of art is wide open—to the extent that it is hard to define it at all. Second, it can be especially challenging to gauge the quality of conceptual content, and conceptual content is central to much contemporary work. Third, much contemporary work is intended to disregard or even mock traditional approaches to art, including bases for gauging quality, so measures of quality become explicitly irrelevant. We will therefore turn to product quality as the first marketing principle to consider.

Product Quality

Product quality is perhaps the most obvious driver of success in many markets.[25] Of all the drivers we will discuss, this is nonetheless the one that appears to have the least steadfast influence in the current art market. This observation does not suggest that quality is uniformly lower now than it has been at other points in time, but only that quality has a less obvious correlation with market performance.[26] Perhaps this is because much contemporary art theory encourages products for which a judgment of quality is difficult or irrelevant. Alternatively, it might be because marketing enables these types of works to reach prominence, and much contemporary art theory merely embraces that which is currently fashionable. Either way, it seems clear that a perception of high quality has been central to artistic success throughout most of art history.

Levels of quality are easiest to gauge when there are standards to compare with, and in the past, some of these standards have been clear and enduring. For instance, the Palette of King Narmer[27] (ca. 3100–3000 BC) set a standard for Egyptian figural representation for thousands of years following its creation. Instead of figures scattered haphazardly across pictorial surfaces, these surfaces were henceforth subdivided into bands, with pictorial elements inserted in a neat and orderly fashion. A canon of ideal proportions was also accepted by Egyptian artists for long periods of time. Although these rules

of aesthetics fit poorly with optical fact, they provided a basis for evaluating excellence in pictorial representation.

In ancient Greece, architecture also corresponded to ideal proportions, albeit with variations, such as those between the Doric, Ionic, and Corinthian orders. Ideal proportions guided sculpture as well, despite evolving poses and degrees of realism. Whereas the archaic kouroi were inspired by the unnatural, rigid Egyptian pose, later Greek sculpture reached an astounding level of realism. But still, the figures conformed to ideal body shapes and facial lineaments.

Vitruvius was one of the most famous authorities on these types of aesthetic ideals. In his book *De Architectura*, he laid out guidelines that became a major inspiration for Renaissance, Baroque, and Neoclassical architecture. He also elaborated on the Greek proportions for the human body, as exemplified by the Vitruvian Man, famously depicted by Leonardo da Vinci. Throughout much of art history, one measure of product quality has been the degree of skillful and creative application of such aesthetic principles. However, this yardstick has become increasingly difficult to use, especially during the past one and a half centuries. With movements such as Impressionism, the standards changed radically, and today, there exist no standards at all for a large part of the market. For better or worse, this complicates judgments of product quality.

Technical mastery of the medium represents another aspect of product quality. Few people would gaze upon the colorful sculptures and temples in Greek antiquity and argue that technical proficiency with marble was lacking. Still today, when the passing centuries have transformed these marble works into white remnants of a glorious past, viewers cannot but respect the craftsmanship of the ancients. The Baroque sculptor Bernini's marble masterpieces, such as *Ecstasy of Saint Teresa*, inspire comparable respect, as does the Florentine Mannerist sculptor Cellini's work with bronze; his *Perseus* combines artistic vision and exquisite execution, and even the casting was technically impressive. Similar statements could be made for myriad painters and sculptors throughout history. I have yet to hear a critic say that Jacques-Louis David could not paint, that Rachel Ruysch lacked precision, or that Albrecht Dürer's graphic works were sloppy. When the product quality is so obviously impressive, critics and laymen alike bow to these achievements.

What should be said about Manzoni's aforementioned canned feces, or the multitudes of similar examples found in various contemporary galleries and art fairs? For instance, Maurizio Cattelan's ordinary banana, duct-taped to the wall at Art Basel Miami Beach, recently raised some eyebrows, presumably in part due to the $120,000 price tag.[28] In these cases, it is difficult to know how one should gauge the product quality; in the latter example, the skill with which someone fastened a piece of duct tape to the wall is presumably not the key measure.

16 A Few Marketing Principles

The contemporary art world is certainly not devoid of artists who demonstrate skill with their chosen medium. To use an auction house favorite as an example, Gerhard Richter is clearly a proficient painter. The same is true of numerous unknown artists who exhibit even more impressive skill. However, skill with a medium is no longer a prerequisite for critical acclaim and commercial success. A lack of skill may even be a selling point for artists such as Damien Hirst and Jeff Koons, in part because it highlights the perceived centrality of ideas or originality of artistic vision and the irrelevance of technical skill in much contemporary art. Artists who lack technical skills may outsource production to highly skilled artisans, who execute the visions, making what the artists are unable to make for themselves.

This view of skill is a differentiating factor between past and present art markets. Throughout much of history, many artisans have worked under the guidance of master artists, but the masters were rarely lacking in the relevant skills. It might be noted that artists combining vision and skill in new ways sometimes have been overlooked or vilified in their own time, and yet have been praised in later generations. However, two observations should then be added. First, the notion of misunderstood genius throughout the ages has been exaggerated in the popular imagination, partially thanks to some very famous examples such as Vincent van Gogh. Second, the works of such artists contained aesthetic elements by which quality could be assessed, whether or not surprising departures from the norms of the day tended to overshadow such assessments.

Today, it is difficult for art professionals and lay public alike to specify the limits or characteristics of the product category of art, let alone delineate the parameters for quality assessments within that category. This would be true even if the central players in this market—collectors, gallerists, critics, and so on—were in complete agreement about what constitutes great art. Given that no such consensus exists, matters are further complicated. When a degree of consensus does exist, it seems to be predicated on factors such as high sales prices and exhibitions in important galleries. But that just brings us back to the question of why these works have been endorsed in this manner in the first place.

For much contemporary work, the historical standards appear all but irrelevant. One might argue that this situation is inevitable, given that artists are constantly striving to create something new and unique. In general, innovations complicate assessments of quality, at least in the short run. In the technology sector, for instance, disruptive innovations often make existing benchmarks obsolete. Typically, though, consumers can understand the benefits that a new technology product brings to the table, and they can assess how well it performs. This is often not the case with new art, for which standards of quality may not only be unclear, but even discouraged.

Innovation

The perception of innovation in contemporary art may be one of the reasons why consumers accept unclear standards by which to gauge quality. Innovations not only capture public attention, but consumers also give innovative brands leeway in terms of departing from category norms.[29] Although novelties may fascinate, however, the interest quickly fades if they are not also useful. This observation is related to a commonly held distinction between mere novelty and actual creativity. A creative solution achieves a desired end or provides some kind of improvement, whereas this is not a requirement for novelty.[30] Replacing the wheels on a car with rolling garbage cans would be novel, but it would not be creative, and the car would probably not be a commercial success.

In the art market, it has become increasingly difficult for consumers to differentiate between creativity and mere novelty. Further, even novelty has become easy to fake, for at least two reasons: First, there are no longer any real restrictions on what may be marketed as art. Second, it often takes effort and experience to distinguish conceptual replicas from new ideas. As noted, what matters most is not actual novelty, creativity, or product quality, but the consumers' perception of these features. As these features become increasingly difficult to assess, the correlation between perception and reality is likely to decrease.

Throughout most of art history, it has been relatively easier to assess innovations, some of which have also stood the test of time. Ancient Greece, although conservative in some areas, was the birthplace of innovations in a number of others, including the arts.[31] In my opinion, the world has yet to see a wellspring of innovation that eclipses it. Not only did the Greeks appear to be aware of the magnitude of their own achievements, but these achievements also commanded the respect of other populations. It seems likely that Alexander the Great's efforts to Hellenize his brief but vast empire would have been less successful without Greek culture's capacity to impress the inhabitants of his conquered lands. More than 2,000 years later, many ancient Greek innovations continue to influence Western culture, and more than a few of them have proven difficult to replace or improve upon. For instance, numerous public edifices such as colleges, libraries, and government buildings are fashioned after an ancient Greek style of architecture. The technical excellence of Greek statuary also remains difficult to outdo.

Many Roman innovations built upon and extended those of the Greeks.[32] Although the rate of innovation was slow compared to modern areas such as computing and communications technologies, and although Rome was in some ways more conservative than Greece, the Roman mix of respect for the ways of the ancestors with a willingness to bend to circumstances was unique in classical times. Sculpture became less idealized, and architecture

became more practical, along with other innovations in areas such as law, military, and infrastructure, which enabled Rome to dominate vast territories for hundreds of years. Technical innovations such as opus caementicium, pertaining to the use of concrete in many structures for which the Greeks would have relied only on marble, facilitated a multitude of Roman building projects. Roman innovations, like those of the Greeks, have led Roman art and architecture to remain marketable to this day.

During the middle ages, the rate of much innovation slowed down, and in some areas, there was outright deterioration of knowledge and skill. It has recently been popular in some veins of scholarship to object to the term *Dark Ages*, because there was some progress in medieval times as well.[33] In my opinion, however, one cannot reasonably characterize this time period as bright just because some innovations occurred in the millennium between Rome and the Renaissance, especially since many of the innovations were actually reinventions of that which had already deteriorated during the same time period. Having said that, the arrival of Gothic architecture was a notable exception.[34] Breakthroughs in engineering and masonry enabled the erection of magnificent structures that seemed to reach for the sky. A number of churches built in this style incorporated previously inconceivable stained-glass windows, contributing to the impression that the structures consisted partially of light itself and defied the laws of gravity. These innovations continue to fill onlookers with wonder, well into the age of skyscrapers. Interestingly, Gothic was initially a somewhat disparaging term, given by commentators of the Renaissance who disdained the lack of classical ideals in Gothic workmanship. The Goths were in no way the driving force behind this style, but the name stuck.

The Renaissance represented the most abundant resurgence of innovation and artistic mastery since classical times—hence the term we use for that era.[35] Scholars, philosophers, artists, and other protagonists of the Renaissance were also fiercely aware of the importance of their own achievements. Innovations of the time ranged from the painterly perspective of Giotto and Masaccio—formalized as an artistic technique in the writings of Brunelleschi and Leon Battista Alberti—to the studies of light, shadow, and human anatomy, as exemplified by Leonardo da Vinci. Leonardo, like Michelangelo, epitomized the universal creativity and skill that gave rise to the term *Renaissance man*. This special stamp of prolific genius lends such giants of art history a legendary and almost magical aura, leading to heightened public interest in their works to this day.

One reason for the impact of such innovations was that they preserved some aspects of tradition, even if they made a momentous break with the recent past. If the changes were surprising, they were still interpretable within the existing schemas for art. For the Renaissance, this notion is especially obvious; whereas the time period was brimming with innovation, it was

also a return to the past. More generally, art created in any recognizable style tends to be judged in light of traditional benchmarks within that style. Whether that style is Baroque, Rococo, or Neoclassical, emerging artwork is evaluated not only in terms of its break from previous styles, but also in terms of its embodiment of the current style. Such continuity is especially evident in enduring principles of traditional Chinese and Japanese art forms.

When developments in the arts maintain a measure of continuity, people can interpret novelty within a familiar context. Many successful products, including artworks, rely on the interplay between familiarity and novelty. On the one hand, people like what they have encountered before.[36] Most popular songs, books, and other consumer products follow well-worn and easily recognizable patterns, and the difference between a hit and a flop can just be exposure; innumerable pop songs with hit potential can be churned out by a vast array of musicians, but exposure—whether by a lucky coincidence or good marketing—causes just a few of them to fulfill that potential.[37] Familiarity also makes a product easier to mentally process, which contributes to aesthetic pleasure.[38] On the other hand, a certain amount of novelty helps keep things fresh. As long as the novelty is not so extreme as to be unintelligible, it resonates with consumers' curiosity and provides the right level of excitement.[39] Whereas overly familiar products can be pleasant but boring, those that challenge expectations are more likely to capture our interest,[40] and products that seem familiar yet new at the same time hit the bull's-eye. This pattern of preferences presumably has a straightforward evolutionary background; it ultimately stems from our ancestors' competing drives for safety and discovery.

As we will discuss, the roles of familiarity and novelty differ somewhat depending on the market segment or product type, and they also change over time. For example, recognizable Impressionist paintings delight the crowds, whereas wealthy collectors of contemporary art might prefer works that shock rather than please. However, recognizable Impressionist paintings may not have become famous in the first place, had they not been novel when they were introduced to the public—arguably more novel than the vast majority of shocking contemporary works.

Impressionism is in fact a strong contender for the most significant upheaval in visual art since the Renaissance,[41] not just because the style has become so popular among the current lay public, but because it represented a fundamental break with the past that was truly progressive. It was more than just a reaction to the status quo or a comment on society; Impressionism represented a new way of perceiving the world, and it successfully translated this vision into a convincing and aesthetically coherent pictorial representation. This movement also laid the groundwork for serious innovations that have followed in its wake. Some of us (including me) may find other styles more exciting than Impressionism, but that is a matter of

personal taste. The significance of the movement is nonetheless difficult to deny. The emphasis on individual impressions and the explosion of color and light that Impressionism brought to the world constitute innovations with a broad and continuing appeal, as well as a springboard for later developments. Indeed, the decades following the heyday of Impressionism gave birth to a diverse array of artistic innovations that in many ways reflect more wide-ranging variety than the innovations of the previous millennia combined. In my opinion, the past century has given us some of the most interesting innovations in the history of art, but also some of the least interesting ones. Whether this observation reflects personal tastes or objective yardsticks, the variety may be an inevitable result of artistic freedom—a freedom that was achieved, at least in part, through past innovations and movements.

The Impressionists also enhanced the popular perception of the starving artist, indicating to the public that innovation is anything but marketable. At the same time, because critics famously slammed Impressionist artists who were subsequently hailed as geniuses, many later critics appear intent on avoiding that mistake.[42] They seem eager to embrace anything with the semblance of novelty—whether the innovation is real or skin-deep—often with little or no evident consideration of quality. Indeed, such considerations may appear antithetical to the spirit of innovation; work that can be evaluated by previous standards of excellence cannot be entirely free from the shackles of the old.

Several influences thus coincide to complicate judgments of innovation today. Among them are the freedom of the contemporary art scene, the constant need for artists to nurture an image marked by novelty, the desire of critics to embrace such artists, and the relative appeal they have for buyers and sellers. When these factors are coupled with a lack of standards by which to evaluate actual, meaningful innovation in contemporary art, true innovation ceases to be a prerequisite for market success, although the appearance of innovation remains paramount.

One difference between our current era and most of art history is that it is much more difficult now, both for the lay public and for most players in the art market, to distinguish between apparent and actual innovation. Exacerbating this situation is the role of the media—both social media and news media—which is entertainment-focused and tends to endow the scandalous or controversial with much fanfare. Similar mechanisms have presumably helped spread the word at any point in history, but their impact is stronger now that channels of communication are more efficient than ever.[43] Today, most actual innovations in art would slip under the radar, virtually undetected by the media, unless they tap into the mechanisms that create sensations in a fast-paced entertainment-oriented society. Ironically, given the current emphasis on novelty, actual artistic innovation is therefore not very newsworthy.

Innovations in mediums and methods occasionally appear to constitute exceptions to this tendency. The invention of the camera was newsworthy, and its applications had a profound influence on the art world, not only because photography could be an artistic medium, but also because photographs changed the incentives of artists employing other mediums. For many artists, drawing or painting faithful representations of nature became a less essential challenge when a camera could effortlessly produce accurate depictions. Today, artificial intelligence (AI) is newsworthy for similar reasons, and its role in creating art demands increasing attention. In 2018, for example, Christie's sold an algorithm-generated portrait for $432,500.[44] However, one might question whether the most noteworthy aspects of such innovations are artistic in nature. Cameras, computers, and AI represent large steps forward in terms of technology, but their initial newsworthiness in the current context has more to do with the mere novelty of applying them to create art. On the other hand, technologies such as AI, which are still in their infancy, have yet to reveal their full potential, both in the creation of art and in related areas, such as in the analysis of artworks and artistic techniques.[45]

On a related note, artworks may find the spotlight not just because they are innovative, but because the time is ripe for new developments. Many contemporary works—at least ones that do not rely on new technologies—would have been simple enough for any artist of the past to create, but they would not have been considered art, given the standards of creativity and skill that were dominant at the time.

Timeliness

This observation brings us to another principle that can make or break a new product in the marketplace: timeliness. Tastes, values, and preferences evolve, as do factors such as knowledge, education, and the landscape of existing products amongst which the new product is introduced. Products tend to go through life cycles, and an important determinant of a new product's success is whether it is launched at a time when the market is ready to adopt it.[46] Not only do successful products often have the right blend of familiarity and novelty, but the surrounding context must also be compatible. For consumer electronics, timeliness might entail compatibility with existing technologies. For cultural products, such as art, it typically entails compatibility with the zeitgeist. In other words, the general intellectual, moral, and cultural climate must be ripe. For example, Gothic architecture fit well with the emerging philosophical landscape of the time. The fit is even clearer for Renaissance art and architecture; the court of Lorenzo de Medici was filled with artists, philosophers, scientists, and writers who rallied around the emerging humanism of the time and shared much of the same vision for humankind.[47]

22 A Few Marketing Principles

Dada, a European avant-garde art movement in the early 20th century, is an example of timeliness prompted by events viewed as negative rather than positive. Confronted with the First World War, Marcel Duchamp and the other Dadaists promoted anti-war politics and rejected the prevailing standards in art. Overall, it seemed that there was something very wrong with a culture in which such a cataclysm could come about. Thus, the Dadaists produced a number of predominantly conceptual works that otherwise may not have been taken seriously.

Strictly speaking, one might actually question the basis for the Dadaists' cultural criticisms, while acknowledging the futility of the Great War and appreciating their incisive political statements. After all, it would be difficult to pinpoint one specific culture on which to blame that particular war. Further, humankind has always been a violent species, as evidenced by investigations of diverse cultures around the world, and the human propensity for warfare has if anything been attenuated over the course of the last 50,000 years. Even today, with the efficiency of modern killing machines, there are fewer deaths per capita due to warfare and violence than in any time period in the past (although that positive trend may be broken if the recent spike in antagonism toward international trade and cooperation continues in parts of the United States, Europe, and elsewhere).[48] The tendency toward more peaceful behavior is evident in other areas as well, and a large part of the reason for this appears to be culture. Nonetheless, the political and philosophical climate—especially during the war and in the years immediately following it—was such that Dada surfaced at the right place at the right time.

Dadaism is also historically important because it paved the way for the current trend of conceptual art. Today, a century later, one might say that the entire contemporary departure from aesthetic concerns is timely. The ability for art to communicate via aesthetics depends on the willingness of the audience to immerse itself in a form of experience that seems at odds with today's fast-moving world.[49] A conceptual work can insult, inform, provoke, or amuse in a fleeting moment, whereas aesthetic appreciation needs to be cultivated. This match with the pulse of contemporary society is a clear strength of much conceptual art from a marketing standpoint, and it characterizes much of the art that draws large crowds to contemporary galleries and museums. Of course, purely conceptual statements of a complex or challenging nature might also require time and effort to fully appreciate, but statements of that kind are found more often in books than in galleries.

Timelessness

Timelessness is a perpetual kind of timeliness in that an artwork transcends trends or other temporary contextual influences. A few years ago, I asked the CEO of Tiffany how the company navigates the waters between changing

fashions and timeless appeals. He replied that, whereas clothes and accessories rely on fashions, jewelry is mostly timeless. In my view, the art world has somewhat similar divides between the timely and the timeless.

Many Dadaist works, for instance, must be understood in light of their relevant time and context. Otherwise, they become meaningless. As a case in point, the current interest in Duchamp's *Fountain* relies on its fame, historical context, and association with museums and fine art. In comparison, the impact of abstract expressionists, such as Willem de Kooning, Franz Kline, or Helen Frankenthaler, relies to a higher degree on the general capacity to experience aesthetics, notwithstanding any references to hidden meanings or the politics of the time. The degree to which these works are liked, and the degree to which the creativity and skill involved in their creation are recognized, may depend on individual and cultural differences, as well as the art–historical context in which the works were made. However, much of the basis for their appeal is nonetheless timeless, although perhaps not to the same degree as classical works.

It can be difficult to differentiate between timelessness based on skillful creativity and iconicity based on well-timed novelty. In fact, unprecedented displays of skill constitute one form of novelty, as demonstrated in many of the old masters. In the age of the Renaissance, viewers were genuinely impressed by the technical mastery of painters like Masaccio and sculptors like Donatello. Masaccio's ability to create three-dimensional illusions and Donatello's ability to shape clay and marble can be replicated today, but much of the old masters' fame is tied to the fact that they pioneered new forms of skillful creativity. However, when a high level of technical mastery is broadly attainable, along with reproductions of masterpieces from every time period preceding ours, then it becomes exceedingly difficult to distinguish oneself with skill. Although novelty retains its power to turn heads, it thus becomes increasingly unlikely that this novelty will be tied to skillful creativity.

As the ability to attract attention becomes less tied to skill and more exclusively tied to novelty, the battle for fame and fortune increasingly becomes a race to provide the newest fashion. The timeless becomes crowded out by the ephemeral, with the ultimate prize being those fashion statements that create enough buzz to become iconic. There are bound to be some of those, even if they are brought to prominence by purely random processes, and critics and art historians of the future will laud the creators of those works as visionaries. In a sense, the ephemeral has then become timeless in its own right.

This latter type of timelessness is contingent on an unbroken stream of historical knowledge across the generations. The situation would presumably change if a nuclear war wiped out current societies, and groups of humans without our specific historical knowledge somehow arose from the ashes. If these humans came across a magazine with a portrait by Rembrandt on

one page and a soup can image by Warhol on another page, I believe the Rembrandt would be recognized as an artwork, but the Warhol would be dismissed as an ad for soup. If this assumption is true, it suggests that the appeal of the Rembrandt relies less on historical happenstance than the appeal of the Warhol does.

Related to the iconicity argument above, however, the appearance of timelessness in Warhol images is boosted by the use of iconic images, such as photographs of celebrities like Marilyn Monroe and Elvis Presley. Further, Warhol prints are frequently mislabeled as paintings, perhaps in part because painting, as a medium, has a certain timeless appeal. Although Warhol painted some Campbell's soup cans, most of his famous works are screen prints; he relied on his background as a commercial illustrator to achieve striking images by simply adding some basic coloring. Nonetheless, mislabeling them as paintings presumably increases their perceived importance and value. This tendency seems almost ironic in a time when the idea, rather than the execution, is purportedly central; paintings imply more workmanship than screen prints do.

Branding

Whether or not such criteria for assessing individual artworks take part in an overall branding strategy, branding can boost the marketability of those works over time. The images and brands of artists have increasingly become distinct selling points, along with the perception of their output as unique products among a multitude of diverse, competing offerings. Consequently, the artist as a brand or brand manager has become a popular topic in the literature on arts marketing.[50] This notion would not be as relevant for craftsmen whose work was considered interchangeable and paid by the hour, but the Renaissance launched the era of artists as individual brands.

These brands were characterized by individual styles. In painting, for instance, Michelangelo's muscular figures were as recognizable as the graceful characters depicted by Botticelli. Since then, recognizable styles have been the norm. Think of El Greco's elongated bodies, Caravaggio's chiaroscuro, Vermeer's gentle light, Turner's roiling landscapes, Hokusai's rhythmic markings, Klimt's decoratively patterned scenes, Schiele's emaciated characters, Kollwitz's starkly depicted protagonists, Mondrian's geometrical shapes, Kahlo's tortured self-portraits, Basquiat's raw brushwork, Celmins' detailed environments, Bacon's agonized portrayals, Lucian Freud's or Jenny Saville's fleshy exuberances, Wangechi Mutu's intricacies, and so on and so forth. If we were to continue the list of easily recognizable styles, we would eventually find that it encompasses most famous artists. This observation does not suggest that a recognizable style is always the result of conscious branding efforts. It frequently results from personal preferences and the will

to immerse oneself ever further in focused explorations. Some artists also develop more than one distinctive style. Gerhard Richter, for instance, is famous for his photorealistic paintings as well as his abstract ones. Picasso is famous for several styles, some of which are markedly different from each other, but all of which are nonetheless easily recognizable as his own (with the exception of some Cubist works that are difficult to distinguish from Braque's paintings in the same style).

The style of an artist does not constitute a clear parallel to branding efforts in the typical corporate sense; one might rather speak of it in terms of product design, although artists tend to create a stream of individually different products. However, the artist's presentation, style, and even signature—frequently compared with a logo—all come together to create a marketable proposition. Artists like Picasso have said outright that collectors buy their signatures rather than their actual artworks. This observation echoes people's tendency to buy a branded consumer product for several times the price of an alternative that is otherwise similar in terms of quality or performance. Branding contributes to brand equity and allows products to be sold for more than they would otherwise command. In fact, a consumer learning process can occur that enhances brand equity while sidestepping quality-determining attributes; when consumers learn the relationship between product quality and brand name before the relationship between product quality and product attributes, inhibition of the latter assessment may result.[51] Extrapolating this observation to the realm of art, it seems feasible that the branding of artists can diminish consumers' ability to determine the quality of artworks by any other measure than brand strength.

Consumers may go to great lengths to identify themselves with brands. In some brand communities, such as for Apple or Nike, many consumers exhibit a devotion to the brand that goes beyond ordinary purchase and use.[52] In some cases, consumers have gone so far as to permanently tattoo a brand logo all over their bodies. In the absence of monetary incentive, what could possibly drive them to such extremes other than an overwhelming sense that affiliation with the brand is meaningful?

Some players in the art market are no less adept than the most successful corporations at exploiting such branding effects. Thus, Jeff Koons can successfully offer ordinary consumer products such as basketballs and vacuum cleaners under his own name. They are the same products you can buy in a department store, but now they are taken seriously as artworks, exhibited in galleries and museums, and given extremely high prices. It is one of the clearest examples of branding effects imaginable. The exhibitor does not even bother to make his own merchandise. He merely attaches his own brand to the products of others and adjusts their manner of presentation, and the items magically increase in value and importance, much more so than when Michael Jordan endorses Nike shoes.

26 A Few Marketing Principles

Not all of Koons' items can be purchased at department stores at a lower price. He actually does produce some items for himself as well. That is to say, like Warhol and Hirst, he has other people produce much of his work for him. "I'm not physically involved in the production. I don't have the necessary abilities," Koons reportedly admitted in connection with a 1996 exhibition at the Guggenheim.[53] He is at least refreshingly honest. Whereas some critics bend backwards to explain the deeper meaning of his work, Koons himself has not said or done much to indicate that he agrees with their explanations. And this apparent nonchalance only adds to his charm. He is the epitome of seemingly effortless marketing.

The implication is not that marketing requires no talent or effort. Koons began his career selling memberships at the Museum of Modern Art, and he was apparently the most successful salesperson in the museum's history. He then went on to a successful five-year stint as a Wall Street commodities broker. In his artistic career, he seems to have applied the same principles that made him successful in his other endeavors. One difference between Koons and most players in the art world is that he does not bother to intellectualize his work or hide the simple realities of the marketplace. He even speaks of increasing his market share when placing his work in various galleries. Whatever one might think of his artistic abilities or of critics who stubbornly proclaim hidden meaning or conceptual profundity in his work, Koons is clearly a talented and hardworking marketer. It is also not my intention to oversimplify the concept of branding in this section; a brand is more than a name, and effective branding may require a variety of efforts and skills. It does not, however, appear to require some of the skills one might reasonably expect in an artist.

Damien Hirst seems no less willing to admit that he cannot paint and that a buyer would get an inferior painting if Hirst, rather than his assistants, were to produce it. However, he is aware of the power of his brand. In his own words, "Becoming a brand name is an important part of life." In addition to his paintings (along themes such as spots or butterflies), Hirst sells tank pieces (dead animals in formaldehyde) and cabinet pieces (various items displayed in pharmacy medicine cabinets). He meticulously manages each of these product lines and is probably now the richest and most powerful of all artists, all without knowing how to paint. Such is the power of branding.

In the art world, even the simplest and most repetitive works may command high prices, as long as they are branded products. For instance, Japanese On Kawara's *Today* series features a given day's date painted on a flat surface in simple characters and numerals. The solid background color may vary from canvas to canvas, but this would not seem enough to qualify the works as particularly imaginative, and definitely not enough to explain the price tag. There are more than a couple of thousands of these works in existence, yet an individual piece may fetch hundreds of thousands of dollars.[54] In 2014,

one of them sold at Christie's for $4.2 million.[55] Consumers should have no trouble writing a given day's date on a piece of paper or perhaps just typing it out on a computer—free of charge—but instead they pay vast amounts of money to have it written by someone whose brand they covet.

As a general observation, the more difficult it is for consumers to make determinations of quality, the more important branding becomes for manufacturers and sellers who wish to achieve high prices. I am not aware of any market for which this observation is more relevant than it is for the art market, nor do I believe there has ever been a time in which it has been more relevant for the art market than it is today.

Placement, Promotion, and Publicity

Even for branded artists with products of an undisputedly high quality, however, exposure remains essential to commercial success. Whether or not that exposure relies on strategic marketing efforts, it may be worthwhile to consider it from a marketer's perspective. For example, Leonardo's *Mona Lisa* is the world's most famous artwork—and presumably the most valuable one, although it is unlikely to be up for sale anytime soon—but this supreme honor was far from inevitable. In the 1800s, this portrait was not even the most valuable painting in the Louvre, let alone the world.[56] But when it was stolen in 1911 and recovered with great fanfare several years later, the ensuing international attention elevated the painting to a new level of fame. Since then, parodies by other painters, widespread use of the image in advertising, and other sources of exposure have further increased its fame. Today, some critics and art historians argue that this masterpiece's unrivalled quality underlies its preeminent position, whereas others recognize that its fame is based, at least in part, on other factors. The latter people do not necessarily dispute the observation that the *Mona Lisa* is an outstanding painting, but they realize that there exist numerous outstanding paintings in the world, albeit none with better exposure.

Although exposure in the art world often is linked to distribution channels, it typically involves more mundane sources than sensational thefts. Dealers and auction houses provide promotional efforts such as direct mailings and magazine ads, in addition to engaging in personal sales to convince prospective buyers that the promoted merchandise is exactly what they need. Some artists, for whom the established options may not be available, choose alternative distribution channels to attract attention, such as the Impressionists exhibiting their work at the Salon des Refusés. Better-established artists may gain additional attention via opportunities such as highly visible public commissions. In ancient Greece, Phidias could not have asked for a more prominent spot for his Athena statue than the Parthenon. Michelangelo's *David*, sculpted from the famously awkward Duccio column,

was ensured crowds of spectators when it was placed in the public square adjacent to the seat of civic government in Florence. Similar commissions today ensure widespread, enduring exposure for the chosen artist. One might argue that such public commissions are typically tied to a prior track record of demonstrated mastery, and as such the visibility ultimately results from product quality. However, given the increasing difficulty of gauging product quality, it seems likely that other factors, such as branding, become the basis for public commissions.

These observations once again illustrate the intertwined nature of various marketing variables in the art world. The aforementioned 4-P marketing-mix framework would discuss distribution channels under the heading of place, rather than a heading that combines placement with promotion and publicity. However, whereas aspects of distribution can overlap with aspects of promotion for a number of product categories, the overlap can be especially noteworthy for artworks. The places in which artworks—often unique pieces—are exhibited may have promotion and publicity, as much as sales or consumption, as the primary benefit to the artists and their collaborators. Galleries, museums, fairs, and auction houses are branded, and being associated with the best brands represents a highly visible stamp of approval. Further, artworks exhibited in the right places may generate headlines; it is rarely newsworthy in the same way when a typical retail outlet begins stocking a new product line of some sort.

Of course, much of the attention generated by art and artists has little to do with placement or distribution channels. Some artists arrange political media stunts or engage in activism, as exemplified by the protests of the Guerrilla Girls. Others merely behave in a bizarre manner, as with Salvador Dalí's eccentricities. Adequately peculiar episodes, such as Caravaggio killing a young man or Vincent van Gogh chasing Paul Gaugin with a razor blade and cutting off a part of his own earlobe, can add color to an artist's reputation long after his or her own passing. (Such episodes may also be embellished; in popular retellings, it is usually the whole ear that van Gogh sliced off.) Since van Gogh shot himself in the chest, even the way he committed suicide was bizarre (unless he was actually shot by someone else, as some observers might speculate).

Scandal has always been a reliable way to get into the spotlight. Sometimes, it arises from the manner of depiction, as with the Impressionists, Fauvists, and several other movements. Other times, it arises from the content of particular artworks, as with Francisco Goya's painting La *Maja Desnuda* (sometimes described as the first clear manifestation of female pubic hair in a large Western painting) or Édouard Manet's painting Le *déjeuner sur l'herbe* (depicting a nude female and a scantily clad female bather on a picnic with two fully dressed men). Works of this kind tend to stir up controversy. Anything that gets attention is also bound to be repeated, much like it is in the

gossip columns, and topics such as sex and nudity are still among the most frequently rehashed ones, presumably because they are among the simplest and most predictable ways to get attention. Thus, Robert Mapplethorpe and Jeff Koons gain much publicity when they follow up with photographs of genitalia and sexual acts portrayed in vivid detail. Whereas Mapplethorpe tends to stay behind the camera, applying well-developed technique and a personal style to create an aesthetic impact, Koons takes the self-promotional aspect a step further and gets in front of the camera while having sex in various positions. More recently, an example of adding some humor is provided by Murakami's *Lonesome Cowboy*, a sculpture of a naked youth brandishing a stream of semen as a lasso.

As a general rule, an artist hoping to be perceived as controversial and attention-worthy needs to provide a twist of some kind. It is not a rule without exceptions; Marcel Duchamp's urinal has not only been repeated conceptually countless times, but it has even been repeated literally, and several of these straightforward replications have wound up in museums. Nonetheless, some small twist usually helps the appearance that one is pushing the limits. In fact, one of the most frequent themes in popular art commentary over the past several decades is the one in which the artist purportedly pushes the boundaries of what should be considered art, thereby stirring debate.

As a source of examples, we might turn to the annual Turner Prize, which frequently causes the public to question whether the winning entry should qualify as art in the first place. It is an easy publicity-lever to push, and there will always be commentators—whether critics, journalists, or the general public—who join the debate. That, of course, is much of the point. From a marketing perspective, it need not be a particularly illuminating debate, as long as some buzz is generated. For instance, the 2001 Turner Prize winner was Martin Creed, with his installation *Work No. 227: The Lights Going On and Off*, featuring an empty room with a light going on and off every few seconds. Whereas this piece may have been intended as a reflection on consumerism and clutter, much of the discussion it sparked revolved around whether it should be considered art, let alone win such a prestigious prize.

It is not difficult to come up with similar installations. For example, a Phillips auction in 2010 featured an installation by Felix Gonzales-Torres consisting of two 40-watt light bulbs hanging from two extension cords. The estimate was $200,000–$300,000, and the work sold for $506,500. The work was from an edition of 20, plus 2 artist's proofs. Whether or not this installation was as "ephemerally beautiful and deeply profound" as suggested by the catalog, the main trick is to promote oneself well enough to sell at a high price or, as in the prior example, to be awarded the Turner Prize. Such outcomes can turn any installation into a topic of conversation and justify the use of superlatives. Incidentally, the price for the two light bulbs paled

in comparison with another installation by Gonzales-Torres sold at the same Phillips auction: a pile of candies wrapped in light-blue cellophane, which sold for $4,562,500.[57] It is generally understood that the candies should be piled in a corner of the room, and if they are eaten, they may be replaced with new candies.

In most chapters on marketing theory, several of the above observations would clearly fall under the heading of product design, not promotion. In the realm of art, however, the boundaries between product design and promotion are often blurred. If a product's main function is to generate buzz and promote an artist, then it does not seem unreasonable to discuss that product under the heading of promotion. These days, both artworks and exhibition spaces may also encourage attention and word of mouth on social media. Multitudes flock to instagrammable or TikTok-worthy opportunities; whether or not the visitors spend much time actually contemplating the sights, they may want to share pictures of them—frequently selfies. To many consumers, the social media-worthiness of a product, place, or experience is essential in determining whether or not to make a visit. As a case in point, 50,000 $25 tickets to *Yayoi Kusama: Infinity Mirrors* at the Broad Museum in Los Angeles sold out within hours of going on sale.[58] Visitors waited in line to get 30 seconds in mirrored enclosures, and the deluge of images posted on social media reportedly indicated that the majority of visitors spent most of their time posing and taking selfies.

Whether artists or marketers view visits, experiences, sales, publicity, or social media mentions as strategic goals, the actual products, as well as their distribution channels, may be an integral part of promotional efforts. To some degree, the approach taken by artists and their collaborators depends on those goals. In turn, those goals, as well as consumers' expected or actual responses to the products and promotions, depends on who the consumers are. The next sections therefore consider aspects of the interaction between providers and consumers of art.

Segmentation, Targeting, and Positioning

Artists sometimes react to market feedback, and there are notable historical examples that we do not necessarily think of in such terms. In 1401, for instance, Filippo Brunelleschi entered a competition to design a new set of bronze doors to the baptistery in Florence, but he failed to beat fellow goldsmith Lorenzo Ghiberti. Both had produced a panel depicting the Sacrifice of Isaac, but a 1403 judgment held that Ghiberti's panel demonstrated superior technical skill. After this, Ghiberti went on to a successful career as a sculptor, while Brunelleschi instead focused on architecture. The latter decision could be viewed as a response to negative market feedback, although Brunelleschi's illustrious career as an architect is seldom thought of in these

terms, especially since his subsequent creation of the dome for the cathedral of Florence is one of the most famous architectural achievements in history.[59]

Whereas Brunelleschi's versatile and prolific genius allowed him to switch between different art forms and still achieve a rare level of excellence, a career change is a somewhat drastic solution compared to merely selecting a new target market. In general, marketers rely on segmentation when selecting a target on which to focus. They segment markets on various bases, including demographics (e.g., income brackets, age groups, and geographic locations), psychographics (e.g., attitudes, values, and lifestyles), or needs (i.e., specific benefits sought from the product). A firm might select one or more targets based on criteria such as the size of the segment, the extent to which the segment is already well served by competitors, and whether the firm's existing strengths are well aligned with the challenges associated with the segment in question. The firm attempts to reinforce the connection between its products and target customers and ultimately stimulate profitable sales via a process of positioning, which includes cultivating an image intended to appeal to those customers while developing suitable products, with suitable prices, distributed via suitable channels.

Although most artists are presumably less sophisticated in their approach, many of them at least demonstrate a rudimentary grasp of segmentation, targeting, and positioning, sometimes even catering to more than one segment at a time. For example, painters often adopt the practice of printmaking. A print can be priced at a rate affordable to those consumers for whom an original painting or drawing is too expensive. At the same time, it is clearly distinguishable from a painting. Thus, the artist can reap additional profits from less affluent buyers without adversely impacting the perception that more affluent ones have of the painting. Similarly, a sculptor might exhibit work in clay as well as in bronze, thus appealing to different market segments with different purchasing power.

In terms of the overall thrust of an artist's career, the selection of a target market can nonetheless be a consequence of circumstance rather than strategic decisions. Whereas dealers and auction houses have the knowledge and resources to implement strategies of this kind, most artists appear to fit with certain market segments depending on the type of production they happen to have. One artist may appeal to the average tourist because of decorative qualities and regional subject matter. In this case, success would depend on factors such as the plentiful production of broadly appealing images for reasonable prices. Another artist may attract Manhattan socialites who crave the newest fashion but have no interest in tourist images. Yet another artist may appeal to collectors with specific tastes who care little about fashions and are willing to pay what they can afford. Outlets such as galleries are often specialized, and dealers choose artists whose works are readily positioned in

32 A Few Marketing Principles

accordance with their gallery's image. This practice is not very different from the practice of any other retailer choosing merchandise that fits the image of the store.[60] In turn, it also tends to engender or reinforce a specific image for the artist.

Segmentation, targeting, and positioning have become more important in the art world in recent history than they have been in much of the past, for at least three reasons. First, the rise of the individual artist—as opposed to the craftsman or collaborative worker—has made these practices more relevant, since the artist is now viewed as providing unique products. Second, the proliferation of diverse styles and types of art has resulted in so much variety that consumers lack the capacity to focus on, or identify equally well with, each alternative. Third, there has been an increase in discrepancies between popular conceptions of art and those espoused by small influential interest groups. We shall discuss the existence—and sometimes intentional cultivation—of such discrepancies in a later section on conspicuous consumption. First, however, we shall consider how artists may customize or co-create works that appeal to their consumers.

Customization and Co-Creation

Artworks often are made to fit with a specific context or to please a specific audience. Sometimes, customization suits purposes of propaganda, as when the Egyptian pharaoh Akhenaten attempted to guide his people into the monotheistic worship of the god Aten. Rulers throughout history have integrated art into a more or less active propaganda apparatus.[61] In Christendom, artworks for churches and public buildings were frequently custom-made to educate the common people in religious matters. Wealthy patrons might also have their own likenesses inserted into artworks, whether of a religious or secular nature. Other times, the subject matter itself could serve a more mundane purpose. For instance, mythological topics might be chosen to justify the inclusion of naked bodies. In the contemporary art scene, customization can be less obvious. The dealer may instruct the artist to produce works of a specific kind because they are currently easy to sell, but this is not necessarily evident to buyers. Of course, portraits and commissions also represent a type of customization.

It is difficult to gauge whether the practice of customization plays a greater role now than at other times in history, but the topic is interesting in light of broader business trends. Information technology and flexible operations allow for a great deal of customization, including mass customization.[62] When purchasing a car today, consumers can often choose specific details such as color or safety equipment before the vehicle is made. It will be interesting to see what role such practices might play in the future art

market. It could possibly work as a gimmick, because mass customization of art would probably strike many consumers as a novelty. In line with the principle of perceived innovation, this could help generate critical acclaim and commercial success. This practice may undermine the perception of scarcity and hence force prices down, but value pricing does not preclude commercial success if the sales volume is high enough.

If mass customization becomes more widespread in the art world, the process can also differ in the level and type of consumer involvement. Recent research on consumer product customization shows that consumers can enjoy partaking in product assembly tasks; as long as customization decisions and assembly processes are integrated, consumers become creatively engaged and derive pleasure from these tasks.[63] Customizing a product by choosing each of its attributes individually tends to be onerous for consumers, but the process can be improved by having a prespecified set of partially completed starting solutions that consumers participate in refining to create the final product.[64] In general, consumers regularly enjoy engaging in creative activities, and constraints such as instructional guidance or target outcomes may increase this enjoyment.[65] These types of findings in the domain of consumer products can help inform the development of artist–consumer collaborations. For example, artists might offer partially completed artworks, with consumers providing input that helps shape the final product. Current technology and internet-based sales channels would facilitate collaborations of this kind. Whereas some observers would presumably object to the apparent commercialization of artistic productivity, others might welcome the democratization represented by collaborative creativity in which any individual could participate.

More generally, and less related to commercialization, collaborative art has deep historical roots. From the outset, it may even have been the norm rather than the exception, developing through prehistory as part of rituals and ceremonies in which participants imbued objects and events with special meaning.[66] Current movements toward participatory art experiences appear to draw on some of these early practices, with artists and ordinary community members collaborating in the creation and proliferation of artworks.[67] These movements are also reflected in some of the arts-marketing scholarship that focuses on participation and relationships with audiences.[68] That scholarship is not necessarily focused on collaboratively created objects, but on the collaborative experience of such objects, such that the audience is more than a static observer.[69] Consumers are active participants, engaging cognition, emotion, and imagination to appropriate and make sense of artworks.[70]

Whether or not consumers co-create in this fashion, however, providing funds remains one of their central functions in the art market. Therefore, the final two sections in this chapter deal with issues related to sponsorship and purchasing behavior.

Sponsorship

Sponsorship has a long history. For instance, Alexander the Great endorsed the Greek sculptor Lysippos and commissioned him to make his portraits. Alexander's support of Lysippos—like Lorenzo de Medici's support of Michelangelo, Peggy Guggenheim's support of Jackson Pollock, and Charles Saatchi's early support of Damien Hirst—facilitated publicity and commercial success, whether or not this support was formally labeled as sponsorship. The support of a powerful dealer provides similar opportunities. This sometimes involves paying artists a retainer, which gives the dealer leverage in controlling what they create. It is a form of sponsorship that allows artists to continue production while minimizing risk and guaranteeing an income. It is also a way for the dealer to ensure a predictable flow of products with which to feed the market. However, the backing of a patron or dealer does not guarantee success, especially if that sponsor is insufficiently wealthy or influential. Vincent van Gogh is a famous example of an artist who achieved no commercial success in his own lifetime, although his brother Theo supported him and provided an allowance that enabled him to continue his production until he killed himself at age 37.

The government can provide support, too, although that may entail other complications. For instance, Auguste Rodin wrestled with commissions such as *The Gates of Hell*, *The Burghers of Calais*, or the *Monument to Balzac*, leading to frequent disagreements about details concerning the execution of these sculptures. A more recent example pertains to the American National Endowment for the Arts and the controversy arising in connection with funding issues in late 1989 and early 1990. In essence, there were objections to uncritical public funding for works that had no apparent artistic merit and did not provide a public benefit. The debates could become heated, and a reproduction of the photographer Andres Serrano's *Piss Christ*, an image of a crucifix immersed in urine, was even torn up on the floor of the US Senate.[71] Since then, there was a gradual withdrawal of American government funding and a shift from public-sector to private-sector sponsorship.

When corporations collect art, they may do so for at least three reasons: to improve public relations and brand equity, provide benefits for employees, and diversify investments.[72] Sometimes, art sponsorship may also be part of cause-related marketing, in other words, a form of corporate philanthropy.[73] Yet, other times the lines between support and the signaling of corporate or personal identity can be blurred; a study of business magazines in Germany, Austria, and the United States found that in approximately 6% of all photographic portraits of executives, these executives were pictured in front of an artwork in their office or boardroom.[74] Private firms, however, often sponsor the arts via purportedly neutral channels such as entire festivals, rather than focusing on individual artists.[75] At an individual level, artists may

have more luck with individual patrons. Otherwise, if they are independently wealthy or have alternative sources of income, they might be able to pay their own way. Today, an affluent society allows many artists to live and work comfortably without commercial success. Some artists may be born with enough money to live well without any other source of income, and others are able to support themselves through alternative means such as day jobs. Either way, sponsors and buyers may have their own motivations for supporting the arts, beyond altruism toward artists or appreciation for their work. One such motivation, which often is overlooked but plays a central role in the art market, has more to do with social signaling among consumers than it has to do with art or artists.

Conspicuous Consumption

When powerful rulers such as Egyptian Pharaohs, Roman emperors, or church leaders of Christendom sponsored or commissioned art, they directed the development of the arts by setting an agenda and providing funds for the works to be produced. At the same time, commissions of these kinds were often highly visible to others; a frequent expectation was that they would favorably influence popular perceptions of the patrons, whereas an ancillary effect was on popular perceptions of the art in question. A similar—though perhaps less pronounced—impact stems from collectors and patrons in general, who do not merely buy what they are offered but who vote with their wallets. They have tastes and preferences, shaped by various factors such as individual experience, current fashions, and the opinions of peers, and these in turn determine which works are bought or supported. Whatever the reason for a purchase may be, the money paid also signals to artists that this type of art is viable.

The term *conspicuous consumption* was introduced by Thorstein Veblen in his book *The Theory of the Leisure Class* and initially referred to the manifestation of social power among the rising upper class via displays of wealth.[76] The concept was later broadened to include this type of behavior among the middle class and even the poor,[77] and research has shown that the behavior may arise not only as a general drive to display wealth and social power but also as a reaction to social exclusion in the form of being ignored by others.[78] Conspicuous consumption can also entail displays of taste, erudition, or other desirable attributes. One consumer may wear a Rolex watch or sport a Louis Vuitton handbag to signal that she has money to burn, but another consumer might make a show of frequenting the opera, reading the right books, or drinking the right wine to indicate refined culture. Among these types of signals, the acquisition and patronage of art have long been among the most potent ones. Not only do artworks serve as simultaneous displays of wealth and culture, but they often provide no obvious function other

than being perceived and appreciated. Whereas an Aston Martin provides transportation, and a Rolex keeps track of the time, a painting primarily provides an invitation to look at it. Generally speaking, the status-signaling potential of expensive artworks remains evident despite the concurrent trend toward democratization and mass adoption of luxury products.[79] Ordinary consumers may flock to art museums and buy any number of luxurious indulgences, but the truly noteworthy purchases are still reserved for the elite.

Traditionally, the signaling effect of artworks has been tied to the copious amounts of time, skill, and effort devoted to their creation. The works displayed superb craftsmanship and meticulous attention to detail. Only the wealthiest patrons could afford them, and acquiring them presumably also demonstrated discerning taste and refined culture. These works were unique, expensive, and difficult to obtain. In more recent times, however, several developments have coincided to change the landscape of consumption. A widespread rise in wealth and increasingly efficient methods of mass production have greatly increased the potential for nonessential purchases, such as artworks, among average consumers. The increased wealth also enables societies to support a multitude of artists, many of whom have better-developed skills than artists of the past; it is easier to learn established techniques than to develop them individually. At the same time, technologies like the camera have made dazzling depictions of nature possible without the need for much skill, and electronic methods of reproduction and distribution have made such depictions easily accessible to the masses. In sum, the acquisition of a beautiful or skillfully executed work by a contemporary artist does not make the same statement today that it did in the past.

To really make a statement today, an individual might do well to pay enormous amounts of money for something that most consumers would hesitate to put in their living room for free. It takes a moderately wealthy person to buy a Ferrari, but it takes someone with real money to pay a million dollars for a single hubcap baptized as art. It also takes a singularly discerning eye to see the deep meaning and artistic vision represented in the act of hanging that hubcap on the wall. That, at least, is the intended signal, and it often works remarkably well. These types of purchases regularly receive media attention, because the public never ceases to be shocked and amazed by vast amounts of money being shelled out for apparently nonsensical items. Such reactions further increase the signaling effect of the purchase, as people are likely to confer higher status and competence on individuals perceived to be nonconforming.[80] It does not matter much whether the wealthy art patrons are actually conforming to each other and buying the same kinds of artworks; the *perception* that they are nonconformers is what matters. Further, even apparent conformism may be desirable, as long as wealthy peers and fellow collectors are the only ones to whom the conformism is evident. People are often happy to signal conformity to their in-group with

indicators that are opaque to their out-group; the conspicuous consumption thereby signals the collectors' membership to a cultural elite while separating them from the mainstream.[81]

Marketers and other communicators can rely on related effects in various domains, when they target a specific audience with information that is recognizable only to that group. To draw on a personal anecdote, the theoretical physicist Brian Greene once had a cameo on an episode of the sitcom *The Big Bang Theory*. Shortly thereafter, I had an opportunity to ask him whether he thought more people recognized him from that cameo or from images on the back of book covers. He replied, quite logically, that nobody would have recognized him on the sitcom unless they already knew who he was. Popular actors and singers can be broadly recognizable, but physicists tend to have a somewhat narrower fan base, which makes the group membership of fans who recognize them all the more salient.

When wealthy collectors make expensive purchases, whether in art, fashion, or other areas, they are often emitting a signal that is immediately recognizable only to other group members. However, the broader dispersal of that signal via media coverage, museums, and other channels ensures that larger audiences tune in as well. The endorsement of the art world is also a likely outcome of conspicuous purchases that perplex the broader public, whether or not that public comes to accept them over time. Galleries and auction houses deal in works that turn a profit, so a million-dollar hubcap will attract their attention. Critics tend to focus on works that attract attention, because otherwise they quickly find themselves irrelevant. Even art museums follow suit, in their effort to represent "important" developments of the time; it does not necessarily matter whether the only reason they are considered important developments is because someone with money decided to invest in some conspicuous consumption.

It does not take many purchases of the truly expensive kind to create a trend. In turn, artists crop up to fill the marketplace with similar products. Wherever there are profits to be made, manufacturers and distributors always do. Conversely, those artists who attempt to work outside the hot trends are unlikely to get much notice, let alone influence the further development of the arts.

The influence of an elite set of consumers on prevalent tastes has been noted by authors ranging from Pierre Bourdieu to Steven Pinker.[82] These authors often speak from the perspective of an outsider using common sense, and it might indeed seem that it should be a matter of common sense. However, art history as well as contemporary commentary is frequently written as if the artists were fully in charge of development and change. Even when famous patrons are acknowledged, it is often to note that they supported the efforts of the artists, not to recognize that they personally influenced the direction of the arts by choosing which styles and works would become prominent.

The Middle Ages saw a boom in Christian imagery, despite periods of iconoclasm. At the same time, there was a decline of realism in art, along with the deterioration of some technical skills. Both trends can be traced to the patronage of church leaders who strived for Christian symbolism but who cared less for representations of nature. The Renaissance saw the return of classical skills and a celebration of the human body and spirit in a real, three-dimensional world. These trends can be traced to the influence of humanist patrons such as Lorenzo de' Medici.

There may currently be fewer bishops and statesmen actively setting an agenda for the development of the arts, but the conspicuous purchases of a handful of wealthy collectors can still have a substantial impact on the contemporary art market. The next chapter will zoom in on that market to consider the roles of collectors, artists, and other key players. In other words, whereas this chapter discussed some principles that characterize the art market, the next chapter focuses on some protagonists who operate in that market today.

3
THE CONTEMPORARY ART MARKET

The Cogs and Wheels of Today's Marketplace

The painter Eric Fischl once noted, "Now the art world has become the art market."[1] A related statement by the art dealer Mary Boone illustrates how that might happen: "I had reservations about making art a business, but I got over it."[2] In 1982, a cover story in *New York* magazine dubbed Boone "The New Queen of the Art scene."[3] Over the years, her gallery has represented the likes of Jean-Michel Basquiat, Francesco Clemente, Eric Fischl, Anselm Kiefer, Jeff Koons, Barbara Kruger, Yoko Ono, Sigmar Polke, Julian Schnabel, Ai Weiwei, and others. Boone avoided bankruptcy in the 1990 art market collapse that followed the boom of the prior decade, but it left her struggling, and several big artists left for other galleries. In 2019, she was convicted and sentenced to 30 months in prison for tax evasion. Although deciding to close her two gallery locations, on Fifth Avenue and in Chelsea, she announced plans to get back on her feet, stating, "I want to be the Martha Stewart of the art scene."[4] Meanwhile, Eric Fischl, one of the artists who had stayed with Boone after 1990, had nonetheless parted amicably with her gallery in recent years, over concerns that art buyers behave like "hysterical collectors of brand names."[5]

As this example suggests, there is colorful behavior on both the supply side and the demand side of the contemporary art market. (For readers interested in more anecdotes than the ones mentioned in this chapter, authors such as Georgina Adam, Noah Horowitz, Don Thompson, Sarah Thornton, Olav Velthuis, and others have written on the topic in recent years.) This market is noteworthy in the current context for at least three reasons: First, in line with the principles from the previous chapter, it is particularly marketing-centric. Second, because of the attention and interest it generates, it has a considerable influence on current perceptions of what art is and how we

should engage with it. Third, it concerns work being made today, or at least in the recent past.

The term *contemporary art* is sometimes used to refer to work by living artists, but it is more often used to refer to art from the past few decades. Works made in the century preceding the past few decades are usually classified as modern, at which point the contemporary era begins. Sometimes, the contemporary classification is also granted more flexibility. This is why, for instance, early Warhol pieces might be put on auction as contemporary work. Other auction houses classify an early Warhol as postwar and a later Warhol as contemporary. Some base the contemporary category on the type of work, such that Gerhard Richter's photorealistic work is classified as modern, whereas his abstract work is classified as contemporary. An exact timeframe is not essential for our purposes, and in any case, the frame for the contemporary term will shift as time progresses, given the present-tense connotations of the word. What matters more is the general character of contemporary art and how art-world players and the public at large deal with it. To have a rule of thumb, let us define contemporary art as works from the past 40 years or so, although we might stretch the frame further back in some cases.

Andy Warhol is often considered a marker for the transition between modern and contemporary art, so it is perhaps fitting that his work exemplifies the dramatic rise in prices in parts of the contemporary market. At a postwar and contemporary Christie's sale in New York in 2006, eight works by Warhol realized a total of almost $60 million. This included a record-breaking price for the single piece entitled *Mao*, which realized $17 million. Within a half year, this record was broken by the $72 million shelled out for Warhol's *Green Car Crash (Green Burning Car I)*, a record which itself was broken a few months later by hedge fund manager Steve Cohen's acquisition of *Turquoise Marilyn* from a Chicago collector for $80 million. In 2007, Warhol was the overall market leader, with 74 multimillion-dollar sales netting a total of $420 million, surpassing even the $319 million realized by works by Picasso. This was the first time that a contemporary artist was ranked highest in total revenue from the public sale of his works.[6] Since then, Warhol's works have achieved even higher prices, with *Eight Elvises* selling in a private transaction in 2008 for $100 million, and *Silver Car Crash* selling at Sotheby's in 2013 for $105 million. (The latter is often reported as being the new record at the time, but in reality, it was only higher than the 2008 price if one ignores inflation-adjusted value of money.) In 2022, *Shot Sage Blue Marilyn* shattered previous records, selling at Christie's for $195 million.[7]

Prices for earlier works have been higher still, as with Picasso's *Les Femmes d'Alger*, which sold at Christie's, New York for $179 million in 2015, Mark Rothko's *No. 6 (Violet, Green, and Red)*, which sold privately for $186 million in 2014, or *Salvator Mundi*, attributed to Leonardo da

Vinci, which sold at Christie's, New York for $450 million in 2017. With the highest-priced private sales, only reported estimates are available: Jackson Pollock's *Number 17A* fetched around $200 million in 2015, Cézanne's painting The *Card Players* was sold for approximately $250 million in 2011, and Willem de Kooning's *Interchange* sold for about $300 million in 2015. Thus, contemporary art does not hold all the records, but it represents estimated global yearly sales that are pushing beyond $20 billion, and it is a market controlled largely by a handful of players.

As Joan Jeffri puts it, "The art market is a small, incestuous family, inaccessible to the general public, and kept alive by groups of tightly connected insiders."[8] The group of high-end buyers has actually grown quite a bit in the past few decades, though. Before the late 20th century, there were fewer than 100 buyers in the world for works above $5 million. Today, that number has grown to more than 1,000. Much of the reason for this growth is globalization and increasing wealth in different parts of the world—not just in the Middle East, but in Russia, China, India, Brazil, and other countries.[9] In 2018, China accounted for about 19% of the global art market, trailing only the US (44%) and the UK (21%),[10] whereas China overtook the UK in 2023.[11]

Whether or not the growth of wealth in different parts of the world causes the market to become less incestuous over time, the cogs and wheels of the art market are similar in most places. Let us take a closer look at some of the players and institutions involved.

Artists

With the exception of those who are also accomplished marketers, the artists themselves are seldom among the most influential players in the art market, but they are usually the ones most familiar to the general public. Stories abound about their struggles, failures, successes, and dedication to their work. Michelangelo thundered if his work was ever disturbed, even if it was by the Pope himself. Mary Cassatt embraced feminist ideals, while the pervasive sexism of the time prevented females from using live models at the Pennsylvania Academy of Fine Arts, where she studied painting. Henry Ossawa Tanner faced racism, but nonetheless succeeded as an artist. Picasso was exceptionally prolific, with a lifetime output of artworks estimated at around 50,000, including paintings, sculptures, drawings, prints, ceramics, tapestries, and more. Pierre Bonnard reportedly kept painting until the very end. When he had become too weak to lift the brush, he asked his nephew to add a touch of yellow "On the left, at the bottom, there on the ground under the almond tree." This was just before he died.[12]

Both history and present are filled with colorful examples of artists applying talent and effort to their creations. Consistent with the principles

outlined in the previous chapter, however, the success and fame of contemporary artists are increasingly tied to marketing activities rather than to artistic creativity. If that observation is correct, then the curious result could be that the amount of concentrated effort dedicated to the creation of artworks becomes negatively correlated with the amount of success attained from them. There is no dearth of sincere, talented, and hardworking artists, many of whom create masterpieces that will forever remain unknown to the world. Unfortunately, they are not the focus of this book, since they have scant impact on the art market. Many artists who focus wholeheartedly on their work do not have the time or inclination to mingle with the right people, provoke the appropriate scandals, and create an image conducive to success. If they do not already have the right contacts via friends and family, it is therefore unlikely that they ever will. To make matters worse, they are also unlikely to create easily marketable work. Conversely, as the sociologist Olav Velthuis comments, artists such as Maurizio Cattelan, Damien Hirst, Jeff Koons, Takashi Murakami, and Richard Prince might be considered examples of successful commercialization. Velthuis further notes, "The increasingly commercial motivation of artists is reflected in the type of work they make: easily recognizable and digestible, iconic or provocative images, often borrowed from popular culture, have come to dominate the market in the 2000s."[13] This motivation may also figure into various marketplace collaborations, such as the ones Louis Vuitton has had with Takashi Murakami, Cindy Sherman, Richard Prince, and Yayoi Kusama.[14]

As discussed, there are different market segments, and some artists attain a degree of market success simply by producing work that happens to resonate with a segment of art aficionados. These artists might achieve moderate prices and even some sporadic acclaim without strong commercial motivations, but they rarely have the strongest or most visible brands. Nonetheless, it would be misleading to suggest that work produced without commercial aspirations cannot become commercially viable, as long as it somehow finds its way into galleries or other sales channels. This just appears to be the exception rather than the rule, which should maybe not be overly surprising; making money is the specialty of business professionals, not artists, and few products of any kind do well in the marketplace in the complete absence of commercial aspirations. After all, marketplaces exist because of commercial aspirations, although this reality may not fit with a romanticized notion of the art world. This observation does not imply that there no longer exist artists who fit that notion—in other words, those who work passionately to create art for art's sake or who strive to express their own creative vision without regard to public or market.[15] However, they are increasingly unlikely to be among the most visible and commercially successful artists. One might say that they represent the outdated view of marketing as a way to sell products that a

given manufacturer happens to have produced. That view somehow seems appropriate to artists, but it does not align with the reality of the marketplace.

Becoming a branded artist today often entails a few predictable steps. Creating some fuss in the media by exhibiting work perceived as absurd or shocking can be helpful, but not strictly necessary. What is more important is being represented by a branded gallery or dealer, being collected by a branded collector, and perhaps being sold at a branded auction house or displayed at a branded art fair. Recent research, reconstructing the exhibition history of half a million artists, also shows the career benefits of getting this type of institutional prestige early; it facilitates long-term success, whereas artists who start at the periphery have a harder time ever achieving success.[16] Access to this prestige need not demand much involvement on the part of the artist. For instance, if a branded dealer decides to represent an artist, then the prestige of the dealer immediately spills over, creates legitimacy, and entices collectors. A similar effect arises from being purchased by a collector who is so influential as to have a recognizable brand. It becomes a mark of approval. Once the dealers, collectors, and high prices are in place, the talent of the artist may be extrapolated from that.

This last statement might sound like I have it backwards. In most professions, it is possible to measure talent and quality with a reasonable amount of objectivity, and success tends to follow from superior performance. Throughout most of history, the technical components of art similarly ensured that gauging performance was possible, at least to some extent. This is true for some contemporary art as well. For much of it, however, a technical component is no longer strictly necessary and is often explicitly eschewed. Consequently, our perception of talent frequently follows from our observation of success, rather than the other way around.[17] In some cases, it is the only yardstick we have.

Once the perception of an artist has been nudged in the right direction by a collector or a dealer, others are likely to jump on the bandwagon. For much the same reason that people will stand in a crowded queue outside one club rather than enter a similar club without a queue, collectors want to buy the same artists that other collectors want to buy. This type of behavior has been demonstrated in contexts ranging from consumer product purchases to auction bidding behavior.[18] For example, prospective buyers tend to bid for auction listings that have received other bids while ignoring comparable or even more attractive listings that have not received other bids, and the bias is particularly strong when it is difficult to evaluate quality.[19] The behavior is a common response to social influence, but it can also be a sound investment strategy, unless one is among the last to jump on the bandwagon.[20] In the art world and elsewhere, it is a self-perpetuating process: The more collectors who are interested in a given artist, the more interest they in turn generate.

Even in the absence of other influences, this alone is enough to ensure that some artists begin to achieve astronomical prices.

Contemporary artists can of course contribute to their own success via marketing efforts as well. As mentioned, entrepreneurs such as Warhol, Koons, and Hirst have demonstrated noteworthy marketing acumen. A curious implication of branding is also evident in some of the absurdities that arise regarding authentication. Warhol, for example, employed assistants who would make silkscreen prints for him, and after a while, he contracted the work out to local printers instead. Both of these practices led to subsequent problems for the Andy Warhol Authentication Board before its dissolution in 2012. Their challenge was not to decide whether a given work was original or fake, or whether Warhol had actually touched the work himself; he may not have needed to touch the work even to sign it, since others could do that for him, too. The challenge was to establish whether the work had ever come into his presence at all, such that he at least had seen it on its way to the dealer.[21]

Individuals such as Warhol, Koons, and Hirst clearly seem to have played a central role in making their own fortunes. We should not underestimate the random processes that propel some artists to fame and fortune regardless of other circumstances, but these specific individuals also have a flare for selling themselves. In 2008, for example, Hirst arranged to have a one-man auction at Sotheby's, thus bypassing the galleries and raising around $200 million. This does not happen by itself. Koons, Warhol, Murakami, and most other top sellers take the initiative to create and maintain an image and to market their products. They can employ whichever assistants they want to actually create their artworks, but they have personally been actively engaged in branding themselves and therefore endowing their signatures with value. When questions of authentication seem ridiculous, they highlight how successful the branding efforts have been.

In any case, these kinds of success stories are few and far between. Most artists profit little or nothing from the arts. The profession provides a certain status, and the high risk of poverty might actually contribute to this status, but the reality is that almost all artists make their living from non-artistic sources such as second jobs. This further increases the status of those who do make a living from art, and their success stories lure ever more aspiring artists to try their luck. At the beginning of the current millennium, there were about 100,000 artists in New York alone.[22] If you include painters, sculptors, musicians, and dancers, US census data show the number of artists in the five boroughs reaching 141,000 as of 2012.[23] As the media buzz swirls around record prices for contemporary artworks, increasing numbers join the hordes every year. Exceedingly few of them will make a dent in the art market. For those few who do, success is almost always tied to marketing. When

competing for success in a product category without objective standards of quality, it is difficult to envision how it could be otherwise.

Critics

What, then, about the role of the critics? They are surely there to provide insight, dissenting views, analyses, and interpretations. Might not this be a force that could level the playing field, remove some of the influence of marketing, and reinstate talent and quality to their rightful, central place? In theory, this should indeed be the case, and I have personally known critics with an abundance of knowledge, integrity, and good intentions. However, as Eric Moody notes, "today's critics are employed by the system they might, as independent voices, be expected to criticize."[24] Even those who have other sources of income, and therefore could be expected to operate independently, quickly find themselves irrelevant if they keep bucking the trends. Not only would a number of stakeholders—from funding agencies to independent curators—rather have praise for their pet projects than independent criticism, but a focus on these projects also increases the likelihood that a review will be perceived as interesting and noteworthy. After all, these projects tend to involve publicity and high prices, both of which grant critics a bigger spotlight than they could hope to achieve by praising the exhibition at the local café down the street.

Whether or not they are knowledgeable and insightful, critics may respond to the same incentives as the rest of us do—and otherwise, there are always others waiting to take their place. Regardless of whether replacements have the same qualifications or knowledge, who is going to challenge them? Given how difficult it is to judge the quality of contemporary artworks, how can we possibly judge the quality of their reviews, and, by extension, the critics who author those reviews? We are likely to do so in a manner similar to how we judge the artists: We gauge how well the critics' pronouncements line up with the success and prominence of the artists they review. Sales prices speak for themselves, and those who review big sellers favorably might be welcomed to the club, whereas others tend to be ignored. And even if they write critically about a top seller, they are still not focusing on the show at that local café down the street. They are directing their attention where the money is.

Critics desire not only to recognize current winners, but also to be among the discoverers of new talent and trends. As discussed, some famous examples of genius that went unrecognized by contemporary critics serve as a stern reminder never to disapprove of works that seem new or strange. Therefore, if critics ever do go out of their way to mention work that is not already considered important, it almost always has the semblance of being cutting-edge material. As we have seen, however, novelty is often skin-deep.

For better or worse, these are difficult times for critics, at least for those who would like to operate outside the influence of marketing.

Dealers

Norman Rosenthal, the Royal Academy's secretary for exhibitions, remarked that "[t]he great decisions in art have not been made by critics in the last hundred years, they've not even been made by curators: they've been made by dealers [...] they've put their money where their mouths were."[25] You may wonder if it is not the money of others that they usually put there, but in the art world, it takes money to make money. Other than that, there are low barriers to entry in this market. There are no requirements of background or certifications to become a dealer. For a shot at becoming successful, one typically needs plenty of operating capital, preferably along with some good contacts, marketing savvy, an aggressive yet charming approach to collectors, and a dollop of good luck. In 2018, the dealer sector accounted for about half of the global art market.[26]

As an example of how different parts of the art world hang together, Jeffri observes, "It is well-known in the art world that galleries that do not advertise in major art publications (*ArtNews*, *Art in America*, *ArtForum*) will probably fail to have their artists reviewed in those publications."[27] As if by sheer coincidence, those who advertise heavily tend to get relatively favorable reviews, which brings us back to the difficult position of critics. The incentives provided by such unspoken agreements do not exactly encourage a free and unbiased atmosphere.

Once the dealer manages to build a reputation, the work exhibited in his gallery can be given a higher price. The patron can trust the brand of the dealer and hence does not need to make difficult judgments about quality or worth. Collectors do not necessarily buy mindlessly, much like customers at Tiffany do not buy everything recommended to them by a salesperson. However, if you are trying to sell jewelry at a high price, it will probably be easier to do at Tiffany than at most other outlets—even though it is much easier for customers to gauge the quality of the products sold at Tiffany compared to those sold at a contemporary gallery. In fact, consumers tend to expect high prices at a luxury outlet—whether a gallery or jewelry store—so much so that the luxury image may quickly be eroded if prices are too low.[28]

Michael Findlay, a director of Acquavella Galleries in New York, comments on the changing role of dealers, "A century ago most art dealers were glorified shopkeepers. Now some are themselves celebrity entrepreneurs."[29] These dealers run the likes of Gagosian Galleries, Pace Gallery, David Zwirner Gallery, Hauser & Wirth, Acquavella Galleries, and a handful of others. In addition to marketing efforts such as advertising and public relations work, the branded dealer wines and dines potential patrons and critics and

introduces them to artists, and in whatever way he can creates both a network of contacts and an image of success. In fact, the higher-end galleries do not seem like galleries at all but more like private showrooms in museums. There are often no prices on display either, as if discussing such details outside the back room shows low class.

Two main activities go on in the back room: negotiating prices for the art in the front room and selling art from elsewhere. The former category is usually part of the primary market, in other words, new work by artists represented by the gallery. The latter category is the secondary market, which involves work that has already been in circulation, and it usually does not pertain to artists represented by the gallery. This latter category of work is often provided by collectors wanting to sell and may be from earlier periods such as Old Masters, Impressionist, or modern, but it can also be contemporary. The secondary trade can be quite lucrative, but it is stigmatized among primary dealers. These dealers want to be perceived as cutting-edge patrons of the arts, whereas the secondary market gives the more mundane impression of a merchant seeking profit. This is why many primary dealers conduct any secondary trading behind closed doors in the back room. As an aside, some dealers in the primary market prefer the term *gallerist*. If I use the term *dealer* more frequently—for several reasons, such as the term being more common until recently, some individuals still preferring it, and some market reports consistently using it—no disrespect is intended.

Leo Castelli, a famous dealer who exhibited contemporary art for five decades, is a good example of someone who focused on the primary market, and hence would be referred to as a gallerist by many writers today. He did not complain if other dealers made millions in the secondary market, on work that he had sold for mere thousands of dollars in the primary market. He also tended to avoid exhibiting artists who had become famous without him. For instance, despite being a close friend of Willem de Kooning, he opted not to show his work.[30] Instead, he liked to discover and market new talent, and he could reportedly sell virtually anything. After explaining how *Target with Plaster Casts* by Jasper Johns was purchased by Castelli for $1,200, sold some time later to theatrical producer David Geffen for $13 million, and later still was valued at eight times that price, Don Thompson writes:

> Johns was in awe of Castelli's ability to market art. In 1960 Willem de Kooning said of Castelli, 'That son of a bitch, you could give him two beer cans and he could sell them.' Johns laughed and created a sculpture of two Ballantine Ale empties. Castelli immediately sold the work to collectors Robert and Ethel Scull. The cans are now in a German museum.[31]

During the second half of the 20th century, Castelli wielded enormous influence and was arguably instrumental in shifting authority away from curators and critics over to gallerists.

Larry Gagosian, who might be described as Castelli's heir as the bigwig of contemporary art, is an equally capable salesman. He can presell work for millions of dollars, apparently based predominantly on his own judgment and reputation. Buyers may also acquire existing work unseen, just because he or one of his employees suggests that they should have a given piece in their collection.[32] This level of trust and influence has enabled Gagosian to achieve an estimated yearly turnover of more than $1 billion in art.[33]

Sometimes, collectors are not allowed to buy even if they offer the money, because dealers keep waiting lists for certain works. Museums tend to come first, since acquisition by a museum increases the value of the artist. Next in line are loyal collectors, those with high status, and those with important collections. (When using the term *important* in this type of context, I do not intend to provide an actual assessment of the quality of the artworks, but only to convey their current value and centrality as established by the art market.) Certain works are only sold to collectors who have a history and expressed intention of lending out works for exhibition. Waiting lists and restricted access tend to make the favored collectors feel special, so dealers have an incentive to make such practices known.

As for the relationship between dealer and artist, this also tends to be more involved than a typical business relationship. The dealer provides promotion, distribution, and money, but he can also establish close social bonds and function more like a friend and mentor than a business partner or employer. He might even help guide the artist's work.

There are different ways to arrange the business aspects of the relationship. It is no longer common for artists to be employed outright, as was often the case at royal courts in the past. An arrangement that has been common more recently, but which is also becoming rare, is the one in which the dealer purchases the work from the artist and then sells it at his own convenience. This was common in France in the late 19th and early 20th centuries, during which dealers like Ambroise Vollard purchased or traded for works by painters such as Paul Cézanne, Edgar Degas, Paul Gauguin, Edouard Manet, Pablo Picasso, Camille Pissarro, and Pierre-Auguste Renoir. If they could manage it, dealers would also negotiate exclusive contracts and thus retain the rights to the entire output of a given artist over a specified time period.

Today, a consignment arrangement is by far the most common. Under this arrangement, the artist consigns works to a gallerist. The gallerist then exhibits these works in solo or group shows or attempts to negotiate private sales. If a work is sold, the proceeds are divided between the gallerist and the artist according to a predetermined ratio. Often, the split is about 50/50. Lower-end dealers might demand 20 or 30%, but the higher the status of the dealer, the higher the percentage she usually takes. This arrangement allows the dealer to take on lower risk in terms of capital investments in the work. A drawback, however, is that the artist may choose to break off the relationship. In this case, since the gallerist does not own the work, all her

prior marketing expenditures will be of no benefit to her. She may have spent a considerable amount of time, money, and effort promoting the artist, but as soon as the relationship with that artist is discontinued, all the expenditures must be written off as a sunk cost.

Sometimes, a gallerist decides to provide a stipend to an artist, to provide a secure and stable environment in which the artist can work, as well as to cement the relationship and receive works to sell. Leo Castelli, who pioneered this system in New York, paid a monthly stipend to artists such as Robert Rauschenberg and Jasper Johns. This arrangement not only ensures a supply of works from these artists, but it also creates bonds of loyalty. In the case of dealers such as Castelli, this can pay off handsomely when he has managed to successfully promote these artists such that their prices rise dramatically. At times, a dealer may also demand, or at least forcefully suggest, a certain type of output that he knows is currently marketable.

Commenting on the shifting dynamics in the relationship between artist and dealer, Olav Velthuis refers to a *Forbes* cover from the early 1980s, depicting the dealer Mary Boone front and center, with the artist Julian Schnabel off-center in the background. As Velthuis notes:

> The artist himself remarked cynically about the subordinate relationship with his dealer that this picture symbolized, 'I was expected to have on a little blue cap and shorts [...] It was as if the artists were tubes of paint, and she was the real visionary. We were the earrings to embellish her aura.'[34]

Auction Houses

Alongside galleries, auction houses have had a growing influence on the contemporary art market, and far from all dealers are delighted by this development. Secondary dealers have little or no interaction with artists, and collaborating with auction houses is unproblematic. In contrast, primary dealers work with artists over extended periods of time, trying to develop their careers and slowly but surely build their prices. The operations of auction houses can destabilize this process.

Imagine that work by a contemporary artist is sold at auction at a particularly opportune moment in time. It might be that her work is temporarily being exhibited at a museum, that she was recently under scrutiny by the media, or that she for some other reason comes to be considered a hot artist. Let us say that the work therefore achieves a record sales price at the auction. At first, this might seem like a good thing for both the artist and the dealer who carries her work in his gallery—and sometimes, it might in fact be a good thing, because it can launch the artist into a new price bracket. However, it

is not necessarily possible to achieve these prices outside the excited air of the auction house. Further, if the inflated price is not repeated at the next auction, or if the work fails to sell at all, then this gives the impression that the artist is falling out of favor. A sudden boom and bust of this kind can kill the career of an artist whose image her primary dealer spent years building. It is therefore not surprising that the relationship between primary dealers and auction houses often can be described as rocky at best. Sarah Thornton thus quotes one dealer's take on the virtues of auction houses: "Only two professions come to mind where the building in which transactions take place is referred to as a house."[35]

At an auction house, the incentives are to a large extent aligned with immediate profit goals. These firms do not necessarily have a big stake in the long-term career of an individual artist. When a high auction price is set for a contemporary artist, auction houses might therefore approach dealers who own work by that artist and aggressively advise them to sell. They suggest that the time is ripe to do so, because the window to achieve a price this high will soon close. This leads to a flooded market for the artist in question, and prices will predictably go down. In the meantime, the auction house can enjoy increased revenues before moving on to the next shooting star.

While the operations of auction houses can therefore adversely affect the longevity of individual artistic careers, they have certainly had a positive effect on the overall publicity of contemporary art. The rich and semi-famous flock to high-profile auctions, and every new record price is fodder for the media. The public spectacle has helped to propel the contemporary market beyond that of the Old Masters, Impressionist, or modern categories.

Incidentally, there is an unfortunate tendency, exhibited by journalists as well as art professionals, to disregard the current value of money when quoting record prices.[36] Comparing prices that are unadjusted for inflation is largely meaningless, but it typically favors the more recent sales, thereby providing more opportunities to claim that new records have been set. The practice is similar to the meaningless comparisons frequently made between movies from different time periods. For example, *Gone with the Wind* from 1939 is the highest-grossing movie of all time, but it does not even crack the top 100 list if we refrain from adjusting for inflation. Journalists and commentators should always take inflation into consideration when quoting box office or auction records, but it is perhaps understandable that they almost never do. First, they might not have basic business or economics knowledge, so the omission may be an honest mistake. Second, inflation can easily slip the mind of well-informed commentators, too. Third, movies or auctions that did not quite set a new record are not very newsworthy, and the incentive structure for media professionals often appears to be based on the interest their stories generate, rather than the accuracy or insightfulness of those stories. This problem may be exacerbated by the increasing reliance on internet-based

news outlets, given the ability to track attention via indicators such as click-through rates and reader comments. In any case, the unwarranted headlines benefit production companies and auction houses alike.

Sotheby's and Christie's are the big, branded, heavy-hitting auction houses. Together, they control the majority of the global market for high-value art, and certainly for works selling for over $1 million. Bonhams and Pillips are two other houses that occasionally sell major works, while a number of houses handle domestic and lower-end markets. Reflecting the trend of globalization in general and growth of wealth in China in particular, Beijing Poly International Auction Co. and China Guardians Auction Co. have recently taken third and fourth place, respectively, in terms of auction sales by value, each of them surpassing $1 billion in sales. Globalization has been driving growth for the older auction houses as well, with Sotheby's and Christie's opening branches in places like Hong Kong and the Middle East.[37]

Being included in an auction by Sotheby's or Christie's is a major branding event for an artist, whether or not it leads to a long-term upward trajectory or a burst bubble and disintegrating market. When discussing two auctions in 2007—one for each house—which achieved a combined sum of $640 million, Thompson notes that a key part of the word *contemporary* is *temporary*.[38] In other words, much of the work that makes a splash is soon forgotten, with values dwindling rather than continuing to rise. For example, some of the work at the aforementioned auctions achieved record prices. Jim Hodges' *No-One Ever Leaves* was basically a leather jacket tossed in a corner. It sold for $690,000. Another work by Jack Pierson consisted of plastic and metal letters nailed to the wall, spelling the word *Almost*. This sold for $180,000. One might note that each letter differed from the next in size, color, and design and leave it to the reader to decide whether that level of creativity merits the price. Either way, marketing will presumably decide whether the price increases or decreases over time. As for the overall contemporary auction market, it continues to grow, and in 2014, it came close to the pre-recession peak of 2007. (It is typically reported that the 2014 market surpassed the 2007 market, but that is once again only true if one disregards inflation.)

Art Fairs

Art fairs provide dealers with an alternative to auctions. These events typically last a few days, during which dealers come together and offer their merchandise to swarms of visitors. The big ones draw collectors from around the world. These include Art Basel, Art Basel Miami Beach, The European Fine Art Fair (TEFAF), and Frieze in London. Reflecting the trend of globalization, new art fairs are popping up in Dubai, Hong Kong, New

Delhi, Rio de Janeiro, Istanbul, Sydney, Moscow, and numerous other cities. The annual number of major fairs has recently skyrocketed to over 200, and sales at art fairs accounted for 46% of all dealer sales in 2017.[39]

Fairs of this kind are convenient to wealthy collectors with little time, because they bring together important works from a large number of influential dealers. They are desirable to dealers because they offer opportunities to compete with the auction houses for high-value consignments, provide good publicity, and bring together eager collectors in an exciting atmosphere. On the other hand, a booth at an art fair costs plenty of time and money, making it difficult for small and mid-sized galleries to attend them. This reality, combined with the tendency for art fairs to decrease wealthy collectors' motivation to take the time to visit galleries, contributes to an ever-increasing focus on works that are easily digestible while scurrying around at a bustling fair. One time when I was at Art Basel, it struck me that I often spend more time contemplating a single artwork of the deeply engaging kind than I needed for hundreds of works combined at the fair.

Dealers, press, and a few central buyers and agents are invited on a fair's opening night. Many of the most noteworthy works sell within the first hour of opening. Some do within minutes. The pace is frantic compared to a leisurely afternoon in a gallery. At the fair, collectors can be seen racing between booths and considering, evaluating, negotiating, and purchasing in a matter of moments. Viewing conditions are typically far from optimal for actually contemplating art. Various works are hung haphazardly in a cluttered environment, with lighting more reminiscent of a factory than a gallery, and with people constantly buzzing around. Nonetheless, some organizers appear sincerely committed to providing suitable locations to enhance the experience of an art fair; when I asked Noah Horowitz, prior Executive Director of the Armory Show, how he would characterize his job at the time, he responded that it was mostly about real estate. Whatever the drawbacks of art fairs, they can provide opportunities to view an assortment of work gathered from different parts of the art world for a few fleeting days. Even if you visit more as a tourist than as a serious collector, it can make for an interesting afternoon.

Museums

Whereas auctions and fairs are transient events, museums have an air of permanence. That is one of the reasons why acquisition by a museum is a high honor for an artist. The museum not only adds value to the artist's brand, but it also invites him to take a seat at the table of history. Even Marcel Duchamp, who criticized the role of museums, was happy to negotiate the acquisition of his own work by one. Some would view that as hypocrisy. Duchamp apparently viewed it as being practical.[40]

Museums have the position they do partly because we trust them. They are supposed to be neutral gatekeepers that safeguard and display the best and most important work that humankind has to offer.[41] This helps explain why something exhibited in a museum takes on an air of importance, almost regardless of what that something is—which in turn helps explain the many anecdotes featuring random objects, such as door stoppers or fire extinguishers, that are sometimes mistaken for exhibits in museums of contemporary or modern art. Recently, for example, two teenagers placed a pair of ordinary eyeglasses on the floor of the San Francisco Museum of Modern Art as a prank. Within minutes, visitors began thoughtfully viewing the glasses, with some people taking pictures of them, thinking that they must be an artwork.[42] After the prank was revealed, the same old debate about what counts as art ensued in the media and elsewhere. A century after Duchamp's urinal, people still expect objects presented in a museum to be inherently special, without necessarily realizing that the mere act of presenting something in a museum makes virtually any object seem special.

This ability to imbue any object with a special significance represents part of the influence of museums, and one might reasonably expect this kind of influence to carry with it a certain responsibility. The influence of museums should presumably not be wielded on a whim. This is one of the reasons why museums traditionally purchase only work that has passed the test of time and is considered impressive long after it was initially created. The work is not part of a mere fad but is rather a substantial achievement, even when viewed with the benefit of hindsight.

Contemporary art museums, on the other hand, often purchase work by artists who are very much alive. In fact, it may barely have left the artist's studio before it finds itself within those venerable walls. Museums like the MoMA or the Guggenheim can help launch the names of new artists by purchasing and displaying their work, perhaps even buying the work of students still in school. This practice places immense power in the hands of curators and directors. Their job is purportedly to collect specimens of the most important work, and yet they have a large hand in deciding which artists will be perceived as important. And, whether or not they attempt to refrain from abusing this power to make self-fulfilling prophecies, the contemporary art scene is shaped by capital and marketing. In one sense, curators may be like critics in that they try to get it right and endorse the big contemporary artists of the present and the future, but the market decides who those artists are. Thus, the contemporary museums do not necessarily serve as repositories of quality but as reflections of the marketplace. In theory, quality and marketplace success can certainly go hand in hand, but, as we have seen, there is little reason to suppose that they do so in this particular market.

Dealers and collectors can also directly influence curators. If a sufficiently important collector decides to donate artwork to a contemporary museum, then the museum will often accept. In this manner, the private collector decides what will be displayed to the public as the cream of the contemporary crop. It can be especially problematic when an influential collector is on the museum's board. Georgina Adam quotes an American museum director in 2013: "The problem of collectors sitting on museum boards is ubiquitous, and is being exacerbated by the new class of trustees, who today are investor-collectors."[43] In another example, the museum might be considering several artists for a retrospective. The final choice of artist is highly likely to be influenced by the willingness of dealers and other sponsors to help finance the exhibition. Thus, the dealers are deciding the work that will be presented to the public. These kinds of relationships can appear similar to the relationships that lobbyists and special interest groups have with US politicians. Critics of this system may call it corrupt, whereas supporters may argue that money is free speech.

Consider how the museum fits into the marketing efforts of a powerful dealer. He might create a lot of buzz around a given artist by exhibiting her prominently, using his public relations team to engage the interest of the media, advising key collectors to invest, and perhaps whispering some predictions in the ear of a critic or two who are eager to endorse a future winner. The ensuing buzz sparks the interest of the curator, who might be offered an artwork at a steep discount, or free of charge. The acquisition by the museum confers added prestige and confirms the importance of the artist. Thus, the critics and the media contacts are pleased that they wrote about this important artist before the fact, and the key collectors are happy that they purchased the work of a rising star. All parties are pleased with the dealer, who now has even more credibility and influence the next time around. Occasionally, the museum might take a donated or steeply discounted artwork and flip it at the next auction, but this can still confer benefits on all parties. An artwork consigned by a museum is likely to achieve a high selling price, thus also stimulating other sales by the same artist.

Another example of questionable practices is provided by the Tate Modern, which in 2014 came under scrutiny for exhibiting work by Tomma Abts, a Turner Prize winner and trustee of the Tate.[44] The incident raised some eyebrows since the Charities Commission had previously condemned the Tate after a similar incident in 2005, involving Chris Ofili, another erstwhile trustee and Turner Prize winner. The Tate had spent more than £700,000 purchasing his work. Incidentally, the controversial Turner Prize is usually given to conceptual artists, and Ofili was the first painter to win it in 12 years. Then again, his paintings featured ample amounts of elephant dung, so the enthusiastic response to his canvases may have resulted as much from his choice of materials as from his actual execution of the work.

Collectors

Museums are perhaps the most public and prestigious of collectors, but as mentioned, there are also a handful of private collectors who substantially influence the contemporary art market. On a global basis, a few thousand of them might spend $1 million each buying art in a given year, but only one or two dozen spend $100 million, whereas some of the big spenders actually end up creating their own museums, too. With new billionaires entering the market, the list of influential individuals is growing. Well-known names such as Eli Broad, Steve Cohen, David Geffen, Jose Mugrabi, and Charles Saatchi were not among the top ten collectors for 2016, as the market felt the influence of new players.[45] As Derrick Chong puts it, in a somewhat insensitive but apt simile, "In extreme cases, a major collector of art can be likened to the fat boy in a canoe: when he moves, all the others need to change their positions."[46]

The market sometimes even responds to analyses of the underlying reasons for the movements of prominent collectors. For instance, when Steve Cohen began buying Impressionist work, there was some concern that he might be moving away from contemporary art, thus possibly causing a downswing in that market. However, there was little concern over the contemporary or modern market when David Geffen sold off two paintings by Willem de Kooning, as well as a Jasper Johns and a Pollock, over a period of a couple of months. This is because he was known to be raising funds to bid for the *Los Angeles Times*. The fact that he could raise $420 million with the sale of four paintings was remarkable, but he was not seen to be offloading them for any worrisome reason.[47] Incidentally, one of those paintings went to Ken Griffin, the hedge-fund billionaire who made another headline-grabbing art purchase from David Geffen: In September, 2015, he bought a Pollock and a de Kooning for a combined $500 million. The de Kooning from 1955, entitled *Interchange*, for which Mr. Griffin paid around $300 million, originally sold to a Pittsburgh department store owner for $4,000.[48]

Collectors can sometimes make headlines and influence prices even without intention or forethought. In October 2006, the casino magnate Steve Wynn had agreed to sell the painting Le *Rêve* by Picasso to Steve Cohen for $139 million. Before he had a chance to deliver it, Wynn took a last occasion to show the painting to some guests. When doing so, he accidentally backed up into it and poked his elbow through the canvas. He canceled the sale, and following a $90,000 repair job, he estimated the value of the painting at $85 million. His insurance reportedly paid out around $45 million, although some art market observers estimated that the enhanced backstory resulting from the incident had caused the value of the painting to increase rather than decrease. Indeed, Wynn completed the sale to Cohen in 2013 for $155 million. Combining the insurance and the price increase, one might say

that Wynn made around $60 million extra by putting his elbow through the canvas.[49]

Many collectors are sincere, art-loving individuals who spend hard-earned money on work that they feel passionate about.[50] I suspect that this description fits most buyers of art, whether they purchase a single piece or fill their houses with artworks, and whether they are wealthy or can afford very little. For other collectors, it may be more important to signal their status by paying vast sums of money for something, especially if that something looks worthless to most ordinary people. Some of these collectors rely heavily on the advice of their dealers. If they have no idea what they "should" like, they can still invest in the brand of the dealer, the auction house, or the artist. This behavior is similar to that of the socialite draping herself with high-end fashion brands without having a personal eye for their aesthetic appeal. An important name carries a seal of approval, and thus collectors do not risk the ridicule associated with buying unremarkable artworks.

Other collectors are confident in their own ability to set the trends. For instance, Charles Saatchi is known for picking emerging stars, and being collected by him jumpstarts the career of a contemporary artist. His investments are highly publicized, and his name bears a stamp of approval comparable to that of a museum. Similarly, as owner of Christie's and two museums, François Pinault can singlehandedly decide an artist's future. It is nonetheless interesting that collectors, much like dealers and critics, often appear proud to have "discovered" the talent of a rising artist. When this artist has become established, they feel that their early support confirms their cultured sensibilities and discerning eye. To a business professional familiar with the art market, it is clear that these so-called discoveries are often self-fulfilling prophecies. Not all artists represented by a branded dealer or purchased by a branded collector will go on to become big sellers, but the endorsement certainly helps a great deal.

Saatchi at least appears to be honest about his activities and to be fully aware of his influence on the art market. Perhaps someone like Damien Hirst would have become famous without the early support of someone like Saatchi, but this seems far from certain. There are so many artists in the world, and though they may not all have Hirst's marketing acumen, those who do far outnumber the lucky few who are promoted by influential dealers and collectors before their own name becomes a recognizable brand.

Firms

Because of their ample resources, numerous firms also have a substantial potential for influencing the art market. Firms collect and sponsor art, and aspects of art are sometimes incorporated into various parts of their marketing efforts, ranging from product design to promotional material.[51] In

fact, it has been observed that reproductions of art images reach more people more frequently through advertising than via any other medium.[52]

There can be a fine line between art images and advertising images, and the distinction between art and non-art might best be described in terms of a continuum rather than absolute category membership. For this and other reasons, it is difficult to pinpoint when and where the practice of using art images in consumer product advertising really began. Nonetheless, a reasonable case can be made that a milestone was set when the soap manufacturer Pears acquired the rights to use John Everett Millais' painting *A Child's World*. In the late 19th century, Millais was an exceedingly popular painter in England. He was knighted for his contributions to high culture in 1885 and elected president of the Royal Academy in 1896. Because he was not born wealthy, he needed to sell his work, often by taking commissions to paint portraits of the children of the Victorian aristocracy. *A Child's World* was a portrait of his cherubic grandson innocently playing with soap bubbles. Sir William Graham, the owner of the *Illustrated London News*, purchased the copyright to this image and ran it as a full-page illustration in the 1887 Christmas issue. Thomas J. Barratt of Pears subsequently persuaded Graham to sell him the rights to the image, and he persuaded Millais that it was acceptable to engrave the Pears name on a bar of soap in the bottom right-hand corner of the painting.

Barratt spent more than $6 million circulating this image, renamed *Bubbles*, throughout the British Empire. This was an enormous sum of money at the time. The affair was frowned upon by the art community, but it was embraced by consumers, who hung the poster on the walls of their homes. It was certainly successful from a commercial perspective, and the practice of using art images in advertising was continued by Pears and other firms.

Perhaps the Absolut Vodka campaign is the most famous example from recent times. Of all alcoholic beverages, vodka is arguably the one with the greatest need for advertising. After all, it is largely a colorless, odorless, flavorless drink, at least if one disregards the relatively recent trend of flavored vodkas. For the most part, high-end brands of vodka are costly not because of any noticeable difference in quality but because of the brand image. Along with art and bottled water, vodka represents one of the clearest cases of the power of branding. In this particular example, Absolut featured numerous images by known and unknown artists, contributing to a reported 14,000% sales increase over the duration of the campaign.[53]

In their promotional efforts, firms not only rely on the fame of art images, but they help perpetuate it. Many consumers are familiar with artworks such as Botticelli's *The Birth of Venus*, Leonardo's *Mona Lisa*, Michelangelo's *David*, Munch's *Scream*, Seurat's *Sunday Afternoon on the Island of La Grande Jatte*, and Wood's *American Gothic*. Some consumers know them from art history classes, postcards, or other channels of popular culture.

Others know them from advertising. They are used to sell an endless variety of products, ranging from diamonds to detergent.

Some years ago, I decided to investigate how consumers' perceptions and evaluations of products are influenced by the artworks with which they are associated. I must admit to being personally ambivalent in my feelings toward this practice in marketing, since it involves the unabashed use of art images for commercial purposes. On the other hand, much of the art market reflects commercial enterprise, the main difference being that marketers in other areas tend to be more transparent about it. Further, if consumers are to be bombarded with visual images, why not art images? They are presumably more interesting than other images with which we might be bombarded. Either way, whether we approve or disapprove of the practice, it is worthwhile to study the mechanisms at work. Doing so can teach us something about art, marketing, and the psychology of viewers. As an added benefit, enhanced knowledge may enable marketers to rely on art in an effective yet respectful way, rather than sully it in a way for which art enthusiasts will resent them. It can also enable society at large to respond to such use of art in a more informed manner.

A basic assumption in my research is that an artwork, such as a painting, is perceived and processed differently than other images—not because of its content (i.e., that which is depicted in the painting), but because of its manner (i.e., how it is depicted). This is why van Gogh can create an artwork by painting an ordinary pair of shoes; the shoes are not necessarily noteworthy in and of themselves, but they nonetheless form the basis for a noteworthy pictorial representation. In a promotional context, a general influence of art images therefore stems from their manner. This observation diverges from the common view in marketing that the content of an ad image should have a relevant link to the ad message, thereby reinforcing this message or in other ways telling a positive story about the product. In collaboration with my long-time friend and co-researcher, Vanessa M. Patrick—who was also my advisor during my doctoral studies—I predicted and demonstrated that an association with artworks favorably influences the evaluation of consumer products, even if the artworks do not portray content relevant to those products. It is enough that the images are processed as art. We called this phenomenon the Art Infusion Effect.[54]

We conducted a number of studies that supported our theory. Not only were ordinary consumers readily able to identify art images and distinguish them from non-art images, but they also interpreted products associated with the former as superior to those associated with the latter. These assessments were based on the perception of artistic manner, regardless of the content depicted. In one of our studies, for instance, we collaborated with a restaurant. We custom-made boxes with silverware, so that the front face of the box featured an image that had been pretested as art (a painting

of an outdoor café) or non-art (a photograph of a similar outdoor café). Our rationale for this use of images was not that photographs cannot be perceived as art, but pretests had confirmed that the painting, at least in this case, was perceived as art to a higher degree than the photograph. Dressed up as waiters, we approached diners at their tables and asked them to evaluate the silverware in a brief survey, with the cover story that we were considering new silverware to use in the restaurant. We found that when the box featured an art image on the front face, the silverware was evaluated more favorably.

We further assumed that this effect arose because humans have an evolved appreciation for art images. People recognize art images as being special, and they process them as a form of intrinsically valuable communication. We invited neuroscientists at Emory University to join us in investigating this assumption. While scanning study participants' brains with functional magnetic resonance imaging, we exposed them to art images and non-art images with the same content, and we found that the art images engaged the reward circuitry of the brain, including the ventral striatum, hypothalamus, and orbitofrontal cortex.[55] Based on prior research, one would expect similar activity in the brain upon exposure to images depicting desirable content, such as an attractive potential mate or a tempting slice of chocolate cake. But our findings indicate that art images are intrinsically rewarding, regardless of the content they depict.

In other studies, we demonstrated a limitation of this effect in a marketing context: If viewers could be made to specifically focus on the content of the image, the artwork came to be perceived as a mere illustration. In other words, it was no longer different from other visual images used in promotion, and its influence now depended on the match between the image content and the associated product. In one example of our studies, we collaborated with a bar. We custom-made wine labels using images that were pretested as having a good fit or a poor fit with the product category of wine. On wine labels with paintings by Renoir, the good-fit image featured diners having lunch and drinking wine, whereas the poor-fit image featured a woman and child playing with toys. Only the wine labels differed from each other; the wine in the bottles was identical. When patrons entered the bar, the bartender asked if they would be willing to partake in a taste test. When they consented, he grabbed one of the bottles from behind the bar and directed the patrons' attention, in a relatively subtle way, toward either the content or the manner of the label image: He just glanced at the bottle in his hand and said "Ah, this is the one with the painting," thereby calling attention to the manner of the image (recall that either image was a painting), or "Ah, this is the one with the people," thereby calling attention to the content of the image (recall that either image depicted people). The patron then tasted the wine and filled out a brief questionnaire.

We found that when the bartender directed attention toward the content of the label image, the patrons reported that the wine with the well-fitting label tasted better than the wine with the poorly fitting label (recall that the wine was actually identical). However, this difference disappeared when the bartender emphasized the manner of the label image. At least two aspects of this finding are interesting: First, the image on the wine label influences consumers' taste experiences. Second, this effect depends on whether the consumer focuses on the content or the manner of that image. In other words, it depends on whether the consumer processes the image as an illustration or as an artwork.[56]

Whatever the psychophysical basis for the influence of art images might be, marketers continue to use them for commercial purposes. This practice is likely to influence not only the products and brands associated with the art, but also the art associated with the products. One might think that the latter perceptions would be less affected, especially since they have solid roots in culture and tradition. However, as we will see in the following chapter, advertising can mold our perceptions of culture and tradition as well.

Of course, firms do more than just advertise or affix art images to wine bottles and boxes of silverware. Corporate collectors may be seen as the heirs of royal, political, and religious figureheads of the past. They invest large sums of money in the art market and have a proportionately large impact on it.[57] The collecting activities of these firms are usually guided by factors relevant to their overall marketing strategy. Many firms invest in established art with a decorative appeal, especially if it is intended to hang in their own facilities. Other firms collect work perceived as new and edgy to enhance their own image as modern and innovative. Even with contemporary art, however, they tend to favor established names. After all, art collecting and sponsorship are part of branding and image creation. Executives and board members do not necessarily view it as their role to support the arts out of the goodness of their hearts. Rather, the arts are employed to cultivate the image of the firm. This is easier to do with artists and works that are well known and have a predictable influence.

To illustrate the extent to which some corporations are involved in the arts, consider the collections of the following firms: Deutsche Bank with more than 50,000 pieces; ING with 22,500; JPMorgan Chase with more than 30,000; UBS with 35,000. Compare this to the collection of the Louvre in Paris, probably the world's most famous art museum, which consists of 35,000 works. The relationship between corporations and museums also influences public perceptions of art as well as the market value of work by individual artists. In 2006, for example, UBS exhibited corporate art at the Tate Modern, thereby endowing the firm's collection with the halo of a publicly funded museum. American museums, too, have been accused of yielding creative control to corporations by mounting ready-made shows

curated by those firms' staff rather than by the museum's curators. For instance, Bank of America sponsors these types of exhibitions in smaller museums like the Montclair Art Museum in New Jersey and the Millennium Gate Museum in Atlanta.[58]

Julian Stallabrass discusses the Guggenheim as a particularly transparent business enterprise in which some exhibitions, such as *The Art of the Motorcycle*, seem like straightforward retail showcases with sponsorship opportunities rather than art shows. He observes:

> *Giorgio Armani*, held at the NY Guggenheim in 2000, was a puff piece that, it was suspected, had some relation to Armani's $15M sponsorship deal with the museum. The show was more a display of currently available merchandise than a historical survey of the fashion house's products, and neither the display nor the catalogue did more than celebrate Armani's designs. Armani had, in effect, hired the museum to display an advert.[59]

Whether or not corporations exhibit their own work, corporate funding can effectively decide the kinds of exhibitions that are presented to the public via museums. Firms sponsor shows that otherwise may not have come about, while potential alternatives are discarded if sufficient funds are not provided. Following restrictions on public funding of the arts, the revenue stream provided by firms is especially welcome in the art world. However, it constitutes yet another example of the blurring of the lines between public goods and private commerce.

I do not pretend that anyone has enough data to fully map out the impact of firms and other major collectors on the art market, whether we focus on popular preferences and behaviors or specifically on the players dealing in high-end commercial work. However, the observations we have made so far might be combined with some general insights about trends and social influence, to reveal more about how patterns in the art market can arise through the interaction of focused marketing efforts and common human behavioral tendencies. The following chapter takes a step back and draws on numerous examples from a variety of domains—ranging from colors to cults and from politics to consumer products—to discuss how trends can seemingly take on a life of their own, although the underlying mechanisms may nonetheless be identifiable.

4
TRENDS, FASHIONS, AND SOCIAL INFLUENCE

How Popular Patterns Emerge in Art and Elsewhere

As Victor Hugo once put it, "Fashions have done more harm than revolutions."[1] It can be difficult to understand the trends that come and go in art, fashion design, or other areas in which standards of excellence are ill defined. Such developments are easier to understand when functional concerns are central. For instance, automobiles change in size, performance, or fuel efficiency depending on the extent to which consumers focus on factors such as speed or environmental concerns.[2] Further, functional changes often entail improvements, whereas those who fail to improve may fall behind those who innovate. For instance, a market leader can become complacent and eventually be outcompeted by entrepreneurs. Similar situations arise at various levels, ranging from individuals to entire countries. Sometimes, an early mover makes investments that are difficult to adjust later, which explains why American outlets have half the voltage of outlets in many other countries. Other times, there is limited will to adjust. For instance, the US was the crucible of modern democracy, and it is still a world leader in many respects, yet it has not implemented improvements long since adopted by some other countries, including for controversial practices such as the electoral college system. The US is arguably also the world leader in scientific research, yet it still maintains the archaic and awkward imperial measurement system for most other purposes. Liberia, Myanmar, and the US are the only countries to do so (although some other countries, such as Canada and the UK, use parts of the imperial system alongside the metric system). Most people could quickly familiarize themselves with the comparatively user-friendly metric system and then benefit from it for the rest of their lives, but the need for an initial effort discourages the adjustment. Similar observations can be made in

DOI: 10.4324/9781003531340-4

myriad contexts, ranging from personal habits to entrenched companies that struggle to adapt to changing times.

However, not all trends or changes have obvious or novel benefits. Writing more than 50 years ago, William H. Reynolds explains that there is a difference between functionality developments, such as the then-ongoing change from black-and-white to color TV, and developments in taste and style, such as the lengthening or shortening of women's skirts.[3] One could argue that, it is often possible to measure—and perhaps even to predict—trends as they evolve in a given society, and Reynolds mentions Pop and Op Art as examples that might be measured. But the term *trend* merely refers to a vogue, prevailing tendency, or something that is currently popular or stylish; charting a trend does not necessarily translate to truly understanding how and why it evolves the way it does.

Even with insights into the marketing principles and art-world players discussed in the prior two chapters, one might question why their influences spread quite so broadly. What causes certain artists, movements, styles, or fashions to become successful? Do people really succumb to the seemingly arbitrary influences of marketers, resulting in popular trends? If we focus on specific artists or artworks to answer such questions, we cannot avoid arguments about taste or individual merit, and as we have already seen, it would be exceedingly difficult to resolve such arguments in a context as nebulous as art. Therefore, the current chapter takes a step back to consider the broader realm of social influence, relying on a variety of examples in diverse contexts.

A Shining Example of Marketing

To illustrate the role of marketing in the creation of trends, we might begin with a classic example of a trend masterminded by De Beers. The story of the diamond engagement ring is one of advertising at its most effective.[4] In this case, the story begins with the N. W. Ayer campaign that encouraged the sale of polished transparent rocks as symbols of eternal love. Less than a century ago, there was little reason to believe that diamonds would become such a symbol. All sorts of gifts were used to profess love and devotion, but they usually did not involve diamonds (although there were famous examples, such as the ring that the Hapsburg emperor Maximilian I gave to Mary of Burgundy in 1477).[5] If jewelry was involved at all, it would typically feature colorful rocks such as rubies or sapphires, which were considered more romantic and exotic.

Nonetheless, an exceedingly effective ad campaign changed all of this. Before the launch of this campaign, not only was the demand for diamonds more limited, but the same durability that made diamonds valuable also ensured that new demand could not arise from the depletion of existing rocks.

It is extremely difficult for a consumer to use up a diamond. As plentiful diamond fields were being discovered in Africa (and others would be found in Russia and Australia), it became increasingly problematic for diamond sellers to demand high prices based on a notion of scarcity.

For the outlook of the diamond market to improve, consumers' perceptions needed to change. The beginning of this transformation is arguably traceable to a 1938 meeting between the advertising agency N. W. Ayer & Son, Inc. and Ernest Oppenheimer's firm De Beers Consolidated Mines. To facilitate profits, diamonds should not only be viewed as particularly desirable, but they should also no longer be bought and sold as commodities. They should be kept forever, thus ensuring that the demand for new diamonds would grow rather than diminish. Further, prices should be substantially inflated. These outcomes were achieved via a combination of artificially restricted supply and a remarkably effective campaign that birthed, or at least substantially expanded, the tradition of diamond engagement rings.

A large market study undertaken by Ayer reportedly revealed that the first postwar generation did not associate diamonds with engagement or romantic love. This situation changed with an ad campaign best summarized by the famous line from copywriter Frances Gerety, "A Diamond Is Forever," recognized by Advertising Age as the number-one-rated ad slogan of the 20th century.[6] Consumers were bombarded with the message that diamonds are romantic symbols of everlasting love. Within a few decades, the majority of brides in several countries, including the United States, were wearing diamond engagement rings. Even more impressively, most brides and grooms seemed to believe that this trend, orchestrated by De Beers, was an age-old tradition.

From a purely strategic point of view, this success story is fascinating. De Beers not only changed the market for a commodity such as diamonds, but they substantially inflated the prices, ensured a growing demand, and dramatically decreased the likelihood of secondhand market dealings. In several of the richest countries today, it does not seem appealing to resell a diamond engagement ring, but it is virtually a requirement to buy one. Romantic love is thus commercialized, bringing massive profits to a select set of business owners, and most people embrace this situation with a smile. The perception of tradition was even created, thus effectively transforming culture.

As if this were not enough, De Beers managed to set price guidelines to further increase profits. In the beginning, they merely hinted at high prices, but then they came up with an ingenious device based on the insight that different consumers have different purchasing power. They tied the price guidelines to the salary of the individual consumer, going so far as to run ads suggesting that two months' salary was appropriate for American consumers. In European countries, they could not be quite so ambitious, whereas in Japan the supposed norm became three months' salary. The sheer

audacity of the suggestion was remarkable, but consumers actually appear to believe that this marketing strategy is tradition, and they feel romantic for endorsing it. They do not typically shell out as much as the suggested portion of their salary, but that benchmark has surely pushed the average price of an engagement ring much higher than it otherwise would be.

Incidentally, one of the ways that the status of diamonds was elevated was by associating them with artworks. The De Beers Collection, along with ads featuring prints by artists such as Picasso and Matisse, lent an air of exclusivity to the shiny rocks, suggesting that diamonds could be art, too.

One factor that facilitated De Beers' marketing efforts was that they did not sell directly to end-users and therefore did not need to emphasize specific brands or retail outlets. Instead, their advertising tended to focus on the entire category of diamonds. This type of consumer product advertising is rare, but it benefitted De Beers since they controlled such an enormous portion of the diamond market. In this sense, the story of De Beers and the diamond market differs from that of the art market, in which art professionals promote branded artists and products. However, salient examples of art nonetheless color our perceptions of the entire category, too. If De Beers can singlehandedly create popular perceptions of culture and tradition pertaining to diamonds, the combined efforts of galleries, auction houses, and museums can surely mold our perceptions of art.

As we shall discuss in the next sections, marketers sometimes just need to nudge some people in a given direction. Quite often, others will follow as if it were obviously the right thing to do.

Conformism and Herd Behavior

To illustrate how collective behavioral patterns can emerge without individual knowledge or intent, it can be instructive to consider other animals than humans. For instance, Martin Lindstrom uses termites to demonstrate the blind workings of herd behavior among consumers.[7] Although not a perfect analogy, it may serve as an interesting introduction to the topic. After all, a termite brain does not contain enough neurons to enable its owner any real conception of what it is doing. Nonetheless, a million termites somehow manage to work together in the construction of exceedingly complex mounds that can be as tall as 30 feet. When taking into account the size of termites relative to humans, the structures they build outdo the most magnificent skyscrapers.

As the biologist Pierre-Paul Grasse observes, each individual termite at first appears to be following the same simple steps. It chews on a mouthful of earth and uses its saliva to mold it into a pellet. Then, after wandering about in a seemingly aimless fashion, it drops the pellet by the first elevated area it encounters. The termite repeats these steps over and over like a tireless

automaton. The process seems random, and yet it somehow leads to the slow, inevitable construction of the termite mound. The more pellets that are dropped at an elevated section, the higher that section becomes. The higher it becomes, the more likely it is that the next termite will happen to bump into it and drop its next pellet there. When the elevated sections reach a certain height, they trigger a new behavior, and the termites begin building arches between them. In the end, a complex structure with chambers, tunnels, and sophisticated ventilation channels arises from behavior that is programmed to follow such simple rules. There is no strategy, planning, coordination, or awareness of the process. In a sense, it just happens by itself.

Complex adaptive systems are not the focus of this book, but examples like this are nonetheless worth briefly touching on to illustrate how entire behavioral patterns emerge without individual awareness or intention. The termites follow simple rules tied to cues from their surroundings and connections to the others in the colony. They are not cognizant of the reasons for their actions, and yet they partake in a form of macro-behavior. The behavior seems like a complex incarnation of the mechanism that enables a flock of birds to take flight simultaneously. It is not planned. They just do it. Thankfully, people do not follow a similar procedure when they construct skyscrapers, but they might do so when collectively creating fashions in art and design.

Lindstrom notes a study by researchers at Leeds University as an example of humans behaving somewhat like termites or automatons. In this study, groups of people were instructed to wander aimlessly around in a large hall, without conversing with each other. Unbeknownst to the groups, a few of the people were given precise instructions of where to walk. No matter the size of the groups, everyone blindly followed those few individuals who appeared to have some idea of where they should walk. For the most part, they did not have any conscious notion that they were following anyone. Ten individuals can thus set the direction for a group of 200. The other 95% follow like sheep.

Psychological experiments have similarly demonstrated the human tendency to conform. In studies conducted by researchers such as Solomon Asch and Richard Crutchfield, participants have abandoned their own beliefs and followed the views of the majority in a surprisingly large proportion of cases. Even when asked extremely easy questions, such as which line is longest in a set of five lines, 15 out of 50 participants would pick an obviously wrong choice if they believed it was the choice the majority had made.[8]

Marketers need not have in-depth knowledge of complex adaptive systems to strategically use consumers' tendencies to conform and to benefit from related insights into social influences.[9] Brand ambassadors are recruited on college campuses to influence fellow students. The *like* button on Facebook advertises peer approval. Sometimes, the mere perception of buzz can be enough to stimulate sales, even when the perception is introduced via blatantly

transparent marketing communications, such as commercials touting that "everyone is talking about" this or that. The phenomenon also increases the effectiveness of bestseller lists for products ranging from books to music albums. Once the perceived popularity of a product or brand has reached a certain threshold, the process becomes self-reinforcing. Some authors have gone so far as to secretly purchase their own book from the specific stores monitored to select publications for the *New York Times* bestseller list. Once the book has thereby made the list—regardless of mediocre reviews—it has continued as a bestseller without further intervention by the authors.[10] Perceived popularity spawns more popularity, with the possible exception of those few consumers who explicitly refuse to conform and hence avoid, to the best of their ability, anything that is popular. However, even those individuals tend to conform in regard to items and trends that are implicitly acceptable as genuinely non-conformist alternatives.

From an evolutionary perspective, this type of behavior may have been adaptive. While wandering on the African savannah, it would usually make sense to go with the group, whether or not it was entirely clear why members of the group were doing what they were doing. As Daniel Gardner puts it, "A band of doubters, dissenters, and proud nonconformists would not do so well hunting and gathering on the plains of Africa."[11] With conformity, one can also draw on the collective knowledge and wisdom of the group. When others in the group are convinced that there are lions in the tall grass over there, it may be wise to heed the majority opinion, even if you do not personally see the telltale signs of large, hungry cats. Today, people often make consumer product choices that reflect similar herd behavior. For instance, they make technology adoption decisions that imitate the decisions of others, thereby giving rise to adoption patterns similar to fashion trends.[12]

Group agreement, however, does not always provide the best course of action. For example, consensus in a boardroom meeting can be unduly swayed by impassioned individuals, or just by those who happen to speak first. Consensus emerges when others see no reason to disagree, or at least not a strong enough reason to voice their dissent, and the collective opinion becomes firmly entrenched. We assume that they cannot all be wrong, and we do not necessarily question the reasons why others agree. Other times, the desire for harmony might simply hinder a realistic appraisal of alternatives. This is a phenomenon referred to as groupthink, and it can result in groups making worse decisions than individuals. The virtues of contemporary artworks are probably not a typical topic of boardroom discussions, but if they were, the grounds for disagreement would be murky at best.

The limited benefit of groups is also revealed in tasks such as estimating the number of pennies in a large jar. A group of people can typically come remarkably close to the correct answer, but on one condition: that they make their estimates individually and separately. The errors in estimates tend

to even out, and the average comes close to hitting the mark. However, if estimates are disclosed along the way, then they influence the estimates of the next individuals in line, and eventually they become wildly inaccurate in one or the other direction. A similar phenomenon sometimes underlies movements in the stock market, when investors lead each other to valleys and peaks in the valuation of firms, often without comparable, objectively verifiable changes in the basis for this valuation.[13]

In markets such as contemporary art, the players do not guess numbers of pennies or estimate the value of firms. However, they do suggest prices and signal their approval or lack thereof regarding artists and their works, and individuals are swayed by the opinions they have seen or heard. Whether or not they conform outright, those opinions may at least serve as anchors. If an individual feels the prevailing view is too favorable or unfavorable, she might make a downward or upward adjustment. But such adjustments tend to remain close to the anchor.[14] Players in the art market follow in each other's footsteps, collectively walking in directions that observers characterize as current trends, often assuming that those trends are meaningful developments and that their conspicuous proponents are visionaries. However, the existence of a trend does not constitute proof of its value or necessarily reflect the vision of its proponents.

Much conformist behavior is taken for granted, somewhat like responses to automatic triggers such as audience laughter in sitcoms. Even if simulated laugh tracks are used, such that the cued response is clearly artificial, it tends to be contagious and to increase the perception of humor—although this practice is increasingly viewed as a quaint anachronism and is falling out of use. Its roots may be traced to the practice known as claquing, begun in early 19th century France.[15] Professionals leased themselves out to applaud enthusiastically at orchestral, operatic, or theatrical performances, thus stimulating the response of the audience. While we might thus blame the French for the origins of laugh tracks, the trick presumably works for the same reason that yawning is infectious: We are social animals. This, too, has possibly served an adaptive function in our evolutionary past, but in everyday life, it seems like little more than a harmless quirk of human nature.[16]

Returning to examples of conformity in the traditional sense of the word, wider versions of the odd ornaments known as ties may have been used to protect clothing while eating in the past, but they are ubiquitous in large parts of the world today because of a dress code. They signal conformity. Most social influences of this kind are mildly annoying at worst and useful at best. However, even central views of a political, religious, or philosophical nature can be molded by conformism. Whether beliefs and behaviors arise because one inherits the political views of one's parents or because one conforms to the agendas set by authoritarian leaders, the curbing of independent thought can have stark consequences. War, persecution, and

human rights violations have been spurred on by the influence of authority, peer pressure, suggestive propaganda, and the urge to conform. These tendencies have been illustrated in studies such as the Milgram experiment on obedience to authority figures. In the experiment, Stanley Milgram found that a high proportion of people obeyed instructions to inflict what they believed to be painful electric shocks on others, even if apparently causing serious injury or distress.[17]

Life-and-death scenarios provide vivid examples of herd behavior in a number of other contexts as well. For example, when hunting the North American buffalo, tribes such as the Crow and the Blackfeet found that they could be particularly effective by utilizing this phenomenon. In a stampede, the buffalo would put their heads down and run, spurred on by the others in their immediate vicinity. If the stampede was directed toward a cliff, they would therefore plunge off the precipice and die in large numbers.

Humans sometimes behave in a similar fashion, even when they are aware of the cliff. Striking examples are seen in tragedies such as the Jonestown Massacre. This incident involved the members of the People's Temple, which was an organization led by the Reverend Jim Jones. In 1977, Jones moved the majority of members with him to a settlement in Guyana, South America. In 1978, four men in an American fact-finding party were murdered while trying to leave Jonestown. Realizing that he would be arrested and disgraced and that the People's Temple would disintegrate as a result, Jones decided to end the organization on his own terms instead. He gathered the entire community and called for a collective suicide. First, a young woman calmly administered a dose of the poison to her baby and herself, and then she sat down to die in convulsions. Subsequently, the majority of the members followed her in death, one by one. Only a few Jonestowners escaped, and a few others resisted. Survivors reported that most of the 910 people died in an orderly fashion.

In his popular book *Influence*, Robert Cialdini explains the incident in terms of social proof.[18] The first ones to kill themselves were likely to be particularly fanatical followers, but the other cult members observed their example. They also observed the calmness of their peers around them, and hence they inferred that everything was as it should be. The behavior is similar to the ones sometimes documented when crimes are committed in public, in full view of numerous onlookers. The bystanders see that others do not react, and hence they infer that no reaction is called for, which explains why violent crimes can be committed on the street without anyone bothering to intervene or make a simple call to the police.

Less extreme examples of this type of social influence are observable in the practices of mainstream religious institutions. For example, church ushers might begin by preloading the collection baskets with some cash to get the ball rolling, much like bartenders do with tip jars. It creates the impression

that contributing money is what people do. It invites imitation. Similarly, evangelical preachers sometimes seed the audience with confederates that come forward at strategic moments to bear witness and offer donations, as documented by an Arizona State University research team that infiltrated the Billy Graham organization.[19] The team reported extensive advance preparations prior to a Crusade visit. By the time Graham arrived in town, thousands of believers had already been instructed when and how to come forward to create an impression of spontaneous mass outpourings.

Similar examples abound, but let us briefly return to the implications for the art market. On the surface, it might not be obvious that herd behavior can play a strong role in the development of art trends. But as the above examples illustrate, conformism has a potent influence in a variety of contexts, ranging from trivial ones to calamitous ones. Consumers are especially susceptible to this type of mechanism when they lack a clear or strong basis for forming a personal opinion or staking out their own direction.[20] The aforementioned studies have revealed that social influence can cause individuals to defer to authority or to the majority opinion when making an individual judgment should have been exceedingly easy. Consider now what we have already established: that such judgments are difficult in regard to art, and especially so in regard to contemporary art. Under these circumstances, social influence is more potent than ever.

As Thornton puts it:

Despite its self-regard, and much like a society of devout followers, the art world relies on consensus as heavily as it depends on individual analysis or critical thinking. Although the art world reveres the unconventional, it is rife with conformity. Artists make work that "looks like art" and behave in ways that enhance stereotypes. Curators pander to the expectations of their peers and their museum boards. Collectors run in herds to buy work by a handful of fashionable painters. Critics stick their finger in the air to see which way the wind is blowing so as to "get it right."[21]

We have already discussed how some key players build brands and stake out the directions for the art market. The rest tend to follow in a herd. To some extent, this is true for art from any era. Research in psychology and marketing has established that merely exposing consumers to certain items causes these items to be liked.[22] Much as radio and record-label executives decide the music to which consumers are repeatedly exposed, thus influencing which songs become liked, key players in the art market decide which artworks gain exposure, thus influencing the tastes in this domain. This impact is especially strong when there are few or no objective standards for quality, because then there is little or no basis for observers to form their own judgments and withstand the influence of opinion leaders.

Additionally, Thornton's observations regarding curators and critics suggest that opinion leaders may be similarly affected, which has implications for hierarchies of taste in the art world.[23] If it is easy to envision conformism and herd behavior among museum visitors sharing sights and experiences via social media outlets,[24] it might be equally easy to assume that the highest echelons of taste hierarchies must be immune. As we have seen, however, there is ample reason to doubt that assumption. For starters, the notion of superior taste entails objective criteria for judgments,[25] which brings us back to the lack of objective quality measures for art. Further, humans are social beings, regardless of their level of knowledge and influence. Although expertise can inoculate a person to some degree, social influence may prevail at all levels, in the art world and elsewhere.

Fads and Fashions

Whereas herd behavior typically entails proximal influences restricted to specific situations of brief duration, such as buffalo hunting or the Jonestown Massacre, fads can spread in a less direct manner, as with the names given to boys and girls, which rise and fall in popularity over time.[26] Non-fungible tokens (NFTs) serve as another example. An NFT representing ownership of digital art could sell for exorbitant amounts of money—although anyone could reproduce the image in question with a few taps on a computer keyboard—but become virtually worthless within weeks. Such developments are part of the reason why some observers consider NFTs to be a passing fad—with sales dropping in 2022 and 2023[27]—whereas other observers predict that this market will see strong growth in the coming years.

Similar to herd behavior, fads arise in a variety of contexts, including ones as extreme as suicide. A highly publicized suicide is often followed by a spike in the suicide rates, apparently because of copycat behavior. The spike in the rate tends to be localized to where the initial suicide was publicized, and it involves incidents of a similar nature. David Phillips, a sociologist at the University of California at San Diego, examined US suicide statistics between 1947 and 1968. He found that on average, within the two-month period following a front-page suicide story, 58 more people than would ordinarily be expected during that period also killed themselves. As Cialdini puts it, each highly publicized suicide in a sense caused the additional deaths of 58 individuals who otherwise would have continued living.[28] Phillips ties this pattern of behavior to what is called the Werther effect. In a novel by Goethe, the young Werther commits suicide. Upon its initial publication in the late 18th century, the story set off a wave of suicides across Europe. The effect was so powerful that authorities in several countries banned the book.

Most examples of fads that come to mind are less dramatic than this, but they often seem to spring from thin air. Whether they pertain to a new

hairstyle, video game, or business practice, entire trends arise from seemingly isolated or minor occurrences. Think of the little snowball that begins the avalanche. Or consider the fable of the Indian sage who was to be rewarded by the king for inventing the game of chess. Rather than gold, the sage merely requested a grain of rice for the first square, two grains for the second, four grains for the third, and so on—the number doubling for each of the 64 squares on the chess board. The king was happy to comply, thinking this was a trivial payment, but he quickly realized that it amounted to a great deal more than all the rice in the kingdom. There are different versions of this fable. Sometimes, the sage merely played chess well rather than inventing the game, and sometimes, he asked for wheat rather than rice. Either way, the gist of the story remains the same: When numbers double, they become very large very quickly.

Another way to illustrate this point is to fold an ordinary sheet of paper. Every fold doubles the thickness of the paper. After a few folds, it becomes difficult to continue, and the current world record stands at 12 folds. If it were possible to go beyond that, a few more folds would make the sheet several meters thick. After 30 folds, it would reach beyond the upper limit of the atmosphere. After 50 folds, it would reach the sun. After 100 folds, the sheet of paper would be billions of light years thick. Exponential growth can be mindboggling.

When someone influences two other people, and each person in turn influences two others, the initial notion quickly becomes a fad. Fashion is one of the areas in which such domino effects are frequently evident. From an aesthetics-centric point of view, fashion might be described as the process by which form seems exhausted and then refreshed, without regard to functional improvements. However, if novelty or aesthetic pleasure is the goal, then form might itself be described as a function.[29] In fields such as fashion, design, or art, the presence of fads is not only unavoidable, but it may even be desirable.

As noted by Miller:

> The mainstream fashion industry intentionally produces clothes with extreme and quirky designs and colors so they can be rendered aesthetically obsolete more easily the following year, when the new design features are decided at Paris Fashion Week, and the new colors are "forecast" by the Inter-Society Color Council and other trendsetters.[30]

Of course, designers and retailers pay attention when the Pantone Color Institute forecasts the color of the year—in other words, their annual self-fulfilling prophecies.

Rather than home in on *the* color of the year, the Color Association of America forecasts the 24 colors that will be popular in fashion and interior design two years later. These forecasts are purchased by clients such as

members of the fashion industry, or firms wanting to update their interiors or websites. In describing one of the Color Association's committee meetings, Sheena Iyengar notes that in addition to consulting with one another, forecasters ask prominent designers about their future visions. In turn, the designers are interested in the conclusions of the forecasters. According to the forecasting expert David Wolfe, there is not a successful designer in the world who does not buy trend information.[31]

The art world may not be quite as well organized in terms of forecasts, but nor is it very far behind. When a certain type of art is promoted by top dealers, auctioned off at Sotheby's or Christie's, or purchased by prominent collectors or the curators of important museums, peers take notice. The most recent activities are likely to be discussed at the next branded art fair, as well as finding their way into the media, and they set an example for hordes of less prominent dealers, collectors, and curators. It does not take much for the specific artists in question, as well as the general type of art associated with those artists, to become fads.

Costly Investments

One reason why fads can become extended is that they involve costly displays. Conspicuous consumption not only allows collectors to signal their wealth and sophistication, but it also signals the importance of the objects or activities upon which the costly investment is lavished. Such costs pertain not just to money, but to any type of investment.[32] Before the Jonestown Massacre, for instance, the members of the People's Temple had invested heavily in this movement, even relocating to a settlement in Guyana. In general, many cults and religious affiliations involve effort, money, or sacrifice. Members must dress in a certain manner, forego certain foods or activities, partake in rituals, remove parts of their bodies, or in other ways engage in costly displays that signal to the individual and the group, as well as to outsiders, that membership is genuine and meaningful. These types of signals are effective precisely because they are costly. It is easy enough to proclaim oneself a devout believer, be it in the fraternity and values of major religions or those of minor sects, but it typically requires time and effort to demonstrate this in a convincing manner. The stronger the perceived need for committed membership, the more costly the signals tend to be. An average Christian might be content to attend church once in a while, but some sects demand specific dress codes, avoidance of modern amenities, a restricted diet, and strict adherence to all sorts of rules and regulations.

Such behavior often strikes outsiders as peculiar, but it does serve a purpose. It makes membership costly and therefore difficult to fake. In our evolutionary past, this type of signal may have helped to consolidate groups and to separate them from outsiders. Strong, cohesive groups would be likely

to thrive, so individual proclivities to facilitate group cohesiveness would have become widespread over time, to the extent that the group benefits also aided the individual members exhibiting these proclivities (and hence their genes). Today, the behavioral traits that evolved during our ancestral time as hunter-gatherers are reflected in a variety of displays, ranging from the conspicuous asceticism of mendicants to the opulence of cathedrals.[33]

Lest you think that such practices are restricted to religious communities, think of the hazing rituals that often precede acceptance into other kinds of groups. Examples range from the tribulations endured by youths in many Africans tribes before entering manhood to the hardships to which aspiring fraternity members at American colleges are sometimes subjected. Prospective candidates to fraternities have suffered injuries and broken bones, or even death by choking, from exposure to the elements, or from being buried alive.[34] These fatalities have presumably been accidents, but they have resulted from the extreme lengths to which people take hazing rituals. Although the consequences rarely involve death, the mentality underlying these rituals is the same: Prospective members must pay. Only then, do they prove the value of membership. Through their sacrifices, they develop and demonstrate commitment, which subsequently benefits the group. This effect helps explain why it is so difficult to stamp out these types of rituals, notwithstanding the high costs.

Outsiders also understand the signal of high cost, and they make assumptions about others based on that signal.[35] Whether or not we are familiar with the cult, fraternity, or group in question, we interpret the importance of membership from the costly signals in which the members and prospective members engage. Similarly, we realize the devotion of music fans when they travel far to attend concerts. We identify as true brand fanatics those consumers who spend the night in line on the sidewalk to buy the next version of the iPhone or the newest pair of Nike shoes. In marketing jargon, we might say that those individuals are engaged members of a brand community.[36]

In many cases, money is the main indicator of importance. We infer the exalted status of fashion brands from what buyers are willing to pay for them. Artists, dealers, and collectors are evaluated based on the price tags associated with the work they create, display, and purchase. And, once an expensive artwork has been purchased, this in itself encourages commitment to the artist's brand. If you were the curator or director of an important museum, and you spent thousands or even millions of taxpayer dollars on acquiring the work of a contemporary artist, would you not be committed to maintaining the good reputation of that artist? After all, your own reputation is now directly linked to the artworks you have purchased and to the standing of the artist who made them. If the works were later deemed to be of scant merit, it would indicate that you had demonstrated poor judgment

and wasted taxpayer money in the process. Now, imagine that the purchase in question was controversial. Let us say it was a toilet seat, or a discarded shoebox, or any of the various odd objects that are currently displayed and sold for large sums of money in the contemporary art market. Perhaps some people felt reason to question your judgment. This would only increase the incentive to dig in, defend the purchase, and attempt to enhance the standing of the art and artist in question.

A similar escalation of commitment can occur when cult members experience a discrepancy between faith and reality, such as when a predicted doomsday scenario has failed to materialize. There have been many such predictions, and yet the world as we know it still appears to be here. One might think that the disconfirmation of such predictions would lead to less conviction, reduced faith in the cult, and less attachment to its leader. Often, however, the exact opposite happens, because the cult members are heavily invested. They have dedicated much to their faith, and they would not want it to be a waste. If they have professed their beliefs publicly, then the psychological investment is even heavier.[37]

We should not exaggerate the similarities between curators and cult members, but the notion illustrates how individuals become incentivized to perpetuate their actions. Executives reveal similar behavior when they push their firms to continue investing in a failing venture.[38] They throw good money after bad because they are heavily invested, although they would do better to cut their losses. Curators have not only invested their own reputation, but they have invested the money and authority entrusted to them, and they have done so in a highly public manner. In fact, the museum's collection remains a standing public testament to the actions of the curator, so the incentive to cast those actions in a favorable light is strong and enduring. The best way to do so is to continue to invest and thus enhance the reputation of the art and artist. The actions of influential players in the art scene tend to be quite visible. It is possibly unfair to characterize their collective actions as herd behavior, but at minimum, they nudge each other in the same direction.

Memes and Society

Although fads often appear to arise from thin air, certain concepts can help us understand how they evolve and spread. The meme represents one such concept. I am not referring to the restricted, currently popular internet-culture interpretation of this word, where amusing visuals turn into themes that spread via social media. I am referring to the original, broader sense of the word. The term *meme* was introduced in 1976 by Richard Dawkins, almost as an afterthought toward the end of his book *The Selfish Gene*. The term refers to a unit of cultural evolution, that is, an item of information—a

word, statement, idea, style, usage, and so on—that spreads from person to person within societies.[39]

Some see the role of the meme in cultural evolution as a parallel to the gene in biological evolution, but that comparison is far from perfect. For one thing, there is no physical entity called a meme that mutates or self-replicates. For another thing, ideas and cultural contributions often arise from the efforts of individual minds. Although one might argue that macromutations of the genetic kind also exist, they are few and far between, and they almost never spread. Additionally, many popular memes are propagated via intentional marketing efforts. For example, churches spread religion, governments spread political ideologies, and corporations spread products and brands. And, whether or not they are intentionally marketed, memes can get an enormous, virtually instantaneous boost via a newspaper article, TV broadcast, popular blog post, or celebrity tweet. Genghis Khan might have fathered hundreds or even thousands of children from as many as 3,000 wives, thereby spreading his genetic material far and wide, but even he would be hard-pressed to father millions of children in a single afternoon. Because of these and other limitations, one should be cautious when using biological analogies to explain culture.[40] As long as we keep these caveats in mind, however, the meme can provide a useful perspective in the analysis of societal trends.

Memes spread from brain to brain, and those with certain characteristics tend to spread more successfully than others. If they are catchy, amusing, scandalous, important, or for some other reason encourage retention and dissemination, they may reach host brains around the globe. Often, they also mutate along the way. For example, think of how gossip may begin as a simple rumor but evolve into a completely different story over the course of retellings. If these mutations cause a higher likelihood of retention and dissemination, then the mutated meme will probably outperform the original one, as well as other competing memes. The mutated meme therefore takes over the meme pool.

In his book *Hit Makers*, Derek Thompson argues that ideas almost never spread virally.[41] Viruses proliferate when a host infects two or more others before the disease or the host dies; this pattern provides the potential for exponential growth, as discussed above. Thompson criticizes the "viral myth" in marketing, citing studies showing that the aforementioned broadcasts or celebrity tweets typically underlie successful dissemination, although he concedes that some viral-like spread may supplement the broadcasts. In my view, his stance is simultaneously informative and misleading. It is informative because it highlights the role of single, influential actors; in the current context, a single high-profile purchase or exhibition can have an extensive influence on popular ideas about art. However, this observation in no way precludes the frequent role of viral-like contagion. Customs, linguistic quirks, YouTube

videos, and innumerable other items of culture or information spread far and wide without an initial high-impact broadcast. Indeed, ideas have been spreading through societies since long before the invention of high-impact communication technologies like the internet, television, or the printing press, whereas current social media platforms can substantially facilitate this type of diffusion. Scholars such as Jonah Berger, author of *Contagious*, have amply demonstrated how word of mouth spreads virally in contemporary society.[42]

To reiterate, many new ideas spring from the minds of individuals in a cohesive and useful form. Comparisons to genetic mutation and natural selection can therefore be misleading. However, these new ideas often result from a recombination or tweaking of previous memes. For instance, there appear to be few fundamental themes in literature not already covered by the ancient Greeks, and even inventions of new technologies are rooted in existing memes. The aforementioned tie may serve as another example. This garment did not begin as a tie in the modern sense of the word, but it mutated into its current form and found favor in much of current society. There are still many stylistic variations, but the general design is easily identifiable as a modern tie.

Popularity Is Not Truth

One might add that the common tie is relatively innocuous, albeit potentially annoying for those who dislike wearing them. Often, however, memes represent specific information, which may or may not have a basis in reality. As the saying goes, "A lie gets halfway around the world before the truth has a chance to get its pants on." (Incidentally, that saying is sometimes attributed to Winston Churchill, which may itself be a misleading meme.) The memes most likely to spread are not necessarily the truest ones or those most likely to benefit humanity. Aspects such as veracity and benefit may certainly play a role, at least if the people involved in the memetic diffusion have the motivation and ability to investigate and confirm such aspects. However, these influences can be drowned out by others, such as the ones stemming from catchiness, simplicity, or frequency of exposure.

It is difficult to illustrate this point with examples from art or entertainment, because they inevitably involve arguments about taste. I will therefore choose some personal observations of popular misconceptions, beginning with one that is unlikely to have sprung from personal tastes or vested interests: For some reason, many people think the term *schizophrenia* refers to dissociative identity disorder—otherwise known as split personality. Almost everybody seems to have misunderstood this term in exactly the same way, despite these conditions having little to do with each other in reality. Perhaps the initial confusion arose from the word's Greek roots, which roughly translate to split

mind. Or perhaps the confusion stems from the intention of Eugen Bleuler, who coined the term in 1908 to describe the separation of function between personality, thinking, perception, and memory. There was in fact no clear reason not to include split personality as a possible element. Either way, the meme "schizophrenia means split personality" is apparently so catchy that it is difficult to subdue, even though it is false.

While we are on the topic of words with misconstrued medical connotations, the word *doctor* is another example. It originates from a Latin verb meaning *to teach*. It has been used in Europe as an academic title for over a millennium, tied to the rise of the university. A doctorate has from the beginning been a license to teach, and the title of doctor still refers to holders of the Doctor of Philosophy degree (i.e., Ph.D.), who are often professors. Professional doctorates have also emerged, such as the Juris Doctor (J.D.) and Doctor of Medicine (M.D.). It has therefore become acceptable to use the term doctor when referring to a licensed physician as well, regardless of teaching credentials. However, most people today think primarily or even exclusively of physicians when they hear the term. For some reason, the meme spread among the lay public that doctors are physicians, although this is not true in most cases.

So as not to restrict our examples to words with medical or political connotations, a final curious example comes from the game of eight-ball, the basic rules of which are misunderstood by pool players in bars around the world. Even more interestingly, they appear to be misunderstood in the same way by almost everyone. According to the rules, for instance, a foul such as a scratch allows the opposing player to place the cue ball anywhere on the table. Most bar players, however, think that the cue ball must now be placed behind the head string (which is actually only the case after the less serious foul of scratching on the break). The misconception presumably arose because it favors the weaker player. In any case, it is remarkably widespread.

As an additional observation, it is tempting to point out that the meaning of the word *meme*, in a somewhat ironic twist, has itself become a misleading meme. Most people appear to believe that this term refers to the abovementioned amusing themes that are spread through social media. These constitute one type of an endless variety of memes, but the word is certainly not restricted to this narrow meaning.

A reader might ask why examples of these kinds matter. Most of us do not care if we have misconstrued the meaning of schizophrenia or the rules of pool. But the proliferation of misleading memes can have serious consequences. Politics frequently provides striking examples, and the phenomenon has garnered growing attention since the 2016 US presidential election. Before that, it had long been commonly observed that many politicians, whether conservative or progressive, occasionally bent the truth. One might further argue that a two-party system is bound to encourage polarization, and I use

this example only as a comment on marketing, not on policy preferences. Nonetheless, few observers seemed prepared for the continual tsunami of misleading memes tied to Donald Trump. Along with an astonishingly high number of falsehoods put forward by Trump himself,[43] a number of misconceptions also proliferated due to fake news that was spread via social media such as Facebook, among other channels.[44] Not only do social media platforms use algorithms that can match users with stories that fit their preferences, thereby making balanced news coverage unlikely, but there are seldom mechanisms in place to differentiate between legitimate and fake news. This situation is especially worrisome given social media's tendency to fuel extremism.[45] Relatedly, people tend to focus on and give credence to information that fits with their existing beliefs—a tendency known as confirmation bias—which can cause them to accept implausible stories as true. In the run-up to the 2016 election, fake news stories reportedly spurred more engagement on Facebook than was generated by top election stories from 19 major news outlets combined.[46] Soon after journalists began discussing fake news as a growing problem, the story of this problem became a meme in its own right. Trump then appropriated the fake-news meme and began labeling legitimate news stories as fake if they were critical of him. In other words, the meme about misleading memes was itself turned into a misleading meme. Regardless of political affiliations, the events are noteworthy from a marketing perspective.

Traditional news channels reveal related phenomena, with Democrats and Republicans self-selecting commentary that matches their existing perspectives, and with numerous news outlets leaning increasingly left or right. For example, the right-leaning Fox News has arguably been a trailblazer as the most successful partisan news channel, featuring hosts and pundits seemingly intent on promoting conspiracy theories and one-sided views of politically charged topics. Despite this departure from serious journalism—or perhaps because of it—Fox News is the most popular cable news network in the US. It reportedly dominates among conservative viewers, though other ideological groups tend to seek out a greater variety of news sources.[47] Some competing content appears to be an attempt to emulate the Fox News strategy, but targeted toward a progressive rather than conservative audience. For instance, whereas Fox News might highlight the obsessive political correctness of some Democrats—an obsessiveness that inhibits open and informed discussion of contentious issues—MSNBC might focus excessively on those Republicans who disdain science and education—a disdain that prevents a basis for informed discussion from arising in the first place. In reality, though, the people in the spotlight do not necessarily reflect the views or behaviors of most Democrats or Republicans, many of whom are thoughtful, reasonable individuals. But thoughtful, reasonable perspectives often fail to grab the

spotlight, so balanced views can end up being ignored by people on both sides of a debate.

Notably, even when journalists and pundits make a concerted effort to be impartial, they regularly home in on content that engages viewers regardless of information value—which leads to good ratings. During the 2016 election, most news outlets, including generally balanced ones, paid a disproportionate amount of attention to Donald Trump. Reporters from various outlets occasionally expressed concern in regard to his frequent name-calling, self-aggrandizement, disregard for facts, self-contradictions, and linguistic limitations, but more importantly, they maintained a focus on him as opposed to all the other candidates. As a result, Trump became a spectacle who was constantly in the news, translating to the equivalent of about $3 billion in free advertising in the primary season alone.[48] Analysts have offered various explanations for why someone like Trump became electable and remained popular with his voter base in years (and elections) to come. Beyond policy preferences, explanations have ranged from weaknesses in his opponents to widespread misinformation to a broken political system, including the lobbying and gerrymandering that plague congress. Some critical observers blame those among Republicans who are self-serving or who lack the integrity to withstand Trump. Others blame those among Democrats who are self-righteous, who inject identity politics into everything, or who demonize conservatives for being slow to jump on the bandwagon each time progressives decide that yet another word has become offensive. Whatever role these and other issues may have played, however, all the free airtime was surely a contributing factor.

Important outcomes, which presumably should depend on critical thought, are often shaped by marketable memes. Alongside the crucial societal services provided by a free and critical press, such as checking evidence, informing the public, and exposing political corruption—although the US ranks only 45th among 180 countries in the World Press Freedom Index[49]—the media's tendency to focus on content that is easy to sensationalize contributes to the dissemination of certain kinds of memes. Thus, whereas recent assaults on a free and critical press are dangerous and deeply troubling, many journalists themselves arguably contributed to the election of a president with a hostile stance toward a free press, or at least toward members of the press who insist on factual, truthful discourse.[50]

If major political elections can be affected in this manner, it should not be surprising that the contemporary art market can be similarly affected. During the campaign season and thereafter, many of Trump's statements became popular memes, despite—or perhaps due to—striking many observers as uninformed, infantile, or offensive. Similarly, news stories about the contemporary art world frequently highlight artworks whose appeal might reasonably be described as immature or offensive rather than artistically

masterful; it is precisely the extremism or departure from expectations that makes them newsworthy. Further, the misalignment between expectation and delivery drives the search for hidden meanings. After Trump's 2016 election, political analysts debated the deeper meaning of his statements, especially those that struck them as incoherent or inane. The fact that he had been voted president of the most powerful nation on the planet implied that his proclamations must be more insightful than they appeared on the surface. Similarly, the mere fact that artworks are prominently exhibited or achieve high prices implies that they must be worthy of such consideration. If they seem inane on the surface, then it is often assumed that they must be "challenging" and in need of serious analysis to get to the bottom of their deeper meaning.

These tendencies do not characterize the entire art world any more than President Trump characterizes the entire political landscape, but they partake in trends, based in part on the successful dissemination of memes. Before we once again restrict our focus to the art world, however, a few more general observations may illustrate how misleading memes feed into biases and create narratives that spread successfully.

Biases and Narratives

In modern society, memes have become less directly or obviously tied to the needs of genes. In ancestral hunter-gatherer societies, life changed slowly, memetic transmission was largely limited to a few close individuals, and the success of a typical meme was at least partially tied to the health, longevity, and reproductive success of its carrier. In modern industrialized society, a meme can easily spread to millions or even billions of hosts within short time periods, regardless of any actual or perceived benefit to each individual. We still adopt many of our attitudes and behaviors from those who are close to us, genetically or otherwise; people are overwhelmingly likely to speak the same language, follow the same religion, and have the same political affiliations as their parents and close peers. But memes are also spread through transmitters that did not exist in our evolutionary past, such as radio, television, and the internet. Today, a meme can spread across the planet in a matter of moments.[51]

Successful memetic diffusion of this kind often relies on narratives that have certain traits in common. They tend to be simple, catchy, or for other reasons easy to retain and repeat. Whereas computers are perfectly capable of memorizing, using, and transmitting vast quantities of data, humans have an easier time with stories. That is why you are unlikely to remember all the specific words and phrases in a book you read, but you might remember the general pattern of events. If the pattern is simple or catchy, this facilitates your ability to relate to the story.[52]

The Lebanese-American author Nassim Taleb provides an example concerning a toddler who fell into a well in Italy in the late 1970s.[53] The rescue team had trouble getting him out of the hole, so he remained there alone and crying for an extended period. The entire country was caught up in the boy's fate and paid close attention to the frequent news updates. His picture was prominently displayed in magazines and newspapers, and every street corner in Milan was abuzz with his plight. Other nations became absorbed in the ongoing story as well, including the Lebanese. As Taleb explains, despite the civil war raging in Lebanon, with car bombs exploding and people dying right there in the vicinity, the Lebanese somehow managed to become wrapped up in the story of a little boy trapped in a hole far away in Italy. A collective sigh of relief was felt in Beirut when the little boy was finally rescued.

Taleb refers to a quote with a questionable origin, albeit often attributed to Stalin: "One death is a tragedy; a million is a statistic." Statistics tend not to move us. That is why charities often are marketed more effectively by showcasing one or two touching tragedies rather than revealing the full extent of a pervasive need.[54] From a purely rational standpoint, it is hard to explain why the story of a little boy in a hole should deserve more attention than the story of hundreds dying in the streets. But it is a digestible story. It is a simple and compelling meme.

Thaler and Sunstein provide an example from 1954, when some people in Bellingham, Washington noticed tiny holes, or pits, in their windshields.[55] Local police speculated that vandalism may have been to blame, with BBs or buckshot causing the pits. Following this incident, other victims in cities south of Bellingham began reporting similarly damaged windshields. Within two weeks, a full 2,000 damaged windshields were reported. The wave was nearing Seattle, and it was becoming apparent that it was too widespread to be the work of mere vandalism. Before long, the reports reached epidemic proportions, resulting in wild speculation as to what could be the cause. Possible explanations ranged from shifts in the earth's magnetic field to cosmic rays from the sun. When 3,000 windshields in the Seattle area had been "pitted," the mayor of Seattle wrote the governor and President Eisenhower, asking that appropriate state and federal agencies be ordered to collaborate with local authorities on an emergency basis.

The governor created a committee of scientists to investigate the inexplicable threat. This committee found that the damaged windshields probably just resulted from small objects occasionally striking them, as happens during ordinary driving conditions. A later investigation confirmed that new cars did not have any pits in the windshields. The pits in the older cars had been there all along, but nobody had noticed them before reports of the "pit epidemic" had caused owners to carefully inspect their windshields.

In another car-related example, incidences of road rage were extremely rare before 1994, and the term hardly existed. In 1995, the media began using the term with increasing frequency, and by 1996, this serious concern had become well known to the public. Drivers were apparently going berserk, and they were killing and maiming in the course of their rampages. By 1997, everyone was talking about this so-called epidemic. Then the issue suddenly vanished. Of course, it was not that the actual incidence rate of road rage exploded and then imploded; it was just that the meme came and went. We still hear about occasional instances of road rage, and the term is too catchy to let go completely, but the hysteria has disappeared.[56]

Similar memes proliferate for a period of time almost every year, ranging from infant abductions to exotic diseases to shark attacks. In the latter example, the violent image of the vicious predator attacking unsuspecting swimmers grabs our attention, and the media is therefore more likely to report on it. If another attack occurs while the story is fresh, the meme of shark attacks spreads far and wide in moments. Soon tourists are panicking about a "shark summer," even if there are no more shark attacks than in an average summer, and although there are so few fatalities due to shark attacks that it remains a negligible threat.

The threat of terrorism is arguably a longer-term example of this kind. The world has seen a millennia-long decline in violence and is currently enjoying an era of relative peace and prosperity—despite conflicts and troubled regions—but that reality is understandably overlooked when modern communication technology instantly brings each new terrorism-related story into our living rooms in vivid, hysteria-inducing detail.[57] Notwithstanding the devastating 9/11 attacks of 2001 and other such atrocities, the risk of death from terrorism remains relatively low, not just in the United States, but in most parts of the world. However, it gets a disproportionate amount of exposure in the media, because it strikes fear into people's hearts and makes for a much more impactful news story than the comparatively higher risks tied to traffic accidents or diseases. (The recent COVID-19 pandemic admittedly attracted its fair share of attention, arguably even to the point of obstructing terrorism, but that was an exception rather than the rule.)

As Gardner notes, if a terrorist attack with the same death toll as the 9/11 attacks happened every single month in a given year, the risk for an average American of dying in an ordinary motor vehicle accident that year would still be higher. The combined death toll in North America from all international terrorist incidents between 1968 and 2007—including the 9/11 attacks of 2001—was 3,765 people.[58] The number of Americans killed *annually* in motor vehicle accidents is close to ten times as high, as is the number of annual deaths from gun violence unrelated to terrorism. In a typical year, the number of Americans killed in gun violence without ties to terrorism is hundreds of times higher than the number killed in terrorist

attacks. Nonetheless, whereas enormous amounts of money are spent on preventing terrorism, both in terms of direct expenditures and in terms of opportunity costs incurred through inefficiencies such as waiting times at the airport, comparatively little is done to prevent general gun violence.[59]

My argument here is not about gun rights. That question is beyond the scope of this book, and in any case, attitudes toward guns depend on more than death rates; people trade off safety with all sorts of things they enjoy, ranging from extreme sports to smoking to overconsumption of sugar. The point here is only that common perceptions of risks, which possibly inform those attitudes, appear to be out of step with reality. Death risks represent a striking example of marketable memes distorting popular perceptions, thereby influencing trends.

Globally, measles killed 134,200 children in 2015, down from 651,600 in 2000, thanks to vaccines.[60] Easily preventable diarrhea kills 2,195 children every single day, accounting for one in nine child deaths worldwide.[61] If a million dollars could prevent one death from terrorism or a thousand deaths from disease, malnourishment, street crime, or natural disasters, where should society allocate the money? Most people do not think like rational scientists, so they respond to these types of questions based on narratives rather than numbers and statistics.

Some of the reactions to devastating acts may cause more widespread damage than the acts themselves. Terrorist organizations, whose goal is to spur change through the spread of fear, benefit when journalists and politicians engage in fearmongering and exaggerate the threat; it amplifies the terrorists' influence and aids their marketing and recruiting efforts. At the same time, if governments expend enormous resources in response to terrorism, it deprives other causes of those resources. Terrorists score another win if they can scare their targets into renouncing their own values, thereby exposing moral weakness. Finally, they amplify their impact enormously if they can foster animosity between large groups of people, which ultimately could even lead to full-scale war between nations. Nonetheless, numerous politicians and journalists seem intent on playing right into their hands.

One reason why a meme concerning terrorism or fatal shark attacks spreads successfully is that the frequency of such attacks is overestimated in the popular imagination. Sharks cause only four or five fatalities per year. Malaria alone might cause a million deaths in a given year. Nonetheless, killer mosquitos leap less readily to mind than killer sharks do, and it is therefore the latter danger that is overestimated. This pattern is tied to what researchers in social sciences call the availability heuristic. The vivid example of shark attacks is easily recalled, and therefore we have the impression that it must be a prevalent cause of death. In reality, sharks are the ones with more to fear. For every human killed by a shark, humans kill millions of

sharks. As noted by the National Geographic Channel, an American person is thousands of times more likely to be injured by a toilet than by a shark.[62]

Studies have found numerous similar misconceptions. For instance, in research by Slovic, Fischhoff, and Lichtenstein, study respondents thought tornadoes killed more frequently than asthma, although in reality, the latter causes 20 times more deaths. Dying from disease was judged about as likely as accidental death, although the former is 18 times more likely. Accidental death was thought to be 300 times more likely than dying from diabetes, although the true ratio is 1:4.[63]

When journalists exacerbate such misconceptions, they do not necessarily intentionally mislead the public. On the one hand, news organizations are in business to make a profit, so it makes sense that they tend to report on stories that attract viewers; they grossly overrepresent sensational stories, because that is what their customers want. According to one study, for instance, BBC news aired a story about smoking for every 8,571 people who died from smoking, whereas they aired a story about vCJD (mad cow disease) for every 0.33 deaths from that disease.[64] It is perhaps not surprising if a death from mad cow disease is more newsworthy than a death from smoking, but when the ratio of newsworthiness is 25,713 to 1, then it seems to be getting more attention than it deserves. On the other hand, reporters are afflicted by the same biases as their readers and viewers. They too are only human, and they too are moved by stories of mad cow disease and shark attacks. Therefore, they too believe those stories to be more newsworthy than all the mosquito bites in the world.

Selective reporting of this kind is especially likely when there is little objective basis to assess the narrative—and as we have already seen, this basis tends to be conspicuously absent in regard to art. The examples in the past few pages illustrate how certain types of memes spread easily. They are marketable, regardless of the information value or related benefits they provide. If this pattern is evident in topics ranging from puppies to politics, and even in questions of life and death, it should not be surprising that it appears in the art world as well.

Memes and Narratives in Contemporary Art

As in other areas, marketable memes in contemporary art are often odd, novel, or provocative. Contemporary society is fast-moving, and attention spans are short. Consumers make judgments based on heuristics, and there is little time for contemplation of subtleties. In the absence of critical thought, simple tricks may be used to create the impression of noteworthiness, which often entails relying on conceptual aspects that can shock or amuse audiences in a fleeting moment. At the same time, critics and theorists—who *do* dedicate a great deal of time and effort to the work—can use those aspects as the

impetus for their own creative endeavors, as they analyze culture and society. These observations do not include every niche in contemporary art; I should not make the same mistake I am criticizing by giving arbitrary examples a platform out of proportion with their place in the art world. However, the observations hold true for much of the contemporary art that sells at premium prices, is collected by contemporary art museums, and gets the majority of media attention.

If visible signs of effort and skill are conspicuously missing from work that is nonetheless exhibited in a gallery, the assumption is often made that there must be an underlying idea worthy of presentation. Otherwise, it would make no sense that it was prominently displayed. Tracey Emin's installation *My Bed*, for instance, was exhibited at the Tate Gallery in 1999. It consisted of her own unmade bed with stained sheets and a few other items such as condoms and bloodstained underwear. It would be difficult to argue that it reflected much effort or skill on the part of the artist, so many would assume that the idea of putting her personal life on display in this manner must be noteworthy. Of course, being shortlisted for the Turner Prize did nothing to diminish that impression. Some observers might question what the difference is between Emin and various celebrities and reality-TV participants who put their personal lives on display. Others would answer that those people are in the tabloids and gossip columns, while Emin is in the Tate gallery. For many, that is enough to distinguish between tabloid trash and fine art. The bed was bought by Charles Saatchi for £150,000.

Much work of this kind appears to be rooted in the tradition of Duchamp's urinal; what matters is not the creativity and skill involved in the physical creation and presentation of the work, but the presence of a noteworthy narrative. Buzz Spector's installation *Toward a Theory of Universal Causality*, for instance, consists of piles of books on the floor. Does the title make the piece deep and meaningful? A common view holds that contemporary art invites the audience to complete the work, often through a process of meaning making that draws on individual observers' background and context.[65] This view is not restricted to conceptual work but is compatible with theories of relational aesthetics,[66] as well as some object-focused aesthetics theories.[67] Audience members may disagree, however, on the extent to which a given artwork provides an interesting point of departure.

For some observers, depth and meaning is so readily ascribed to contemporary art that this interpretation prevails in spite of the artist's explicit efforts to the contrary. When discussing Koons' sculpture *Ushering in Banality*, featuring a pig flanked by two angels and a little boy, Robertson and McDaniel comment, "While many sophisticated art viewers would interpret this work as containing an ironic critique of commercialization, Koons claims that he simply takes pleasure in the kitsch imagery."[68] The latter claim is not surprising, since Koons has not attempted to hide his intentions

in this regard. However, it is not clear why those viewers who insist on saying otherwise should be described as sophisticated. Part of the explanation may lie in their apparent focus on the conceptual aspects of the work. A lot of conceptual art is labeled as challenging, inaccessible, or difficult. Perhaps this is why an appreciative audience is deemed sophisticated.

Art that some observers perceive to be challenging, however, others perceive to be simple, uninteresting, and perhaps even wasteful; without clear or objective criteria for judgment, how can we decide who is right? In 2002, for example, Santiago Sierra paid day laborers in Morocco a minimum wage to dig holes in an empty lot. Some might view this as a brilliant way to highlight social issues via performance art. Others might view it as a waste of resources that could have been put to better use. Terry Smith describes another performance by Elmgreen and Dragset from 2003 in which the Museum Kunst Palast in Düsseldorf had:

> its entire collection dismantled, packed into trucks that were driven once around the building, then reinstalled exactly as before. It is difficult to imagine a more exact metaphor for the current standoff between artists and museums. With critique coming from one group of artists, and accommodation being pursued by another, while the institutions struggle to resolve the pull of contradictory purposes, what seems to be a fascinating flurry of activity is actually going nowhere.[69]

Other commentators might find this flurry of activity less fascinating and would once again just describe it as a waste of resources.

One can speak eloquently about virtually any work and invite people to rethink their positions. For instance, Tracey Emin's word art consists of phrases in neon, such as "Is Anal Sex Legal?" Some people may not find this phrase particularly insightful, but as Gibbons explains, in works such as these "Emin simultaneously exploits a potentially prurient appetite for knowledge of her abused childhood and sexual history and frees herself of the burdens of such histories."[70] Viewers may take this interpretation into consideration when deciding whether writing the phrase "Is Anal Sex Legal?" should be proclaimed a momentous intellectual achievement.

Even for much work in which aesthetic elements appear to be central, these elements have little influence on its success rate. For example, Serrano's *Piss Christ* has been described as "a darkly beautiful photographic image.... The small wood-and-plastic crucifix becomes virtually monumental as it floats, photographically enlarged, in a deep golden, rosy glow that is both ominous and glorious. The bubbles wafting across the surface suggest a nebula."[71] But as the writer also must concede, that is not why *Piss Christ* got any attention. It did so because it is entitled *Piss Christ* and because of the liquid used in the photograph. Most other liquids would not have had the same effect, even if

they were visually indistinguishable from Serrano's urine. The same is true of, for instance, Robert Mapplethorpe's photographs. No matter how well done they might be from an aesthetics perspective, they became famous, at least in part, because a number of viewers found their sexually explicit content to be shocking.

This brings us back to the aforementioned observation that provocation is one of the most common and reliable ways to get attention. Not all conceptual art is shocking, but shock value is certainly a good way to promote oneself. Peter Timms holds a somewhat unfavorable view of this situation, noting that "Britain's Turner Prize provides the perfect illustration of how practical jokes and weak visual puns can be marketed as profundities to a mass audience that no longer knows the difference and isn't interested in finding out."[72] He then refers to the findings of a French sociologist regarding the attitudes of contemporary art collectors. Their most commonly cited criterion for purchasing a work was that it should shock people or even displease most people. What, then, must artists do to remain relevant? One answer is to increase the likelihood of shock by resorting to obscenities. Timms offers some examples, including Antonio Beccerra's exhibition in Santiago in 2002 of dead dogs pierced with spikes, as well as a show at New York's Holocaust Museum the same year that featured photographs of concentration-camp inmates into which the artist had inserted pictures of himself holding a can of Coke.

Whether contemporary works are shocking, ironic, whimsical, or contemplative, they often are intended to provide some form of social critique. But Timms is not particularly optimistic in this regard either:

> Despite what they might claim, artists rarely, if ever, explore or investigate issues of social, political or scientific concern. More characteristically, they adopt a given position, usually the commonly accepted one—multiculturalism is good, racism is bad, modern society is too materialistic, modernist architecture is dehumanizing—and simply restate it in a different form. It is a way of making art appear useful, of giving it a purpose.[73]

In my view, restating an important message in an engaging manner, to resonate with people who otherwise might not pay attention or process the information, can actually be a very worthwhile endeavor. Nonetheless, I must admit to agreeing with Timms to some extent. I have frequently found the social critique of conceptual artists to be less than piercingly insightful, although there are bound to be exceptions. I can respect Duchamp's *Fountain*, regardless of whether I personally classify it as an artwork, because it was a novel statement with profound implications at the time. However, I often come across conceptual works that are described as challenging or difficult, but which in my own opinion are trivial. Worse yet, they represent

trivial statements constructed in such an obfuscated manner that they seem inaccessible. In other words, they reflect a combination of simplistic insights and poor communication skills, similar to much postmodernist writing. In those cases, it might be useful to consider the intellectual climate in which these works exist.

Pinker ties some of the limitations of contemporary art to postmodernism, and he ties much of postmodernism to a fundamental misunderstanding, or even outright denial, of human nature.[74] Like so many perspectives that arise in reaction to shortcomings in prevailing norms—in this case to the perceived elitism and rigidness of modernism—postmodernism quickly developed its own restrictive dogma. While postmodernism is really a set of conceptual frameworks and ideologies rather than a unified philosophy in its own right, it tends to be aggressively relativistic and to deny the possibility of broadly shared cultural values or general notions of meaning, knowledge, and progress. Postmodernist art typically avoids straightforward attempts at authentic representation. It tends to be ironic and self-referential, and in dealing with social issues, it is more likely to provide smug comments than actual solutions or anything with the power to inspire or uplift. Simplistic narratives, often with a negative or shocking flavor, are marketable. Constructive narratives that invite deeper, more nuanced contemplation, and especially ones with a positive rather than critical flavor, tend to be ignored.[75] In many ways, it reflects the same intellectual climate that enabled the physicist Alan Sokal, in an intentional hoax, to publish a paper filled with utter gibberish in the journal *Social Text*.[76] In my view, postmodernism facilitates some of the most insidious influences of marketing, and not just in the art world; without objective reality to guide critical thought, other sources of persuasion have free rein. This is admittedly a broad and uncharitable generalization, but it is only intended to describe a trend.

A related concurrent trend pertains to artistic freedom, along with the profusion of styles and modes of expression that has grown tremendously over the past century. This multiplicity poses challenges for art professionals and society in general, but it also provides opportunities. The following chapter will suggest some possible ways to handle those challenges and opportunities, while also considering societal goals that may or may not align with influences of money and marketing. In a discussion that involves societal goals, it is especially difficult to avoid statements of opinion. I therefore once again rely on the reader's ability to differentiate between fact and opinion, though the latter is informed by the former.

5
DISENTANGLING THE MUSES
Some Simple Steps Forward

Perspectives on right and wrong boil down to opinions, as do views on the appropriate types and levels of societal rules and regulations. Pertinent to the current topic, the author G. K. Chesterton opined, "Art, like morality, consists in drawing the line somewhere."[1] At the same time, a somewhat critical view of restrictive guidelines may be discerned in H. L. Mencken's observation, "Puritanism: The haunting fear that someone, somewhere may be happy."[2]

The preceding chapters have discussed how money and marketing—combined with the psychological mechanisms that encourage trends—shape much of the art world, especially in regard to contemporary art. These observations do not apply equally to the entire art world, but the question arises as to what can be done about the parts to which they do apply. Is it desirable to curb the influence of money and marketing? Some observers may say no. Profit objectives constitute a reasonable and valid goal for dealers and other business professionals with a commercial interest in art. Those who disagree with their choice of merchandise have no self-evident right to judge them for pursuing this goal to the best of their ability, nor is there any obvious reason to criticize the buyers and sponsors of art for exerting their influence in whatever manner they please. However, it does not follow that the rest of us should therefore refrain from informed opinion or from attempts to influence the role of art in society. There is a widespread belief that art contributes value to society. Otherwise, governments would presumably not expend substantial resources on arts education, art museums, and other public undertakings. This has less to do with business and more to do with goals that are hard to quantify, such as human fulfillment and wellbeing.

DOI: 10.4324/9781003531340-5

As I have argued repeatedly, certain influences of money and marketing in the art world increase when quality is difficult to assess. Further, quality is difficult to assess when we cannot even agree on what art is, let alone what should count as standards of excellence. It seems, then, that for those wishing to curb the influence of money and marketing, a good first step may be to revisit the conceptualization of art. At the outset of this book, we relied on a market-centric definition for introductory observations about the art market, in part because it obviated the need to constantly stop and theoretically justify the art status of each artwork discussed. At this juncture, however, it seems useful to reexamine that definition with a slightly more critical eye.

Given the inexorable entanglements involving players in the art world, marketing not only influences the art market, but also art theory—especially for critics, art historians, and philosophers of art trying to define art based on everything presented for sale in the art market.[3] In my view, their efforts will fail unless they identify unique properties of art. In science and philosophy—including the philosophy of art—the definition of a construct should identify properties that characterize it and differentiate it from other constructs. The art construct should not merely embrace everything that marketers decide to call art. To echo the above quote by Gilbert Chesterton, we need to draw the line somewhere.

Aesthetics and Concepts

A comprehensive treatment of all the complexity in current art theory is beyond the scope of this book. However, I would argue that much of that complexity—rooted in the conflation of ideas and their execution—is unnecessary. Returning to the final arguments of the prior chapter, I would therefore like to highlight a simple perspective, which may clear up some of the complexity: In artworks (and elsewhere), we can differentiate between aspects of an idea and its execution, and we can evaluate both types of aspects on their own merits. In art, the distinction roughly translates to the difference between concepts and aesthetics. I am not arguing that all art theory is restricted to such a division; a number of observers, especially those with a post-structuralist bent, would likely bristle at that notion. However, I will argue that tensions between the two realms have characterized many of the recent developments in the art world.

For those who conceive of an artwork as an object, one might say that its aesthetic appeal stems from its execution. Otherwise stated, it arises from interactions between the perceiver and the object's perceptual properties. The vast majority of works that are typically considered art, across the globe and throughout history, are characterized by a purposeful structuring of formal qualities to achieve an aesthetic impact.[4] Works thus characterized comprise a readily identifiable category with a straightforward definition.

The nature of relevant formal qualities depends on the specific type of art; painting includes shapes and colors, much like music includes pitches and harmonies, and dance includes positions and movements. Regardless of the specific qualities involved, and regardless of any additional purpose that the creations serve, the deliberate structuring of such qualities into an aesthetic whole differentiates these creations from other products. What primarily distinguishes them as artworks is not *what* they express or represent but *how* they express or represent it. For example, a visual image might depict a landscape, an emotional state, a fantastical vision, a political event, an abstract notion, or anything else. Whatever the subject matter, art resides in the manner of depiction, and displays resulting from this manner resonate with our aesthetic sensibilities. The application of creativity and skill to such displays represents a unique behavior, recognizable to people around the world, presumably for at least as long as modern humans have existed.[5] Relatedly, some scholars theorize that the tendency to create and appreciate art evolved through human prehistory, due to a role of aesthetics as a form of prelinguistic communication.[6] If so, it helps explain why various forms of artistic expression are broadly recognizable as belonging to the same category of work.[7]

Some observers may equate aesthetics with prettiness, but that would be an overly narrow interpretation of the word in this context. The term *aesthetics*, from the Greek word *aisthetikos*, pertains to sensory perception. In the 18th century, Alexander Baumgarten reintroduced the term in a narrower sense, referring to taste or sense of beauty,[8] but it was Immanuel Kant's *Critique of Judgement,* broadly considered the foundational treatise in modern philosophical aesthetics, that brought the term into mainstream philosophy.[9] Kant applied a broader meaning, closer to the original Greek. Today, the *Oxford Dictionary of Philosophy* defines aesthetics as the "study of the feelings, concepts, and judgements arising from our appreciation of the arts or of the wider class of objects considered moving, or beautiful, or sublime" (Blackburn 2016: 10). In my view, one should here interpret the term *moving* broadly. In other words, although an aesthetic response may arise from any sensory experience, it is generally restricted to such experience that is interesting, pleasant, meaningful, or emotionally stirring, often with beauty as a central component.[10] Any object depicted in an artwork may evoke an aesthetic response that would not typically arise from, for instance, a run-of-the-mill photograph of the same object, unless there was something particularly interesting about the design of that object or the manner of the photograph.[11] Similarly, a newscaster may describe an event in a straightforward manner, whereas a novel or a movie may recount the same event in a more poetic manner, giving rise to an aesthetic experience. To some extent, the response depends on the perceiver; in theory, the aforementioned run-of-the-mill photograph could stimulate a strong aesthetic response, and

the newscaster's straightforward manner could be more evocative than a cinematic narrative. The point here is that the manner of presentation has an impact.

We could add that art, in this aesthetics-focused perspective, might best be thought of in terms of a continuum, or degree of purity. For instance, various crafts are characterized by aesthetic elaborations. The same is true of numerous products in the marketplace, designed to be aesthetically appealing to consumers. These designs, however, are restricted by the function that the product is intended to serve. It does not follow that they are less valuable or impressive, but just that these designs are not driven purely by aesthetic concerns. One might say that there is art in them to varying degrees; the more they are characterized by aesthetic expression, the more they approach pure art.

Before continuing, let me take a step back to acknowledge a differing viewpoint, because at this stage I can envision a horde of angry pundits who are quite displeased with the last few paragraphs. They could rightly point out that many works, and certainly many of the ones that have received most attention in the art world over the past century, are conceptual. These works, which emphasize an idea, focus predominantly on *what* is being expressed and not so much on *how* it is expressed—at least not in terms of aesthetics. In fact, aspects such as aesthetic appeal may be strictly and explicitly irrelevant to many of these works.

Such objections are justified, but there are also valid responses to them. One potential response is that these works really belong to a different category of creations. As such, it should have its own definition and its own standards of excellence, rather than being lumped into the same category. This response would not imply that conceptual work is more or less valuable than aesthetic work, but that we can recognize how the two differ. (To reiterate, the somewhat clunky term *aesthetic work* does not entail a measure of beauty in this context but just that aesthetic concerns are a central characteristic. Under normal circumstances, one would simply refer to such work as art.) If aesthetic work throughout the ages and across the globe is easily identifiable as art, and we nonetheless have decided to give conceptual work the same label, then it seems useful to clearly acknowledge the differing characteristics of the two types of work. Many art professionals have little trouble acknowledging such differences in principle, but as we will discuss, doing so has some logical implications that may pose difficult challenges.

Either way, there is no need for art enthusiasts to be purists (or puritans, for that matter), morally obliged to enjoy only one type or aspect of art at a time. In some circles, skillful execution appears to be considered old-fashioned. Worse yet, it might be unfavorably compared to that of works from the past. Therefore, if any effort or skill or aesthetics-based creativity is demonstrated, it should only be done ironically, or at the very least in a quirky way that

renders judgments of quality difficult or irrelevant. Whether these attitudes stem from genuine conviction or merely from a lack of technical skills, they seem unnecessarily restrictive. Further, art often combines conceptual and aesthetic aspects, such that it is difficult to categorize a given piece as exclusively one or the other. In that case, however, one can still identify and appreciate those aspects.

In Paige Bradley's *Expansion*, for instance, a woman meditates in the lotus position as light emanates from cracks in her body. After intentionally dropping and cracking the sculpture, Bradley cast the pieces in bronze and assembled them to float slightly apart, encasing an internal lighting system. A photograph of the glowing cross-legged figure against a backdrop of the Manhattan skyline drew attention on the internet.[12] These types of artworks, which combine a novel idea with a striking execution, can be found throughout art history. In the transept of the Cathedral of Milan, for example, stands a sculpture from 1562 by Marco d'Agrate. It is a statue of a solitary man standing on a pedestal. As you approach it, the intricate musculature may capture your attention. The man is naked, except for what at first appears to be a large cloth draped about his shoulders and across his hips. As you move closer, it seems as if the man's skin is missing, revealing all the details in the underlying flesh. Then, you might notice a distorted hand or face in the hanging folds of cloth, and you realize that this is a sculpture of a fully flayed St. Bartholomew, carrying his own skin with him. The idea is arresting, and it is coupled with a formal execution of impressive creativity and skill. Observers can appreciate the conceptual and aesthetic components simultaneously, much as they can in a more recent and very different sculpture: Anish Kapoor's *Cloud Gate*, which is the centerpiece of AT&T Plaza at Millennium Park in Chicago. It consists of 168 stainless steel plates, welded together and polished such that no seams are visible. The mirror-like exterior, inspired by liquid mercury, reflects and distorts the city's skyline. One can always debate how much of the credit for this sculpture should go to the person with the initial idea, to the engineers who provided the structural design, or to the firm that constructed it, but either way, one can appreciate both the concept and the aesthetic impact.

Many art theorists note additional nuances.[13] For example, their focus may be on audience interaction rather than an object. One can still, however, identify aspects of a work and appreciate them for what they are. If art resides in audience interactions, then presumably the artist's idea or execution must have facilitated this interaction, thereby providing a basis for evaluating the artist's contribution. If the art is all in the audience, then why should the artist get any credit for it? In principle, any individual may have a different definition of art, or emphasize different components of art. For any such individual of influence, it would be helpful if the definition were revealed, if the basis for evaluation were clarified, and if art theory and criticism were

provided with straightforward language. My current intent is not to analyze all art theory or elevate one definition above another, but to illustrate how one might use simple, straightforward expositions when possible.

In my view, there are two major, interconnected challenges in much art theory and criticism today: One is the multiplicity of art, but the other is the need to call a spade a spade. In the vast majority of cases, one can at least identify an idea and its execution, or the conceptual and aesthetic aspects of artworks, and one can evaluate each aspect on its own merits. At a recent art fair, for instance, I noticed some numbers hanging on the wall on the other side of a large hall. They were a Fibonacci sequence (i.e., a series in which each number is the sum of the two proceeding ones). Clearly, the artist did not deserve credit for the idea of the sequence; that credit belongs to mathematicians of the past. The idea of hanging some numbers on the wall did not seem original either. One possible contribution, in terms of execution, resided in how well the numbers had been attached to the wall. Perhaps other contributions escaped me, in which case another observer might have grasped them and explained them to me. The level of contribution is debatable, but at least the basis for that debate may be straightforward. As we have seen, however, market forces cause that basis to become muddled, leading to the conflation of disparate components of artworks. In turn, a muddled basis for evaluation facilitates the influence of money and marketing in the art world. It is a self-reinforcing cycle.

Consequences of Conflation

In some works, it can seem like a muddled basis for evaluation is much of the point. Much conceptual art is compatible with current, fast-paced societies, but it also relies on a heritage of art—all the intellectual and cultural weight of preceding generations, and all the gravity of customs and institutions—for its impact. Whether or not viewers have time to think critically, they expect meaning from work presented to them through channels such as galleries and museums. When Warhol presents a screen print or packaging replica of a consumer product, it is attention-worthy primarily because of a conflict between expectation and presentation. It is marketed as art, yet it does not fit with a traditional conception of art, rooted in aesthetic appreciation. Aesthetic qualities are more central to several of his other works. Most of them are simple, and an amateur artist with access to some photographs and screen-printing equipment should have little trouble making comparable works, yet the application of contrasting colors to familiar images results in what many viewers—including me—find to be aesthetically interesting. However, Warhol's Brillo boxes are considered interesting primarily because of context, and the label of Pop Art does not change the fact that their defining characteristic is conceptual in nature. The

underlying idea is straightforward: Typical non-art items exhibited as art defy our expectations and raise questions about the nature of art, cultural meanings, societal values, the ability to view an object in a new light, and so on. As such, Warhol's Brillo boxes are conceptual replicas of Duchamp's urinal, with the minor twist that they show the packaging rather than the actual product. The same notion has been replicated in countless versions throughout the past century. In other words, the mere categorization of a product as art has been used as a selling point at least a century after it ceased to be novel to do so.

Given the unclear basis for categorization, even courts of law are increasingly becoming involved in decisions about what art is.[14] For instance, a recent legal battle concerns one of Sol LeWitt's wall drawings. LeWitt conceived more than a thousand of them before his death in 2007, although he did not actually draw or paint them. Others did that. LeWitt merely wrote, on signed certificates, directions for how to execute them. The owner of one of his wall drawings sued a gallery that lost the drawing's certificate. The question therefore arises of what constitutes the artwork: the drawing or the instructions written on the signed certificate. The judge must arguably make that decision if damages are to be determined, and identifying the aesthetic or conceptual nature of this work would do much to clarify the judicial dilemma. If art is of an aesthetic nature, the formal execution is central, so the actual drawing represents the most important element. It does not necessarily follow that the instructions or signed certificate are worthless, but their worth has little to do with art. When attempting to determine damages for a lost certificate, a judge does not need to determine its artistic value, but only the market value. If, on the other hand, a conceptual perspective is favored, then neither the drawing nor the certificate is central to the artwork. If the drawing is lost, it can simply be remade from the instructions. The loss of the certificate only matters if the owner has failed to memorize the instructions or to make a photocopy of them. Either way, the certificate may still hold value, but that value is easier to gauge without murkiness surrounding the certificate's status as an artwork.

A similar argument can be applied to a dilemma regarding Damien Hirst's *The Physical Impossibility of Death in the Mind of Someone Living*. What happens to the artwork when this dead shark in formaldehyde begins to disintegrate? According to the aesthetics perspective, the actual, physical work matters. However, it does not take much creativity and skill to put a shark in formaldehyde, so the artistic value may be low according to this perspective. It should also matter little whether the original shark is exchanged with a new one. This latter observation is true for a conceptual perspective as well, since the shark is then merely a physical manifestation of an idea. However, this logic does not preclude consideration of other sources of value, such as branding.[15]

Another work involved in litigation is Cady Noland's *Cowboys Milking*.[16] The art dealer Marc Jancou sued Sotheby's and Noland for $26 million, because in 2011, Sotheby's had pulled the silkscreen print from auction at the last moment at the artist's request, due to minor damage. Sotheby's had agreed to sell *Cowboys Milking* and had estimated that it would fetch $250,000–$350,000, but right before the auction, Noland had reportedly disavowed the work. The suit was settled in Sotheby's' favor, and it may have been unrealistic from the outset, both because of Sotheby's contractual clause regarding the right to withdraw works from auction and because $26 million was several times higher than the record sales price of a work by Noland. However, it provides an interesting example regarding valuation. In terms of aesthetics, it matters little whether the artist disavows the work 20 years after making it. The work speaks for itself. The conceptual perspective holds that it is the idea that matters, but even with this perspective, the disavowal should only matter if we, the audience, are completely incapable of evaluating that idea. Once again, however, the disavowal has marketing implications, especially in terms of branding.

It does not follow from these examples that the categorization of artists and their works should be simplistic or that evaluation of their merit is easy. For example, LeWitt valued the conceptual above the perceptual, but he was sufficiently open-minded to consider other approaches valid. Further, although he personally emphasized the concept or idea of an artwork, whereas "the execution is a perfunctory affair," he did not think all conceptual art merits the viewer's attention. In his words, "Conceptual art is good only when the idea is good."[17]

Arguably, the intended purpose of an artwork should also inform evaluation. Many art enthusiasts sincerely believe that art can contribute meaningfully to our lives. It can enrich, uplift, and provide experiences that go beyond other daily activities. There is also much value in work that merely provides entertainment. However, when the function of art becomes to shock, provoke, or comment on society, with an implied seriousness of purpose, then it seems reasonable to evaluate it by a standard of usefulness. When allocating public funds, for instance, should we support this kind of art rather than the work performed by humanitarian or public awareness organizations? I cannot claim the right to answer that question, but I believe it is appropriate to ask it.

However we approach such issues, a clear basis for evaluating art seems essential. It does not necessarily matter which label we decide to put on different categories of works, unless the labels prevent us from identifying and contemplating the central qualities of those works. Aesthetic work and conceptual work might both be meaningful, but their central qualities, and thus the criteria for evaluating them, are different. This simple insight has substantial implications for various players in the art market.

Art Professionals and the Public

Consider, for example, the difficult position of critics. It is not a given that a critic is equally qualified to evaluate the aesthetic properties of a landscape painting and the philosophical and political meanings of a conceptual piece, unless that critic happens to have a solid education or background in both these areas. This poses a problem, since critics are typically expected to voice their opinions in areas in which they have relevant expertise.

Not all individuals who speak their mind on a given topic must be formally qualified to do so. For example, various celebrities opine vociferously on politics whether or not they are better qualified than the average citizen to do so. Their fame gives them a public platform, and they have the right to use that platform as they wish. Some of them are well informed and contribute constructively to political debate. Others demonstrate a poor grasp of the topics, much like some politicians do. Either way, the celebrities are not presented as political analysts but as civilians who just happen to have a public platform.

Critics, on the other hand, are presented as experts. It thus seems reasonable to expect capabilities that justify their position. For aesthetic work, we might expect scholars of art history or other individuals who have exposed themselves to a variety of aesthetic expressions and are able to write informatively on the topic. For conceptual work, we might expect a social scientist, a philosopher, a political analyst, or other person who demonstrably has the ability to clearly delineate concepts and critique the clarity and communicative strength of conceptual arguments. Preferably, the latter individual would also have broad and deep knowledge of history, physics, biology, psychology, anthropology, geopolitics, or whatever other topic the conceptual art involves. Since we are unlikely to find many polymaths of quite that caliber, we may need to make some compromises. At the same time, the art world can benefit from acknowledging the towering challenges facing critics, who cannot possibly have sufficient knowledge of all the topics relevant to their work.

A similar logic is applicable to museum curators, art professors, and committee members of various kinds who provide grants and awards or in other ways bestow funds and favors upon artists. In these cases, it is arguably even more important to be clear about the basis for judgment, because these individuals often use taxpayer money. Yet, as things currently stand, the same individuals may judge various works of disparate natures, without a clear, overarching basis for this judgment.

Young artists trying to find a suitable art education can be frustrated for similar reasons. Some of them might be talented sculptors or painters but end up at art schools where the instructors have little to teach them; instructors at prestigious art schools might be incapable of drawing a hand

or a decent portrait. Other students want to focus on conceptual work and are uninterested in learning how to draw, but they also may have little to gain from their schooling, unless their instructors are adequately trained in the relevant realms of conceptual analysis. This observation is not intended to belittle the contribution of educators, many of whom are hardworking and highly capable; it is intended to show that unclear conceptions of art have wide-reaching consequences. When there is little clarity about what art is, there is also little clarity about the qualifications needed to teach it. Having said that, clear job qualifications entail clear standards by which to evaluate educators, so one might therefore expect some of them to resist calls for clarity. However, I believe society at large would benefit. And, to reiterate, the current situation is not the fault of individual instructors or institutions; they are merely operating within the parameters that society has set for them.

As for museums and other public art venues, it seems equally useful here to identify the type of art under consideration and the type of criteria that form the basis for evaluation. After all, some kind of judgment must be made to decide which works to exhibit. It is—or at least in my view it should be— the responsibility of museum professionals to display work of the highest quality. Perhaps a pile of bricks on the floor, a jacket tossed in the corner, or bodily waste of various kinds represent outstanding accomplishments that are worthy of such display. In my personal opinion, they do not, but I cannot claim the right to make that decision. It is a question for society to resolve.

Public Funds and Incentives

The incentives provided by society influence the offerings provided by art professionals. For example, museum curators often see it as their function to collect and exhibit works that are representative of the dominant art trends. In other words, they may largely confine their focus to artwork pushed to prominence through successful marketing efforts, whether or not this is their intention. From a historical point of view, it makes some sense to display dominant trends, but one might at least question this practice for contemporary art. As we have seen, trends in the art world do not necessarily reflect contributions valued by society. As an alternative, curators could therefore be incentivized to focus only on quality, regardless of trends in the marketplace. If so, they may appear to reside in an ivory tower, but their expertise is presumably the reason why they have the position they do in the first place; it seems suboptimal to pay for that expertise but refuse them the autonomy to use it.

To put it in simple terms, there are at least two possible systems with arguable merits: An extreme free market system would remove all public funding, placing control of museums entirely in private hands. An alternative system allows a role for government funding, which can insulate independent

expertise from the influence of private money and marketing—as well as from politics, in the ideal scenario. However, a system that implicitly makes museums and curators subservient to money and marketing, while maintaining the illusion of independent expertise, combines the worst of both worlds.

In the latter system, a number of powerful players such as dealers and collectors have a substantial influence on the art market, and their activities gain additional exposure and prestige through the endorsement of public institutions such as art museums. This endorsement is often based on short-term incentives such as sponsorship or heavy discounts for work from fashionable artists. Casual museum visitors are not always sure what to expect from art, but they look to public institutions to provide them with meaningful experiences. If these institutions did not exist, individuals would need to develop their own opinions and seek out their preferred artworks, or they could opt to ignore art and focus on other pursuits. The market could adjust itself accordingly. This does not happen when we use public funds to subsidize private marketing efforts. Public institutions and public funding thus keep the market from adjusting to consumer demand and instead perpetuate market influences that would otherwise be confined to a narrower segment of consumers.

The art market and politics represent two salient examples of areas in which it can be a struggle to maintain divisions between private marketing efforts and public endorsements, but there are others. For instance, religious organizations can advance a narrative about creationism and intelligent design in religious contexts, but proponents of science believe that public science education should stick to science. In this view, those with expertise in science should plan and teach science classes, without interference from special interest groups. The basis for evaluating artworks will presumably remain unclear compared to the basis for evaluating content for a science curriculum, but the principle is similar. In my opinion, people should be able to trust that expertise guides public art institutions, regardless of private marketing efforts, whereas establishing that expertise seems problematic at best without the ability to define or characterize art.

If it seems like an exaggerated claim that visitors look to museums to educate them, Whitaker provides a telling observation made by Blake Gopnik of the Washington Post.[18] At a retrospective exhibition of Giacometti's work, Gopnik surreptitiously clocked viewers as they appreciated the various pieces of art. The average time spent reading the educational wall text was 50 seconds. The average time spent looking at a work of art was four seconds. The shortest time was zero seconds, noted for a woman who entered the room, spent almost a minute reading the educational wall text, and left without even glancing at the art.

Speaking of duration, it is occasionally suggested that museums could avoid transient market influences by only purchasing work that has stood the test of time. Contemporary museums flout this principle by purchasing works by living artists, thus directly influencing the career development of those artists as well as the marketplace in general. Although I agree with objections to this situation, I doubt whether a moratorium on contemporary purchases would rectify it, even if it were practically feasible to implement such a resolution. On the one hand, relying on the test of time would presumably counteract the integration of museum practices with the commercial interests of other players in the art market, at least to some extent. But on the other hand, marketing efforts can cause artists and artworks to become iconic, with or without the help of museums. Even if curators only purchased works from deceased artists, they would still need to make a judgment of the work while disregarding its prominence or iconic status.

Additionally, restricting purchases to work that has stood the test of time would cause museums to lose out on opportunities to buy art for low prices. In fact, the argument could be made that contemporary museums should increase their focus on the best work by lesser-known artists. In this way, taxpayers would avoid paying premiums resulting from the marketing activities and conspicuous consumption of influential players in the art market. This argument does not suggest that museums should avoid purchasing better-known works as well. However, such purchases could still be based on the characteristics and quality of the works rather than on marketing activities.

A similar argument is applicable to other organizations that involve public funds. For example, there has been much controversy surrounding the National Endowment for the Arts. This independent agency of the United States federal government is "dedicated to supporting excellence in the arts, both new and established; bringing the arts to all Americans; and providing leadership in arts education."[19] But politicians as well as the general public tend to disagree vehemently about what constitutes excellence in the arts. Some therefore call for the NEA to be abolished, while others believe its funding should be increased.

There is often a system of peer review in place, even for organizations such as the NEA, but this observation brings us back to the difficulty of making quality assessments for contemporary art. In other fields, such as social or natural sciences, it is easier to be objective. We know the concepts and findings that already exist in the literature, and this knowledge provides much of the basis on which to evaluate the novelty and importance of a subsequent concept or finding. We are familiar with statistics and empirical research procedures, so we have a reasonable basis for judging the rigor and appropriateness of procedures used by peers. The system is by no means

perfect, but at least it has a reasonable basis, whereas it is challenging to come up with a comparable basis for art.

Regardless of such challenges, the situation would be less problematic if it pertained to most ordinary markets, because then the buyers vote with their wallets, and the market adjusts itself accordingly. When the public wallet is opened, however, there is cause to be critical.

Decisions and Trade-Offs

The issue of costs pertains not only to the salaries of professionals such as museum curators, but to the construction and maintenance of buildings, the acquisition and display of artworks, and all the other expenses associated with making art available to the public. Every decision made regarding the use of funds involves trade-offs. A dollar spent on a given exhibition is a dollar less to spend on another exhibition, or on refurbishing a building, improving infrastructure, caring for the sick and elderly, or any of the innumerable other options for public spending. Although many members of society presumably care little about art, enough of us do that we collectively expend a great deal of resources on it. It therefore seems sensible to make the trade-offs transparent and to incentivize decision makers to act in accordance with our goals, which depend on our conception of art and the basis for its evaluation.

If curators are judged by the market appeal of their acquisitions, they are likely to simply acquire highly marketable works with whatever means they have at their disposal. Even if there is a public outcry over shocking or questionable works, the controversy will predictably boost the visibility of the artist, which usually also translates to stature and high prices. Therefore, controversial choices often end up making the curator appear prescient. Given the current system, works that seem controversial to the general public may in fact be very safe choices. Curators may also avoid being blamed for acquisitions that decrease rather than increase in prominence and value, as long as the works were representative of current trends. Their actions are then easily defensible. Choices based on quality assessments are more difficult to defend, especially if we do not identify the basis on which to make those judgments.

In my view, artists can and should disregard standards that restrict artistic freedom, but it seems reasonable to expect some level of creativity and skill in work we pay for with public funds. The alternative is not intellectual and artistic freedom or liberation from the shackles of the past. The alternative is merely a one-sided reliance on marketing. There may never be a perfect system for assessing the quality of art found in galleries or museums, nor is there one for assessing the quality of music, dance, gymnastics, or similar endeavors. However, making an active attempt to improve on the current

system seems better than deferring to factors such as commercial interests or conspicuous consumption. As it is now, we use taxpayer money to subsidize the interests of influential market players while maintaining the illusion of museums as independent strongholds of culture.

An Optimistic Outlook

These observations need not result in pessimism. On the contrary, most of us who engage in the ongoing discussions about the role of art in the world probably do so because we believe in its potential to contribute meaningfully to human lives. And that potential can grow in the soil of diversity. For instance, some of my own research indicates that relatively simple, easily understood art can enhance the sense that life is happy, whereas relatively complex, challenging art can enhance the sense that life is meaningful;[20] I would argue that both outcomes are worthwhile.

Despite the many failings of contemporary societies, despite disparities in wealth and opportunity, and despite ongoing and future calamities such as pandemics, wars, and climate crises, humankind on the whole is currently enjoying a higher level of peace and prosperity than it has through the broad sweep of history.[21] A number of cultures have been instrumental in a great deal of progress, whether in terms of practical issues such as technological advances and material wealth, or in terms of ideals such as civil liberties and eschewal of violence. Much remains to be done, many parts of the world are burdened with poverty, ignorance, strife, and disease, and even the wealthiest of nations have serious problems with which to contend. But culture can reflect a forward-thinking and goal-oriented perspective. In turn, whether we continue on a trajectory of peace and prosperity or we face natural or manmade disasters in the future, art can contribute positively to that culture.

To reiterate, however, this role is more likely to be positive if notions of art become clearer than they currently appear to be in much of the art world. Among my proffered opinions, the abundance of which may perhaps test the patience of some readers, I have suggested two basic steps forward. First, we can more consistently distinguish between art and the art market; art, money, and marketing can all contribute positively to society, but they are less likely to do so if we fail to acknowledge their respective functions. Second, we can utilize straightforward definitions of art, thereby also providing an intelligible basis for evaluation. The latter step is likely to include a consistent recognition of differing bases for evaluating and appreciating aesthetic and conceptual components in artworks. Many participants in the art world presumably hold these views already—they are not very complicated views, and I fail to see why they should be controversial—but the systemic change that should logically follow from them has yet to materialize. For that change to occur, the views must probably be held by a critical mass of interested

parties or by key individuals in positions of power—a development to which I hope this book might contribute. Other observers may also highlight other components of art or interactions thereof, and in that case, one would only hope that they can explain what those components are, preferably with plain, comprehensible language.

This perspective does not restrict artistic freedom or suggest that artworks should become objects of cold, methodical analysis rather than doorways to exploration and related meaningful experience. Picasso once noted, "Art is a lie that makes us realize truth."[22] Of that phrase's various possible meanings, one is that art may not represent a coherent, objective reality but nonetheless a sensory and metaphysical truth. Many of us sometimes lose track of time and space in the presence of artworks, be they famous or unknown. In this sense, it may not matter whence art comes or how it is defined. It touches us in ways that are meaningful, whether or not we can clearly identify and understand these ways or communicate them to others. Nonetheless, the wonder of art is not compromised by attempts to clarify what it is or how it affects us. On the contrary, my hope is that such attempts will broaden and deepen our appreciation of art.

6

AFTERWORD

Some Additional Reflections on Art Theory

After all this talk about the art world, and given the difficulties arising from unclear conceptions of what art is, some readers may wonder why we have such disparate notions of art in the first place. One reason has to do with the ponderings of theorists on the topic. As the proverbial muses have struggled, influential pundits have made sense of that struggle and characterized its outcomes. These pundits have not always agreed with each other's perspectives, as illustrated by divergent observations through the ages. For instance, Nietzsche observed that "Plato was a bore,"[1] whereas Tolstoy observed that Nietzsche was "limited and abnormal."[2] Given this background, it may be worthwhile to take a stroll through some of the history that informs art theory. Rather than a detailed analysis replete with references to eclectic source material, this will be a very brief summary intended for general readers who may not have a well-developed background in the history and theory of art.

Historical and Contemporary Notions about Art

Disagreements about the categorization and value of art have been ongoing for quite some time, whereas the modern distinction between art and craft was virtually nonexistent until recently.[3] In the middle ages, music was often classified along with math, while poetry was grouped with rhetoric and grammar, and painting and sculpture were taught in artisans' guilds. In the mid-18th century, Abbé Batteux presented a separate category of fine arts consisting of music, poetry, painting, sculpture, and dance. A characteristic of these disciplines was their goal of pleasure rather than utility.[4] With time, the arts became tied to cultural institutions, with government support, private

DOI: 10.4324/9781003531340-6

donations, and commerce facilitating the employment of experts to manage and market them. Today, there is still a notion that art represents a unique category of some kind, although the definition of that category is a perpetual subject of debate.

Leonardo da Vinci once pointed out, "Anyone who conducts an argument by appealing to authority is not using his intelligence; he is just using his memory."[5] By quoting this maxim, I may be in danger of illustrating his point, but some well-known individuals have either developed or popularized perspectives on art as a distinct product category, so we shall briefly consider some of their musings.[6]

Art and Nature

Introductions to the philosophy of art typically begin with the ancient Greeks, several of whom characterized art as imitation of nature. Plato (c. 428–347 BCE) speaks of visual images, beauty, and poetry, but he does not operate with anything resembling most current conceptions of art. The word *techné* is often translated as art, but it refers to a general understanding of principles, or the knowledge required to get something done, which today could apply as much to the art of repairing a carburetor as it would to the art of sculpting marble. Further, Plato is typically interpreted as conceding little or no value to artworks. In his *Republic*, he calls for the arts (or poetry, as it were) to be censored for the good of the people.[7] In Plato's view, forms, or ideal archetypes, are thought to govern and structure reality, and the physical world experienced by mankind consists of mere imitations of these archetypes. Worse yet, arts such as painting, sculpture, and poetry are considered imitations of imitations.[8]

Somewhat like Plato, Aristotle (384–322 BCE) discusses the arts as imitation—as *mimesis*. However, as is evident in his *Poetics*, he affords this activity value and has a more positive view of the arts, especially in regard to tragic drama.[9] The notion of art as imitation is also evident in later, more practical writings, such as treatises by Leon Battista Alberti (1404–1472). In *De Re Aedificatoria*, although largely dependent on Vitruvius' *De Architectura*, Alberti draws on both Plato and Aristotle.

The topic of nature, and especially beauty, remains central into the age of empiricism. In his *An Inquiry Concerning Beauty, Order, Harmony, Design*, Francis Hutcheson (1694–1746) ponders the source of the pleasure we take in beauty. The question is two-fold: What is its source in us, and what is its source in objects? The first answer is that we have an internal sense that allows us to take pleasure in beauty, harmony, and proportion. The second answer is that objects of beauty represent uniformity amidst variety. The first answer is possibly of greater historical importance; it reminds us that the secret to understanding human experience may be found in the inner

workings of humans themselves. Thus, while Plato and Aristotle perceive artworks as a reflection of actual or potential nature, Hutcheson focuses on the human nature that enables an appreciation of such works.

David Hume (1711–1776), a fellow Scottish philosopher, similarly asks whether there are objective standards for assessing the quality of artworks. He asserts that certain features of artworks appeal to universal aspects of human nature, leading to broad agreement about the beauty or quality of certain works, although he also acknowledges that factors such as culture or individual psychological traits can interfere with the natural ability to appreciate the beauty of a high-quality work of art. Notably, both Hutcheson and Hume predate later views of aesthetics rooted in evolutionary theory. Human nature is here at the core of art appreciation.

Art and Understanding

Immanuel Kant (1724–1804), in his *Critique of Judgment*, also chimes in regarding Hume's antinomy: How can apparently feelings-based and subjective judgments of artistic merit be considered objective or factual?[10] Kant attempts to reconcile this paradox by claiming that the pleasure involved in aesthetic judgments is unlike the pleasure associated with the fulfillment of personal interests or desires. The *disinterested* pleasure of aesthetic judgments derives from the mere contemplation of the focal object. The *form* of this object causes the imagination and the understanding to coincide in a special kind of harmony, and this free play of the faculties causes a particular kind of pleasurable feeling, leading to the judgment that the object is beautiful. The aesthetic pleasure depends on the most general structure of the human mind, and thus it is universally applicable to human beings. When contemplating a beautiful object, anybody equipped with standard human perceptual and cognitive faculties experiences this pleasure. Thus, although aesthetic judgments do not meet the rigorous requirements for empirical knowledge set forth in Kant's *Critique of Pure Reason*, they are nonetheless presumed to have objective validity.[11] Diverging somewhat from Kant's views, later compatriots such as G. W. F. Hegel (1770–1831), Arthur Schopenhauer (1788–1860), and Martin Heidegger (1889–1996) characterize art as a source of metaphysical discovery and knowledge, whereas Friedrich Nietzsche (1844–1900) similarly assigns great significance to art, claiming that "it is only as an aesthetic phenomenon that existence and the world are eternally justified."[12]

Art and Institutions

Focusing more on the societal role of art, the Russian novelist Leo Tolstoy (1828–1910) emphasizes its role as a channel to communicate an artist's

feelings.[13] His socialist values are apparent in his criticism of elitism in the arts, and in his rejection of the idea that artists should only be concerned with the creation of beauty. The views of Theodor Adorno (1903–1969) are similarly associated with a sociopolitical agenda; opposition to capitalism underlies his outlook and that of other Marxist philosophers and social theorists known as the Frankfurt School. In their view, art can fuel aspirations for freedom where capitalism attempts to restrict it. Art not only brings beauty to our awareness, but it also causes us to compare this beauty with the oppressive world in which we live. But even art is vulnerable to capitalism. Under the influence of the *Culture Industry*, art becomes mere entertainment to assuage those who toil under the burden of the capitalist system, and thus it may contribute to their repression rather than their liberation.[14] Adorno's essays often read more like political propaganda than philosophy of art, and he sometimes seems to underestimate the capacity of average members of society to think for themselves. Like Walter Benjamin, however, he makes some timely observations about the role of factors such as mass production in the transformation of the art market. For instance, he argues that a society could have the illusion of plentiful diversity in artistic creation, whereas reality may rather reflect a commoditization of art where everything is just more of the same.

The notion of commoditization also interests Arthur Danto (1924–2013), in that he gauges the merit of artworks that are indistinguishable from ordinary consumer products. In his essay entitled *The Artworld*, he famously attempts to justify as art Andy Warhol's *Brillo Box*, a replica of a Brillo carton of soap pads found in the supermarket. Danto's solution involves two closely related elements. The first of these entails the presence of art theory: An object is a work of art because of the existence of a theory and interpretation that says it is, even if it is perceptually indistinguishable from an object that is clearly not art. The second element entails the existence of the artworld, comprised of "an atmosphere of artistic theory, a knowledge of the history of art."[15] In other words, to understand an object as an artwork, one must be knowledgeable about the history and theory of art.

George Dickie (1926–2020) expands on the notion of the artworld to form the Institutional Theory of Art. In *Art and the Aesthetic*, Dickie discusses the apparent inability of previous theories to specify necessary and sufficient conditions for conferring the status of art on an object.[16] Therefore, the artworld as an institution confers this status. The artworld is made up of the practices of artists, critics, curators, art historians, philosophers of art, and so on, and these members of the artworld perpetuate the social institution of art. According to Dickie, his institutional theory overcomes the shortcomings of previous theories, as well as Morris Weitz's observation that art inherently evolves and innovative artworks constantly disrupt the existing categories, thus making definitions impossible.

Art, Artist, and Audience

Unlike Danto and Dickie, John Dewey (1859–1952) demonstrates a lack of reverence for the historical and institutional context of artworks. In fact, although he assigns a special position to art, he views its features as not fundamentally distinct from other "ordinary" aspects of human life. Through our conscious appreciation of the complete process of creation, described by Dewey as an *experience*, art reflects the possibilities inherent in human productive life.

Further, the perceiver of the artwork undergoes a process akin to the artist's act of creation.[17]

Monroe C. Beardsley (1915–1985) similarly emphasizes the act of creation in defining an artwork. He also argues that a definition of art is absolutely necessary. Otherwise, there is no criterion upon which critics can base their reviews, funding agencies can base decisions for the allocation of money, art historians can base judgments of historical significance, and anthropologists can base cultural analyses involving artistic activities. In Beardsley's view, the artist's intention decides an object's status as art. In other words, an object is art because the artist created it with the intention to satisfy an aesthetic interest. However, Beardsley does not believe an author's intentions are relevant for understanding the meaning of that author's work. Note that these two latter statements do not conflict, even when one extrapolates from literature to other arts such as painting or sculpture. One might say that art is typically conceived via an intuitive, exploratory process, while the parts of the creative process that require most conscious control pertain to the craftsmanship involved in skillful execution, not to any specific meaning that the artwork should convey. Thus, while aesthetic interest may characterize artistic creation, this does not imply that any intended meaning on the part of the artist is necessary for, or even relevant to, a reading of the resulting artwork.

Whether this aesthetic interest lies in the artist or the viewer, Clive Bell (1881–1964) argues that the formal properties of objects make them art.[18] This formalism may be traced back to Kant and beyond, but with Bell, it becomes more resolute. In his view, nothing other than *significant form* is relevant to the assessment of an object or performance as an artwork. Significant form pertains to the arrangement of lines, colors, shapes, volumes, vectors, and space. Thus, Bell departs from previous views of art as imitation of nature, at least in a narrow sense of this concept that precludes abstraction and deconstruction. He does not deny that many paintings are representations, but the representational content does not influence whether they qualify as art. Whether or not the artist exhibits any commitment to verisimilitude, what the painting represents, or whether or not it possesses any representational content at all, are always strictly irrelevant to the painting's status as a work of art. This standpoint may be especially comprehensible if we consider

the various forms of Post-Impressionist painting that influenced Bell. Post-Impressionism, a term coined by Roger Fry, tends toward an emphasis on geometric forms, the distortion of form for expressive effect, and the use of unnatural or arbitrary color.

As Noël Carroll notes, Bell also contrasts with expression theories of art, which focus on the expression of the creator's emotions.[19] For instance, a Post-Impressionist still life by Cézanne may display an arresting formal design but express no detectable garden-variety emotions. This might seem to put Bell at odds not only with commentators in the vein of Tolstoy, but also with R. G. Collingwood (1889–1943). In *The Principles of Art*, Collingwood asserts that an artwork exists only in the artist's mind, and that it is an expression of the artist's emotion.[20] Artists give form to their feelings via creation, so one might say that the work involves a kind of self-exploration. However, there is no irreconcilable conflict between this view and the view that physical objects resulting from the creative process are distinguished primarily by the formal qualities they exhibit. In line with Collingwood's argument that the work of art exists only in the imagination and must be recreated in the mind of the audience, it seems reasonable that a perception of the significant form resulting from the artist's journey of self-discovery would be precisely the means by which a later viewer of the physical art object could recreate such a journey.

These notions resonate with the views of Hutcheson and Hume, as well as those of Dewey and Beardsley. However, they rely on a common human nature shared by the artist and the audience. To this day, there is much resistance to this notion, but the accumulated scientific evidence leaves little room for doubt about a plethora of behaviors rooted in human nature; art may be one of them.

Artist, Audience, and Evolution

Researchers such as Ellen Dissanayake rely on evolutionary theory to explain the ubiquitous existence of art across societies.[21] Dissanayake asserts the futility of trying to understand deep-rooted human drives by considering only the last few millennia, not to speak of just the last few decades, when these drives have evolved through millions of years and under circumstances much different than the ones we live in today. She argues that a one-sided emphasis on current societal trends in analyses of human behavior such as art creation and appreciation is akin to constructing an understanding of how the Grand Canyon was shaped by casting a glance at only the topmost stratum.

Evoking slightly different imagery, she states it thus:

> What we are conscious of, what we intellectually discern of our experiences of the arts, takes place only at the point from which the water wells out. Its

sources and unique flavors come from forgotten commingling subterranean streams that have traveled through residues of rocky deposits far away, in our own prelinguistic prehistory.[22]

Dissanyake discusses what she calls *artification*, previously termed *making special*, as a universal human behavior that evolved through prehistory, tied especially to religion and ritual ceremonies. In this view, the arts developed from the urge to make important objects and activities special. This tendency was the beneficiary of natural selection because it contributed to solidarity and cohesiveness in groups, thus increasing survival fitness. Interestingly, and perhaps incongruously, an emphasis on community can also be found in perspectives such as relational aesthetics, which otherwise appear to have little in common with Dissanayake's views.[23]

Without subscribing to the group cohesiveness argument, Denis Dutton similarly argues that natural selection shapes the human propensity to engage in artistic activities. The use of the word *instinct* in the title of his book *The Art Instinct* clearly flies in the face of the art theoretical writings that would explain human tastes in the arts as being a socially constructed phenomenon.[24] While Dissanayake presents a more focused thesis of art associated with ritual ceremonies, Dutton takes a broader approach in explaining antecedents to, and implications of, human artistic behavior. He is skeptical to the social cohesiveness argument and the case for group selection as the evolutionary principle behind the development of the arts. He emphasizes the need for individuality in the arts, and he discusses how this individuality is evident in art around the globe. Whether emphasizing groups or individuals, both authors agree that art stems from a common source. It should therefore be possible to identify its distinct characteristics.

Definitional Confusion

By the mid-20th century, however, many writers maintained that a definition of art, in terms of necessary and sufficient conditions, could not be established. For instance, the aforementioned Weitz emphasized that art must always be open to change and novelty. Some have held that this stance is incompatible with any fixed definition of art. In my view, there is no such contradiction. Contemporary math differs from math done by Archimedes, yet it is not difficult to come up with a definition that fits both activities. Similar arguments can apply to art. Nonetheless, Weitz and others have suggested family resemblances as an alternative way to identify artworks. In other words, when confronted with an object with uncertain art status, we should compare it to other works that are broadly considered art. If the new object sufficiently resembles such examples, then the new object is also art.

There are obvious difficulties inherent in this approach. Who decides what the established examples are? What are the criteria along which something must resemble something else? These questions bring us back to the need for clear parameters. Is a decapitated head art because Cellini's *Perseus* features a decapitated head? Is a doorknob art when it is made of bronze, because some sculptures are made of bronze? These types of comparisons quickly seem absurd, and they demonstrate the shortcomings of the family resemblance argument.

The family resemblance argument may nonetheless have intuitive appeal because it reflects the art market; it can explain the lack of restrictions on what is exhibited as art today. If one contemplates an object that resembles an established artwork, then that new object becomes part of the accepted canon of artworks. The next object need only resemble the newest member of artworks, and fairly soon everything is accepted. Further, as Noël Carroll notes, it is a truism of logic that everything resembles everything else in some respect.[25] So even if we begin with works that everyone agrees are art, then all objects become art as fast as we are able to think of them. We might say that the resemblance argument should be restricted to certain aspects of artworks, but deciding what those aspects are puts us back in the business of defining.

So how are we to resolve this conundrum? How can one identify defining characteristics of any category of objects or behavior if everything is in flux? To start, one might point out that permanent openness to change within certain parameters does not also demand that the parameters be flexible. Thus, the parameters could form the basis for a definition of art. In any case, it did not take long before the arguments against definitions of art were contested. Notably, Danto and Dickie reopened the prospects for defining art, so these writers were instrumental in paving the way for further thought in contemporary art theory.

Having said that, Danto and Dickie led philosophy of art in a questionable direction. Their view reflects the increasingly dominant role of marketing in the art world. Danto argues that art status depends on the genesis of artworks in art theories and art narratives. Dickie expands on this notion and emphasizes the social character of art, with the artworld being the historical and social setting of the changing practices and conventions of art, the heritage of works, the intentions of artists, the writings of critics, and so on.[26] Rather than saying that something is art because it resembles something else that is art, the legacy of Danto and Dickie effectively boils down to the notion that something is art because someone with influence says it is art, regardless of the basis for that influence. Danto and Dickie are not wrong, in the sense that their view reflects current reality, if we understand as art, all those objects and activities that are endorsed as art by a given art community. In my opinion, however, this observation is of limited use, not only because

it entails a circular argument, but also because it says nothing about the characteristics of the category of art.

Imagine an exhibit of rare birds in which someone decides to display a coffee cup and call it a bird. The exhibited cup causes a big fuss, creates a lot of media attention, and is sold for a large amount of money, and the exhibitor is proclaimed a genius for having come up with such a novel and impactful bird. Why is this not a likely event? Presumably, everyone can see that a cup is just a cup and not a bird. There would be no talk of how the cup challenges the existing notions of what a bird is. We have a clear understanding of what a bird is; biology provides the category, and the average person can recognize its characteristics. There may be some fringe examples that are slightly atypical, such as ostriches or penguins, but few observers would argue that we should call a cup a bird, or that it is remotely interesting to do so.

The category or art, however, is both unclear and continually updated. It is constantly changing, adapting to the most recent additions to the body of existing artworks. That is why anyone with influence can proclaim whatever they want as art, and it is difficult for anyone else to refute that claim. The implication of Danto and Dickie, at least as they are commonly interpreted, is that this state of affairs should not only be tolerated but also endorsed as right and proper. Danto and Dickie may or may not have intended such an interpretation, but their views can certainly be used to counter attempts to define art in terms of specific characteristics.

This line of thinking is also reflected in the writings of contemporary philosophers of art such as Carroll. When commenting on formalism, Carroll questions whether significant form can be a necessary condition for art status, since modern art includes many examples of found or so-called ready-made objects, which are selected and exhibited as artworks to provoke conceptual insights.[27] These objects are often devoid of what one would call significant form. Among Carroll's many thoughtful and nuanced perspectives, this particular argument seems to approach the question of art status from the wrong end. It suggests that rather than defining the category of art based on clear characteristics, we should uncritically accept as part of this category whatever objects someone happens to call art, for whatever reason. Based on these objects, we should then proceed to disqualify the reasoning of a meticulous theorist such as Bell. In the aforementioned example of cups and birds, one might say that feathers and beaks are no longer a necessary condition for bird status, since the cup exhibited as a bird had neither feathers nor beak.

Why should a philosopher of art accept such an artificially constructed category rather than attempt a deeper analysis of fundamental characteristics of art? My argument here is not that any specific definition of art is superior, or even that definitions must be permanent; words and meanings change as

cultures evolve. My argument is merely that art theory need not be bound to the art market, much like philosophy in general need not be dictated by marketers. Despite being profoundly appreciative of free business enterprise and the immense amount of good that it does for billions of people around the world, I see no reason why business should define art. The art world is more than the art market.

NOTES

1 INTRODUCTION

1 William Shakespeare (1600/2008), *Henry V*. New York, NY: Oxford University Press.
2 Douglas Adams (1980/2008), *The Restaurant at the End of the Universe*. New York, NY: Del Rey.
3 Henrik Hagtvedt, Reidar Hagtvedt, and Vanessa M. Patrick (2008), "The Perception and Evaluation of Visual Art," *Empirical Studies of the Arts*, 26 (2), 197–218. doi.org/10.2190/EM.26.2.d; Henrik Hagtvedt and Vanessa M. Patrick (2008), "Art Infusion: The Influence of Visual Art on the Perception and Evaluation of Consumer Products," *Journal of Marketing Research*, 45 (June), 379–89. doi.org/10.1509/jmkr.45.3.379; Henrik Hagtvedt and Kathleen D. Vohs (2017) "Art Enhances Meaning by Stimulating Integrative Complexity and Aesthetic Interest," *Behavioral and Brain Sciences*, 40, 30–1. doi:10.1017/S0140525X17001728; Simon Lacey, Henrik Hagtvedt, Vanessa Patrick, Amy Anderson, Randall Stilla, Gopikrishna Deshpande, Xiaoping Hu, João R. Sato, Srinivas Reddy, and Krish Sathian (2011), "Art for Reward's Sake: Visual Art Recruits the Ventral Striatum," *NeuroImage*, 55 (1), 420–33. doi.org/10.1016/j.neuroimage.2010.11.027
4 Clare McAndrew (2024), *The Art Basel & UBS Art Market Report 2024 by Arts Economics*, Switzerland: Art Basel and UBS.
5 Maria Lind and Olav Velthuis (2012), *Contemporary Art and its Commercial Markets: A Report on Current Conditions and Future Scenarios*. Berlin, Germany: Sternberg Press.
6 Jared Diamond (1999), *Guns, Germs, and Steel*. New York, NY: Norton.

2 A FEW MARKETING PRINCIPLES

1 Geoffrey Miller (2009), *Spent*. New York, NY: Viking; For an overview of the role of evolution in numerous spheres of marketing, see also Gad Saad (2007),

The Evolutionary Bases of Consumption. Mahwah, NJ: Lawrence Erlbaum Associates.
2 Bryan A. Lukas, Gregory J. Whitwell, and Jan B. Heide (2013), "Why Do Customers Get More Than They Need? How Organizational Culture Shapes Product Capability Decisions," *Journal of Marketing*, 77 (1), 1–12. DOI: 10.2307/41714526
3 Glen L. Urban and John R. Hauser (2004), ""Listening In" to Find and Explore New Combinations of Customer Needs," *Journal of Marketing*, 68 (2), 72–87. DOI: 10.1509/jmkg.68.2.72.27793
4 Fornell, Claes, Forrest V. Morgeson III, and G. Tomas M. Hult (2016), "Stock Returns on Customer Satisfaction Do Beat the Market: Gauging the Effect of a Marketing Intangible," *Journal of Marketing*, 80 (5), 92–107. doi.org/10.1509/jm.15.0229
5 Henrik Hagtvedt and Vanessa M. Patrick (2009), "The Broad Embrace of Luxury: Hedonic Potential as a Driver of Brand Extendibility," *Journal of Consumer Psychology*, 19 (4), 608–18. doi.org/10.1016/j.jcps.2009.05.007
6 Young Jee Han, Joseph C. Nunes, Xavier Drèze (2010), "Signaling Status with Luxury Goods: The Role of Brand Prominence," *Journal of Marketing*, 74 (4), 15–30. doi.org/10.1509/jmkg.74.4.015
7 Dhruv Grewal and Michael Levy (2021), *Marketing*, 8th edition. New York, NY: McGraw Hill; Philip Kotler and Kevin Lane Keller (2015), *Marketing Management*, 15th edition. New York, NY: Pearson.
8 Alexander Chernev and David Gal (2010), "Categorization Effects in Value Judgments: Averaging Bias in Evaluating Combinations of Vices and Virtues," *Journal of Marketing Research*, 47 (4), 738–47. doi.org/10.1509/jmkr.47.4.73; J.-P. Vergne and Tyler Wry (2014), "Categorizing Categorization Research: Review, Integration, and Future Directions," *Journal of Management Studies*, 51 (1), 56–94. doi.org/10.1111/joms.12044
9 Louise Norton (1917), "The Richard Mutt Case," *The Blind Man*, 2 (May), p. 5.
10 BBC News (2004), "Duchamp's Urinal Tops Art Survey," http://news.bbc.co.uk/2/hi/entertainment/4059997.stm.
11 Catherine Milner (2002), "The Tate Values Excrement More Highly than Gold," *The Telegraph*, June 30, www.telegraph.co.uk/news/uknews/1398798/The-Tate-values-excrement-more-highly-than-gold.html.
12 "Record per 'Merda d' Artista' di Manzoni: 275mila euro per la Scatoletta n. 69," *La Stampa*, December 8, 2016, www.lastampa.it/cultura/2016/12/08/news/record-per-merda-d-artista-di-manzoni-275mila-euro-per-la-scatoletta-n-69-1.34752641.
13 Stephen Davies (2007), "Definitions of Art," in *The Routledge Companion to Aesthetics*, ed. Berys Gaut and Dominic McIver Lopes, New York: Routledge; George Dickie (1984), *The Art Circle*, New York: Haven.
14 IBISWorld (2019), "Global Movie Production & Distribution Industry: Market Research Report," September, www.ibisworld.com/global/market-research-reports/global-movie-production-distribution-industry/.
15 Henrik Hagtvedt and Vanessa M. Patrick (2011), "Fine Arts," in *Encyclopedia of Consumer Culture*, Dale Southerton, ed. Los Angeles, CA: Sage.
16 Clare McAndrew (2024), *The Art Basel & UBS Art Market Report 2024 by Arts Economics*, Switzerland: Art Basel and UBS.

17 The Art Newspaper (2004), "Art Newspaper Readers' Questions," www.saatchi-gallery.co.uk/charlesqa/qa.htm.
18 Frank O'Hara (1965), *Robert Motherwell*. Garden City, NY: Doubleday.
19 Philip Kotler and William Mindak (1978), "Marketing and Public Relations," *Journal of Marketing*, 42 (4), 13–20. doi.org/10.1177/002224297804200402
20 The Art Newspaper (2004), "Art Newspaper Readers' Questions," www.saatchi-gallery.co.uk/charlesqa/qa.htm.
21 Simona Botti (2000), "What Role for Marketing in the Arts? An Analysis of Arts Consumption and Artistic Value," *International Journal of Arts Management*, 2 (3), 14–27; François Colbert (2014), "The Arts Sector: A Marketing Definition," *Psychology & Marketing*, 31 (8), 563–65. doi.org/10.1002/mar.20717; Annamma Joy and John F. Sherry (2003), "Disentangling the Paradoxical Alliances between Art Market and Art World," *Consumption, Markets and Culture*, 6 (3), 155–81. doi.org/10.1080/1025386032000153759; Daragh O'Reilly and Finola Kerrigan (2010), *Marketing the Arts: A Fresh Approach*. New York, NY: Routledge.
22 Elizabeth C. Hirschman (1983), "Aesthetics, Ideologies and the Limits of the Marketing Concept," *Journal of Marketing*, 47 (summer), 45–55. doi.org/10.1177/002224298304700306
23 Andy Warhol (1975), *The Philosophy of Andy Warhol (From A to B and Back Again*. San Diego, CA: Harcourt Brace.
24 Ann Landi (2007), "Top Ten ArtNews Stories: How Jeff Koons Became a Superstar," *ArtNews*, November 1, www.artnews.com/2007/11/01/top-ten-artnews-stories-how-jeff-koons-became-a-superstar/.
25 Robert Jacobson and David A. Aaker (1987), "The Strategic Role of Product Quality," *Journal of Marketing*, 51 (4), 31–44. doi.org/10.1177/002224298705100404
26 Gokhan Ertug, Tamar Yogev, Yonghoon G. Lee, and Peter Hedström (2016), "The Art of Representation: How Audience-Specific Reputations Affect Success in the Contemporary Art Field," *Academy of Management Journal*, 59 (1), 113–34. doi.org/10.5465/amj.2013.0621
27 Richard G. Tansey and Fred S. Kleiner (1996), *Gardner's Art through the Ages*. Orlando, FL: Harcourt Brace.
28 Farago, Jason (2019), "A (Grudging) Defense of the $120,000 Banana," *New York Times*, December 8, www.nytimes.com/2019/12/08/arts/design/a-critics-defense-of-cattelan-banana-.html.
29 Michael J. Barone and Robert D. Jewell (2013), "The Innovator's License: A Latitude to Deviate from Category Norms," *Journal of Marketing*, 77 (1), 120–34. doi.org/10.1509/jm.10.0145; see also Peter Drucker F. (1998), "The Discipline of Innovation," *Harvard Business Review*, 76 (6), 149–57.
30 Teresa M. Amabile (1988), "A Model of Creativity and Innovation in Organizations," *Research in Organizational Behavior*, 10, 123–67.
31 Beard, Mary and John Henderson (2001), *Classical Art: From Greece to Rome*. Oxford, UK: Oxford University Press; Thomas R. Martin (1996), *Ancient Greece: From Prehistoric to Hellenistic Times*. New Haven, CT: Yale University Press.
32 Beard, Mary (2015), *SPQR: A History of Ancient Rome*. New York, NY: Liveright Publishing Corporation; Nancy H. Ramage and Andrew Ramage (2015), *Roman Art: Romulus to Constantine*. Upper Saddle River, NJ: Pearson.

33 Morris Bishop (2001), *The Middle Ages*. Boston, MA: Mariner Books.
34 Paul Frankl and Paul Crossley (2000), *Gothic Architecture*. New Haven, CT: Yale University Press.
35 J. H. Plumb (1991), *The Penguin Book of the Renaissance*. London, UK: Penguin Books.
36 Robert B. Zajonc (1980), "Feeling and Thinking: Preferences Need No Inferences," *American Psychologist*, 35 (2), 151–75. doi.org/10.1037/0003-066X.35.2.151
37 Derek Thompson (2017), *Hit Makers: The Science of Popularity in an Age of Distraction*. New York, NY: Penguin Press.
38 Rolf Reber, Norbert Schwarz, and Piotr Winkielman, (2004), "Processing Fluency and Aesthetic Pleasure: Is Beauty in the Perceiver's Processing Experience?" *Personality and Social Psychology Review*, 8 (4), 364–82. doi.org/10.1207/s15327957pspr0804_3
39 Daniel E. Berlyne (1971), *Aesthetics and Psychobiology*, New York, NY: Appleton-Century-Crofts; Daniel E. Berlyne (1974), *Studies in the New Experimental Aesthetics: Steps toward an Objective Psychology of Aesthetic Appreciation*, Washington, DC: Hemisphere; Jordan A. Litman (2005), "Curiosity and the Pleasures of Learning: Wanting and Liking New Information," *Cognition and Emotion*, 19 (6), 793–814. doi.org/10.1080/02699930541000101; George Loewenstein (1994), "The Psychology of Curiosity: A Review and Interpretation," *Psychological Bulletin*, 116 (1), 75–98. /doi.org/10.1037/0033-2909.116.1.75; Jan-Benedict E. M. Steenkamp and Hans Baumgartner (1992), "The Role of Optimum Stimulation Level in Exploratory Consumer Behavior," *Journal of Consumer Research*, 19 (3), 434–48. doi.org/10.1086/209313
40 Paul J. Silvia (2005), "Emotional Responses to Art: From Collation and Arousal to Cognition and Emotion," *Review of General Psychology*, 9 (4), 342–57. doi.org/10.1037/1089-2680.9.4.342; Paul J. Silvia (2008), "Interest—The Curious Emotion," *Current Directions in Psychological Science*, 17 (1), 57–60. doi.org/10.1111/j.1467-8721.2008.00548
41 Ingo F. Walther (2013), *Impressionism*. Cologne, Germany: Taschen.
42 Druann Maria Heckert (1989), "The Relativity of Positive Deviance: The Case of the French Impressionists," *Deviant Behavior*, 10 (2), 131–44. doi.org/10.1080/01639625.1989.9967806
43 Mitchell Stephens (2014), *Beyond News: The Future of Journalism*. New York, NY: Columbia University Press.
44 Eva Cetinic and James She (2022), "Understanding and Creating art with AI: Review and Outlook," *ACM Transactions on Multimedia Computing, Communications, and Applications (TOMM)* 18 (2), 1–22. doi.org/10.1145/3475799; Gabe Cohn (2018), "AI Art at Christie's Sells for $432,500," *New York Times*, October 25.
45 Joanna Zylinska (2020), *AI Art: Machine Visions and Warped Dreams*, London, UK: Open Humanities Press.
46 Sumaiya Ahmed and Ashish Sinha (2016), "When It Pays to Wait: Optimizing Release Timing Decisions for Secondary Channels in the Film Industry," *Journal of Marketing*, 80 (4), 20–38. doi.org/10.1509/jm.15.0484; Donna H. Green, Donald W. Barclay, and Adrian B. Ryans (1995), "Entry Strategy and Long-Term Performance: Conceptualization and Empirical Examination," *Journal of Marketing*, 59 (4), 1–16. doi.org/10.1177/00222429950590040; Venkatesh

Shankar, Gregory S. Carpenter, and Lakshman Krishnamurthi (1999), "The Advantages of Entry in the Growth Stage of the Product Life Cycle: An Empirical Analysis," *Journal of Marketing Research*, 36 (2), 269–76. doi.org/10.1177/00222437990360021

47 J. H. Plumb (1991), *The Penguin Book of the Renaissance*. London, UK: Penguin Books.

48 Nicholas Wade (2006), *Before the Dawn: Recovering the Lost History of Our Ancestors*. New York, NY: Penguin. For extended reading on the topic of declining violence, see Steven Pinker (2011), *The Better Angels of our Nature: Why Violence Has Declined*. New York, NY: Viking.

49 Henrik Hagtvedt (2022), "A Brand (New) Experience: Art, Aesthetics, and Sensory Effects," editorial, *Journal of the Academy of Marketing Science*, 50 (3), 425–28. doi.org/10.1007/s11747-021-00833-8; Henrik Hagtvedt (2023), "Aesthetics in Marketing," *Foundations and Trends in Marketing*, 18 (2), 94–175. dx.doi.org/10.1561/1700000082

50 Carsten Baumgarth and Daragh O'Reilly (2014), "Brands in the Arts and Culture Sector," *Arts Marketing: An International Journal*, 4 (1/2), 2–9. doi.org/10.1108/AM-08-2014-0028; Julie Guidry Moulard, Dan Hamilton Rice, Carolyn Popp Garrity, and Stephanie M. Mangus (2014), "Artist Authenticity: How Artists' Passion and Commitment Shape Consumers' Perceptions and Behavioral Intentions across Genders," *Psychology & Marketing*, 31 (8), 576–90. doi.org/10.1002/mar.20719; Albert M. Muñiz, Jr, Toby Norris, and Gary Alan Fine (2014), "Marketing Artistic Careers: Pablo Picasso as Brand Manager," *European Journal of Marketing*, 48 (1/2), 68–88. doi.org/10.1108/EJM-01-2011-0019; Chloe Preece (2015), "The Authentic Celebrity Brand: Unpacking Ai Weiwei's Celebritised Selves," *Journal of Marketing Management*, 31 (5/6), 616–45. doi.org/10.1080/0267257X.2014.1000362; Chloe Preece and Finola Kerrigan (2015), "Multi-Stakeholder Brand Narratives: An Analysis of the Construction of Artistic Brands," *Journal of Marketing Management*, 31 (11/12), 1207–30. doi.org/10.1080/0267257X.2014.997272; Victoria L. Rodner and Finola Kerrigan (2014), "The Art of Branding – Lessons from Visual Artists," *Arts Marketing: An International Journal*, 4 (1/2), 101–18. doi.org/10.1108/AM-02-2014-0013; Jonathan E. Schroeder (2005), "The Artist and the Brand," *European Journal of Marketing*, 39 (11/12), 1291–305. doi.org/10.1108/03090560510623262; Jenny Sjöholm and Cecilia Pasquinelli (2014), "Artist Brand Building: Towards a Spatial Perspective," *Arts Marketing: An International Journal*, 4 (1/2), 10–24. doi.org/10.1108/AM-10-2013-0018

51 Stijn M. J. Van Osselaer and Joseph W. Alba (2000), "Consumer Learning and Brand Equity," *Journal of Consumer Research*, 27 (1), 1–16. doi.org/10.1086/314305

52 Albert M. Muniz, Jr. and Thomas C. O'Guinn (2001), "Brand Community," *Journal of Consumer Research*, 27 (4), 412–32. doi.org/10.1086/319618

53 More about these artists, including quotes from Koons and Hirst, in Don Thompson (2008), *The $12 Million Stuffed Shark: The Curious Economics of Contemporary Art*. New York, NY: Palgrave Macmillan. See also Don Thompson (2014), *The Supermodel and the Brillo Box: Back Stories and Peculiar Economics from the World of Contemporary Art*. New York, NY: Palgrave Macmillan.

54 Marc Myers (2015), "The Guggenheim Show 'Silence' Spans Kawara's Career," *Wall Street Journal*, January 30, www.wsj.com/articles/the-guggenheim-show-silence-spans-on-kawaras-career-1422655735.
55 Christie's (2014), www.christies.com/lotfinder/paintings/on-kawara-may-1-1987-5792580-details.aspx?from=salesummary&intObjectID=5792580&sid=3a727442-f273-4556-96ce-a711099c12dc.
56 Derek Thompson (2017), *Hit Makers: The Science of Popularity in an Age of Distraction*. New York, NY: Penguin Press.
57 Phillips (2010), www.phillips.com/detail/Felix-Gonzalez-Torres/NY010710/4.
58 Matt Stromberg (2018), "Museum as Selfie Station," *Contemporary Art Review. LA*, 11, 18–29.
59 Ross King (2000), *Brunelleschi's Dome: How a Renaissance Genius Reinvented Architecture*. New York, NY: Bloomsbury.
60 Linda S. Pettijohn, Douglas W. Mellott, and Charles E. Pettijohn (1992), "The Relationship between Retailer Image and Brand Image," *Psychology & Marketing*, 9 (4), 311–28. doi.org/10.1002/mar.4220090405
61 Victoria L. Rodner and Chloe Preece (2016), "Painting the Nation: Examining the Intersection between Politics and the Visual Arts Market in Emerging Economies," *Journal of Macromarketing*, 36 (2), 128–48. doi.org/10.1177/0276146715574775
62 Benedict G. C. Dellaert and Stefan Stremersch (2005), "Marketing Mass-Customized Products: Striking a Balance Between Utility and Complexity," *Journal of Marketing Research*, 42 (2), 219–27. doi.org/10.1509/jmkr.42.2.219.62293
63 Eva C. Buechel and Chris Janiszewski (2014), "A Lot of Work or a Work of Art: How the Structure of a Customized Assembly Task Determines the Utility Derived from Assembly Effort," *Journal of Consumer Research*, 40 (5), 960–72. doi.org/10.1086/673846
64 Christian Hildebrand, Gerald Haubl, and Andreas Herrmann (2014), "Product Customization via Starting Solutions," *Journal of Marketing Research*, 51 (6), 707–25. doi.org/10.1509/jmr.13.0437
65 Darren W. Dahl and C. Page Moreau (2007), "Thinking Inside the Box: Why Consumers Enjoy Constrained Creative Experiences," *Journal of Marketing Research*, 44 (3), 357–69. doi.org/10.1509/jmkr.44.3.357
66 Ellen Dissanayake (1995), *Homo Aestheticus: Where Art Comes From and Why*, Seattle, WA: University of Washington Press; Henrik Hagtvedt (2019), "Shared Aesthetics: A Commentary on Collaborative Art," *Journal of the Association for Consumer Research*, 4 (4), 336. doi.org/10.1086/705024
67 Bublitz, Melissa G., Tracy Rank-Christman, Luca Cian, Xavier Cortada, Adriana Madzharov, Vanessa M. Patrick, Laura A. Peracchio, et al. (2019), "Collaborative Art: A Transformational Force within Communities," Journal of the Association for Consumer Research, 4 (4), 313–31. doi.org/10.1086/705023; Kester, Grant H. (2011), *The One and The Many: Contemporary Collaborative Art in a Global Context*, Duke University Press.
68 Ben Walmsley (2019), "The Death of Arts marketing: A Paradigm Shift from Consumption to Enrichment," *Arts and the Market*, 9 (1), 32–49. doi.org/10.1108/AAM-10-2018-0013
69 Nicolas Bourriaud (2002), *Relational Aesthetics*, Dijon, France: Les Presses du Réel.

70 François Colbert and Yannik St-James (2014), "Research in Arts Marketing: Evolution and Future Directions," *Psychology & Marketing*, 31 (8), 566–75. doi.org/10.1002/mar.20718
71 David Hopkins (2000), *After Modern Art: 1945–2000*. Oxford, UK: Oxford University Press.
72 Rosanne Martorella (1990), *Corporate Art*. New Brunswick, NJ: Rutgers University Press.
73 P. Rajan Varadarajan and Anil Menon (1988), "Cause-Related Marketing: A Coalignment of Marketing Strategy and Corporate Philanthropy," *Journal of Marketing*, 52 (3), 58–74. doi.org/10.1177/002224298805200306
74 Claudia Schnugg and Johannes Lehner (2016), "Communicating Identity or Status? A Media Analysis of Art Works Visible in Photographic Portraits of Business Executives," *International Journal of Arts Management*, 18 (2), 63–74.
75 Martorella, Rosanne, ed. (1996), *Art and Business: An International Perspective on Sponsorship*. Westport, CT: Praeger; Annmarie Ryan and Keith Blois (2016), "Assessing the Risks and Opportunities in Corporate Art Sponsorship Arrangements Using Fiske's Relational Models Theory," *Arts and the Market*, 6 (1), 33–51. doi.org/10.1108/AAM-02-2014-0010
76 Thorstein Veblen (1899/2007), *The Theory of the Leisure Class*. New York, NY: Oxford University Press.
77 Nailya Ordabayeva and Pierre Chandon (2011), "Getting Ahead of the Joneses: When Equality Increases Conspicuous Consumption among Bottom-Tier Consumers," *Journal of Consumer Research*, 38 (1), 27–41. doi.org/10.1086/658165
78 Jaehoon Lee and L. J. Shrum, "Conspicuous Consumption versus Charitable Behavior in Response to Social Exclusion: A Differential Needs Explanation," *Journal of Consumer Research*, 39 (3), 530–44. doi.org/10.1086/664039
79 Henrik Hagtvedt (2020), "Art and Aesthetics," in *Research Handbook on Luxury Branding*, ed. Felicitas Morhart, Sandor Czellar, and Keith Wilcox, Cheltenham, UK: Edward Elgar Publishing, 171–89. doi.org/10.4337/9781786436351.00022; Henrik Hagtvedt (2022), "Art and Aesthetics in the Future of Luxury," in *The Future of Luxury Brands*, ed. Annamma Joy, Boston, MA: De Gruyter, 115–34. doi.org/10.1515/9783110732757-006; Jean-Noël Kapferer (2014), "The Future of Luxury: Challenges and Opportunities," *Journal of Brand Management*, 21 (9), 716–26. doi.org/10.1057/bm.2014.32; Vanessa M. Patrick and Henrik Hagtvedt (2009), "Luxury Branding," in *Handbook of Brand Relationships*, Joseph Priester, Deborah J. MacInnis, and C. Whan Park, eds. New York, NY: Society for Consumer Psychology and M.E. Sharpe; Jose Luis Nueno and John A. Quelch (1998), "The Mass Marketing of Luxury," *Business Horizons*, 41 (6), 61–8. doi.org/10.1016/S0007-6813(98)90023-4; Michael J. Silverstein and Neil Fiske (2003), *Trading Up: The New American Luxury*. New York: Portfolio Penguin Group; Keith Wilcox, Hyeong Min Kim, and Sankar Sen (2009), "Why Do Consumers Buy Counterfeit Luxury Brands?" *Journal of Marketing Research*, 46 (2), 247–59. doi.org/10.1509/jmkr.46.2.247
80 Silvia Bellezza, Francesca Gino, and Anat Keinan (2014), "The Red Sneakers Effect: Inferring Status and Competence from Signals of Nonconformity," *Journal of Consumer Research*, 41 (1), 35–54. doi.org/10.1086/674870. See also Young Jee Han, Joseph C. Nunes, and Xavier Drèze (2010), "Signaling Status with

Luxury Goods: The Role of Brand Prominence," *Journal of Marketing*, 74 (4), 15–30. doi.org/10.1509/jmkg.74.4.015

81 Wilfred Amaldoss and Sanjay Jain (2005), "Conspicuous Consumption and Sophisticated Thinking," *Management Science*, 51 (10), 1449–66. doi.org/10.1287/mnsc.1050.0399; Jonah Berger and Morgan Ward (2010), "Subtle Signals of Inconspicuous Consumption," *Journal of Consumer Research*, 37 (4), 555–69. doi.org/10.1086/655445

82 Pierre Bourdieu (1984), *Distinction: A Social Critique of the Judgment of Taste*. Cambridge, MA: Harvard University Press; Steven Pinker (2002), *The Blank Slate: The Modern Denial of Human Nature*. New York, NY: Viking.

3 THE CONTEMPORARY ART MARKET

1 Eric Fischl and Robert Berlind (2014), "Art in Conversation," *The Brooklyn Rail*, July, https://brooklynrail.org/2014/07/art/eric-fischl-with-robert-berlind.
2 Don Thompson (2008), *The $12 Million Stuffed Shark: The Curious Economics of Contemporary Art*, p. 27. New York, NY: Palgrave Macmillan.
3 Anthony Haden-Gues (1982), "The New Queen of the Art Scene," *New York*, April 19.
4 Jacob Bernstein (2019), "Mary Boone Is Not Done," *New York Times*, March 29, www.nytimes.com/2019/03/29/style/mary-boone-tax-evasion.html.
5 Charlotte Burns (2015), "Eric Fischl Leaving Mary Boone Gallery after 30 Years," *The Art Newspaper*, 22 May, http://theartnewspaper.com/market/art-market-news/eric-fishl-leaving-mary-boone-gallery-after-30-years/.
6 Terry Smith (2009), *What Is Contemporary Art*, Chicago, IL: University of Chicago Press.
7 Robin Pogrebin (2022), "Warhol's 'Marilyn,' at $195 Million, Shatters Auction Record for an American Artist.
8 Joan Jeffri (2005), "Managing Uncertainty: The Visual Art Market for Contemporary Art in the United States," in *Understanding International Art Markets and Management*, Iain Robertson, ed., p. 144. New York, NY: Routledge.
9 Georgina Adam (2014), *Big Bucks: The Explosion of the Art Market in the 21st Century*. Surrey, UK: Lund Humphries; see also Ruby Roy Dholakia, Jingyi Duan, and Nikhilesh Dholakia (2015), "Production and Marketing of Art in China: Traveling the Long, Hard Road from Industrial Art to High Art," *Arts and the Market*, 5 (1), 25–44. doi.org/10.1108/AM-10-2013-0023
10 Clare McAndrew (2019), *The Art Market 2019*, Switzerland: Art Basel and UBS.
11 Clare McAndrew (2024), *The Art Basel & UBS Art Market Report 2024 by Arts Economics*, Switzerland: Art Basel and UBS.
12 Donald Hall and Pat Corrington Wykes (1990), *Anecdotes of Modern Art*, p. 40. New York, NY: Oxford University Press.
13 Olav Velthuis (2012), "The Contemporary Art Market Between Stasis and Flux," in *Contemporary Art and Its Commercial Markets: A Report on Current Conditions and Future Scenarios*, Maria Lind and Olav Velthuis, eds. Berlin, Germany: Sternberg Press.
14 Hannah Ghorashi (2015), "Louis Vuitton Ends Its 13-Year Relationship with Takashi Murakami," *ArtNews*, July, www.artnews.com/2015/07/21/louis-vuitton-ends-its-13-year-relationship-with-takashi-murakami/.

15 Elizabeth C. Hirschman (1983), "Aesthetics, Ideologies and the Limits of the Marketing Concept," *Journal of Marketing*, 47 (summer), 45–55. doi.org/10.1177/002224298304700306; Annamma Joy and John F. Sherry (2003), "Disentangling the Paradoxical Alliances between Art Market and Art World," *Consumption, Markets and Culture*, 6 (3), 155–81. doi.org/10.1080/1025386032000153759
16 Samuel P. Fraiberger, Roberta Sinatra, Magnus Resch, Christoph Riedl, and Albert-László Barabási (2018), "Quantifying Reputation and Success in Art," *Science*, 362 (6416), 825–9. doi.org/aau7224
17 For a similar argument, see Nassim Nicholas Taleb (2010), *The Black Swan: The Impact of the Highly Improbable*. New York, NY: Random House.
18 Chen, Yi-Fen (2011), "Auction Fever: Exploring Informational Social Influences on Bidder Choices," *CyberPsychology, Behavior & Social Networking*, 14 (7/8), 411–16. doi.org/10.1089/cyber.2009.0355; Hanson, Ward A. and Daniel S. Putler (1996), "Hits and Misses: Herd Behavior and Online Product Popularity," *Marketing Letters*, 7 (4), 297–305. doi.org/10.1007/BF00435537
19 Utpal M. Dholakia and Kerry Soltysinski (2001), "Coveted or Overlooked? The Psychology of Bidding for Comparable Listings in Digital Auctions," *Marketing Letters*, 12 (3), 225–37. doi.org/10.1023/A:1011164710951
20 Abhijit V. Banerjee (1992), "A Simple Model of Herd Behavior," *The Quarterly Journal of Economics*, 107 (3), 797–817. doi.org/10.2307/2118364
21 Henry Lydiate (2008), "Authorship and Authentication," in *The Art Business*, Iain Robertson and Derrick Chong, eds., p. 151. New York, NY: Routledge. For related findings on art and authenticity, see also George E. Newman and Paul Bloom (2012), "Art and Authenticity: The Importance of Originals in Judgments of Value," *Journal of Experimental Psychology: General*, 141 (3), 558–69. doi.org/10.1037/a0026035
22 Joan Jeffri (2005), "Managing Uncertainty: The Visual Art Market for Contemporary Art in the United States," in *Understanding International Art Markets and Management*, Iain Robertson, ed. New York, NY: Routledge.
23 Esmé E. Deprez (2014), "Why Starving Artists Still Prefer To Starve in New York," *BloombergBusiness*, May 21, www.bloomberg.com/news/articles/2014-05-21/patti-smith-s-advice-rebuffed-as-new-york-draws-artists.
24 Eric Moody (2005), "The Success and Failure of International Arts Management: The Profitable Evolution of a Hybrid Discipline," in *Understanding International Art Markets and Management*, Iain Robertson, ed, p. 78. New York, NY: Routledge.
25 Peter Timms (2004), *What's Wrong with Contemporary Art?*, Sydney, Australia: New South Wales University Press, citing a quote by Peter Jenkins (1991), *Modern Painters*, 4 (2), p. 75.
26 Clare McAndrew (2019), *The Art Market 2019*, Switzerland: Art Basel and UBS.
27 Joan Jeffri (2005), "Managing Uncertainty: The Visual Art Market for Contemporary Art in the United States," in *Understanding International Art Markets and Management*, Iain Robertson, ed, p. 136. New York, NY: Routledge.
28 Henrik Hagtvedt and Vanessa M. Patrick (2009), "The Broad Embrace of Luxury: Hedonic Potential as a Driver of Brand Extendibility," *Journal of Consumer Psychology*, 19 (4), 608–18. doi.org/10.1016/j.jcps.2009.05.007; Jean-Noël Kapferer (1997), "Managing Luxury Brands," *Journal of Brand Management*, 4 (4), 251–59; Franck Vigneron and Lester W Johnson (2004),

"Measuring Perceptions of Brand Luxury," *Journal of Brand Management*, 11 (6), 484–506. doi.org/10.1057/bm.1997.4
29 Michael Findlay (2014), *The Value of Art*, New York, NY: Prestel.
30 John Russell (1999), "Leo Castelli, Influential Art Dealer, Dies at 91," *New York Times*, August 23, www.nytimes.com/1999/08/23/arts/leo-castelli-influential-art-dealer-dies-at-91.html.
31 Don Thompson (2008), *The $12 Million Stuffed Shark: The Curious Economics of Contemporary Art*, p. 33. New York, NY: Palgrave Macmillan.
32 Don Thompson (2008), *The $12 Million Stuffed Shark: The Curious Economics of Contemporary Art*, p. 36. New York, NY: Palgrave Macmillan.
33 Kelly Crow (2011), "The Gagosian Effect," *The Wall Street Journal*, April 1, www.wsj.com/articles/SB10001424052748703712504576232791179823226.
34 Olav Velthuis (2005), *Talking Prices: Symbolic Meaning of Prices on the Market for Contemporary Art*, p. 69. Princeton, NJ: Princeton University Press.
35 Sarah Thornton (2008), *Seven Days in the Art World*, p. 8. New York, NY: Norton.
36 Eldar Shafir, Peter Diamond, and Amos Tversky (1997), "Money Illusion," *The Quarterly Journal of Economics*, 112 (2), 341–74. doi.org/10.1162/003355397555208
37 For further reading on this globalization trend, see Georgina Adam (2014), *Big Bucks: The Explosion of the Art Market in the 21st Century*. Surrey, UK: Lund Humphries; Maria Lind and Olav Velthuis (2012), *Contemporary Art and its Commercial Markets: A Report on Current Conditions and Future Scenarios*. Berlin, Germany: Sternberg Press; Noah Horowitz (2011), *Art of the Deal: Contemporary Art in a Global Financial Market*. Princeton, NJ: Princeton University Press.
38 Don Thompson (2008), *The $12 Million Stuffed Shark: The Curious Economics of Contemporary Art*, p. 25. New York, NY: Palgrave Macmillan.
39 Clare McAndrew (2018), *The Art Market 2019*, Switzerland: Art Basel and UBS.
40 Pierre Cabanne (1971), *Dialogues with Marcel Duchamp*. New York, NY: Viking.
41 Gokhan Ertug, Tamar Yogev, Yonghoon G. Lee, and Peter Hedström (2016), "The Art of Representation: How Audience-Specific Reputations Affect Success in the Contemporary Art Field," *Academy of Management Journal*, 59 (1), 113–34. doi.org/10.5465/amj.2013.0621; Victoria L. Rodner and Chloe Preece (2015), "Tainted Museums: 'Selling Out' Cultural Institutions," *International Journal of Nonprofit & Voluntary Sector Marketing*, 20 (2), 189–209. doi.org/10.1002/nvsm.1527
42 Christopher Mele (2016), "Is It Art? Eyeglasses on Museum Floor Began as Teenagers' Prank," *New York Times*, May 30, www.nytimes.com/2016/05/31/arts/sfmoma-glasses-prank.html?_r=1.
43 Georgina Adam (2014), *Big Bucks: The Explosion of the Art Market in the 21st Century*. Surrey, UK: Lund Humphries.
44 Martin Evans (2014), "Tate Accused of Conflict of Interest Over Exhibition of Trustee's Work," *The Telegraph*, January 3, www.telegraph.co.uk/culture/10549967/Tate-accused-of-conflict-of-interest-over-exhibition-of-trustees-work.html.
45 Artnet News (2016), "The Artnet News Index: The World's Top 100 Art Collectors for 2016," June 13, https://news.artnet.com/art-world/artnet-news-index-top-100-collectors-part-one-513776.
46 Derrick Chong (2005), "Stakeholder Relationships in the Market for Contemporary Art," in *Understanding International Art Markets and Management*, Iain Robertson, ed, p. 93. New York, NY: Routledge.

47 Christopher Reynolds (2006), "Geffen's Other Dream Works," *Los Angeles Times*, November 10, http://articles.latimes.com/2006/nov/10/entertainment/et-geffen10.
48 Kelly Crow (2016), "Billionaire Ken Griffin Paid $500 Million for Pollock, De Kooning Paintings," *The Wall Street Journal*, February 25, www.wsj.com/artic les/billionaire-ken-griffin-paid-500-million-for-pollock-de-kooning-paintings-145 5902545.
49 Agustino Fontevecchia (2013), "Hedge Fund Billionaire Steve Cohen's $155M Picasso Isn't His First Multi-Million Piece Of Art," March 26, www.forbes.com/sites/afontevecchia/2013/03/26/hedge-fund-billionaire-steve-cohens-155m-pica sso-isnt-his-first-multi-million-piece-of-art/#45d980965030.
50 Yu Chen (2009), "Possession and Access: Consumer Desires and Value Perceptions Regarding Contemporary Art Collection and Exhibit Visits," *Journal of Consumer Research*, 35 (6), 925–40. doi.org/10.1086/593699
51 Anne-Britt Gran and Donatella De Paoli (2005), *Kunst og Kapital: Nye Forbindelser Mellom Kunst, Estetikk og Næringsliv*. Oslo, Norway: Pax Forlag.
52 Barry Hoffman (2002), *The Fine Art of Advertising*. New York, NY: Stewart, Tabori and Chang.
53 For a fuller treatment of this topic, see Barry Hoffman (2002), *The Fine Art of Advertising*. New York, NY: Stewart, Tabori and Chang; James B. Twitchell (2000), *20 Ads that Shook the World: The Century's Most Groundbreaking Advertising and How It Changed Us All*. New York, NY: Three Rivers Press.
54 Henrik Hagtvedt and Vanessa M. Patrick (2008), "Art Infusion: The Influence of Visual Art on the Perception and Evaluation of Consumer Products," *Journal of Marketing Research*, 45 (June), 379–89. doi.org/10.1509/jmkr.45.3.379. See also Henrik Hagtvedt and Vanessa M. Patrick (2008b), "Art and the Brand: The Role of Visual Art in Enhancing Brand Extendibility," *Journal of Consumer Psychology*, 18 (July), 212–22. doi.org/10.1016/j.jcps.2008.04.010; Henrik Hagtvedt and Vanessa M. Patrick (2011), "Fine Arts," in *Encyclopedia of Consumer Culture*, Dale Southerton, ed. Los Angeles, CA: Sage; Henrik Hagtvedt, Reidar Hagtvedt, and Vanessa M. Patrick (2008), "The Perception and Evaluation of Visual Art," *Empirical Studies of the Arts*, 26 (2), 197–218. doi.org/10.2190/EM.26.2.d; Vanessa M. Patrick and Henrik Hagtvedt (2011), "Advertising with Art: Creative Visuals," in *Encyclopedia of Creativity, 2nd Edition*, ed. Mark Runco and Steven Pritzker, San Diego: Elsevier. doi.org/10.1016/B978-0-12-375038-9.00003-0
55 Simon Lacey, Henrik Hagtvedt, Vanessa Patrick, Amy Anderson, Randall Stilla, Gopikrishna Deshpande, Xiaoping Hu, João R. Sato, Srinivas Reddy, and Krish Sathian (2011), "Art for Reward's Sake: Visual Art Recruits the Ventral Striatum," *NeuroImage*, 55 (1), 420–33. doi.org/10.1016/j.neuroimage.2010.11.027
56 Henrik Hagtvedt and Vanessa M. Patrick (2011b), "Turning Art into Mere Illustration: Concretizing Art Renders Its Influence Context Dependent," *Personality and Social Psychology Bulletin*, 37 (12), 1624–32. doi.org/10.1177/0146167211415631
57 Rosanne Martorella (1990), *Corporate Art*. New Brunswick, NJ: Rutgers University Press; Rosanne Martorella, ed. (1996), *Art and Business: An International Perspective on Sponsorship*. Westport, CT: Praeger.
58 Eben Harrell and Frances Perraudin (2010), "Cultural Assets: Banks Stock Up on Art," *Time*, October 24, www.time.com/time/magazine/article/0,9171,2024 218,00.html.

59 Stallabrass, Julian (2004), *Contemporary Art: A Very Short Introduction*, p. 97. Oxford, UK: Oxford University Press.

4 TRENDS, FASHIONS, AND SOCIAL INFLUENCE

1. Victor Hugo (1831/1978), *Notre-Dame de Paris*. London, UK: Penguin.
2. Rex Yuxing Du, Ye Hu, and Sina Damangir (2015), "Leveraging Trends in Online Searches for Product Features in Market Response Modeling," *Journal of Marketing*, 79 (1), 29–43. doi.org/10.1509/jm.12.0459
3. William H. Reynolds (1968), "Cars and Clothing: Understanding Fashion Trends," *Journal of Marketing*, 32 (3), 44–9. doi.org/10.1177/002224296803200308
4. The paragraphs about De Beers draw on James B. Twitchell (2000), *20 Ads that Shook the World: The Century's Most Groundbreaking Advertising and How It Changed Us All*. New York, NY: Three Rivers Press. See also Donna J. Bergenstock and James M. Maskulka (2001), "The De Beers Story: Are Diamonds Forever?" *Business Horizons*, 44 (3), 37–44. doi.org/10.1016/S0007-6813(01)80033-1
5. George E. Harlow (1997), "Following the History of Diamonds," in *The Nature of Diamonds*, George E. Harlow, ed. Cambridge, UK: Cambridge University Press.
6. Advertising Age, Special Supplement (1999), *The Advertising Century*. Chicago, IL: Crain Communications, Inc.
7. Martin Lindstrom (2011), *Brandwashed: Tricks Companies Use to Manipulate Our Minds and Persuade Us to Buy*. New York, NY: Crown Business.
8. Solomon E. Asch (1952), *Social Psychology*, Englewood Cliffs, NJ: Prentice-Hall; Solomon E. Asch (1956), "Studies of Independence and Conformity: A Minority of One against a Unanimous Majority," *Psychological Monographs: General and Applied*, 70 (9), 1–70. doi.org/10.1016/0022-1031(80)90070-0. See also Richard S. Crutchfield (1955), "Conformity and Character," *American Psychologist*, 10 (5), 191–8. doi.org/10.1037/h0040237
9. William O. Bearden, Richard G. Netemeyer, and Jesse E. Teel (1989), "Measurement of Consumer Susceptibility to Interpersonal Influence," *Journal of Consumer Research*, 15 (4), 473–81. doi.org/10.1086/209186; Cindy Chan, Jonah Berger, and Leaf Van Boven (2012), "Identifiable but Not Identical: Combining Social Identity and Uniqueness Motives in Choice," *Journal of Consumer Research*, 39 (3), 561–73. doi.org/10.1086/664804; Young Eun Huh, Joachim Vosgerau, and Carey K. Morewedge (2014), "Social Defaults: Observed Choices Become Choice Defaults," *Journal of Consumer Research*, 41 (3), 746–60. doi.org/10.1086/677315
10. Sushil Bikhchandani, David Hirshleifer, and Ivo Welch (1998), "Learning from the Behavior of Others: Conformity, Fads, and Informational Cascades," *The Journal of Economic Perspectives*, 12 (3), 151–70. dx.doi.org/10.1257/jep.12.3.151
11. Daniel Gardner (2008), *The Science of Fear*, p. 104. New York, NY: Dutton.
12. Heshan Sun (2013), "A Longitudinal Study of Herd Behavior in the Adoption and Continued Use of Technology," *MIS Quarterly*, 37 (4), 1013-A13. doi.org/10.25300/MISQ/2013/37.4.02
13. Thomas C. Chiang and Dazhi Zheng (2010), "An Empirical Analysis of Herd Behavior in Global Stock Markets," *Journal of Banking & Finance*, 34 (8), 1911–21. doi.org/10.1016/j.jbankfin.2009.12.014
14. Minah H. Jung, Hannah Perfecto, and Leif D. Nelson (2016), "Anchoring in Payment: Evaluating a Judgmental Heuristic in Field Experimental Settings," *Journal of Marketing Research*, 53 (3), 354–68. doi.org/10.1509/jmr.14.0238

15 Robert Sabin, ed. (1964), *The International Cyclopedia of Music and Musicians*. New York, NY: Dodd, Mead & Company.
16 See, however, recent research suggesting that the impact of simulated laughter on perceptions of humor may depend on heuristic-based processing: Brian Gillespie, Mark Mulder, and Manja Leib (2016), "Who's Laughing Now? The Effect of Simulated Laughter on Consumer Enjoyment of Television Comedies and the Laugh-Track Paradox," *Journal of the Association of Consumer Research*, 1 (4), 592–606. dx.doi.org/10.1086/688220
17 Stanley Milgram (1963), "Behavioral Study of Obedience," *Journal of Abnormal and Social Psychology*, 67 (4), 371–8; Stanley Milgram (1974/2009), *Obedience to Authority: An Experimental View*. New York, NY: Harper Perennial.
18 Robert B. Cialdini (1984), *Influence: The Psychology of Persuasion*. New York, NY: Harper.
19 David L. Altheide and John M. Johnson (1977), "Counting Souls: A Study of Counseling at Evangelical Crusades," *The Pacific Sociological Review*, 20 (3), 323–48. doi.org/10.2307/1388912
20 Utpal M. Dholakia and Kerry Soltysinski (2001), "Coveted or Overlooked? The Psychology of Bidding for Comparable Listings in Digital Auctions," *Marketing Letters*, 12 (3), 225–37; Young Eun Huh, Joachim Vosgerau, and Carey K. Morewedge (2014), "Social Defaults: Observed Choices Become Choice Defaults," *Journal of Consumer Research*, 41 (3), 746–60.
21 Sarah Thornton (2008), *Seven Days in the Art World*, p. xiv-xv. New York, NY: Norton.
22 For a discussion of mere exposure effects, see also Robert B. Zajonc (1980), "Feeling and Thinking: Preferences Need No Inferences," *American Psychologist*, 35 (2), 151–75. doi.org/10.1037/0003-066X.35.2.151
23 Pierre Bourdieu (1984), *Distinction: A Social Critique of the Judgment of Taste*. Cambridge, MA: Harvard University Press.
24 Kylie Budge (2017), "Objects in Focus: Museum Visitors and Instagram," *Curator: The Museum Journal*, 60 (1), 67–85. doi.org/10.1111/cura.12183
25 Wayne D. Hoyer and Nicola E. Stokburger-Sauer (2012), "The Role of Aesthetic Taste in Consumer Behavior," *Journal of the Academy of Marketing Science*, 40 (1), 167–80. doi.org/10.1007/s11747-011-0269-y
26 Steven Pinker (2007), *The Stuff of Thought: Language as a Window into Human Nature*. New York, NY: Penguin.
27 Leeor Shimron (2023), "NFT Market Meltdown: How Can Investors Best Position Themselves?" *Forbes*, July 11; Paul Vigna (2022), "NFT Sales Are Flatlining," *The Wall Street Journal*, May 3.
28 Robert B. Cialdini (1984), *Influence: The Psychology of Persuasion*. New York, NY: Harper.
29 Virginia Postrel (2003), *The Substance of Style: How the Rise of Aesthetic Value Is Remaking Commerce, Culture, and Consciousness*. New York, NY: Harper.
30 Geoffrey Miller (2009), *Spent*, p. 320. New York, NY: Viking.
31 Sheena Iyengar (2010), *The Art of Choosing*. New York, NY: Twelve.
32 Sara Kim and Aparna A. Labroo (2011), "From Inherent Value to Incentive Value: When and Why Pointless Effort Enhances Consumer Preference," *Journal of Consumer Research*, 38 (4), 712–42. doi.org/10.1086/660806; Aparna A. Labroo, Soraya Lambotte, and Yan Zhang (2009), "The "Name-Ease" Effect and Its Dual Impact on Importance Judgments," *Psychological Science*, 20 (12), 1516–22. doi.org/10.1111/j.1467-9280.2009.02477.x

33 For a broader discussion of this topic, see Nicholas Wade (2009), *The Faith Instinct: How Religion Evolved and Why It Endures*. New York, NY: Penguin.
34 Robert B. Cialdini (1984), *Influence: The Psychology of Persuasion*. New York, NY: Harper.
35 Maura L. Scott, Martin Mende, and Lisa E. Bolton (2013), "Judging the Book by Its Cover? How Consumers Decode Conspicuous Consumption Cues in Buyer-Seller Relationships," *Journal of Marketing Research*, 50 (3), 334–47. doi.org/10.1509/jmr.11.0478
36 Albert M. Muniz, Jr. and Thomas C. O'Guinn (2001), "Brand Community," *Journal of Consumer Research*, 27 (4), 412–32. doi.org/10.1086/319618
37 Robert B. Cialdini (1984), *Influence: The Psychology of Persuasion*. New York, NY: Harper; Leon Festinger, Henry W. Riecken, and Stanley Schachter (1956/2008), *When Prophecy Fails*, London, UK: Pinter & Martin.
38 Barry M. Staw (1981), "The Escalation of Commitment to a Course of Action," *Academy of Management Review*, 6 (4), 577–87. doi.org/10.5465/amr.1986.4283111
39 Richard Dawkins (1976), *The Selfish Gene*. Oxford, UK: Oxford University Press
40 For further discussion of limitations of the meme construct, see also Geoffrey Miller (2009), *Spent*. New York, NY: Viking; Steven Pinker (1997), *How the Mind Works*. New York, NY: Norton.
41 Derek Thompson (2017), *Hit Makers: The Science of Popularity in an Age of Distraction*. New York, NY: Penguin Press.
42 Berger, Jonah (2013), *Contagious: Why Things Catch On*. New York, NY: Simon & Schuster; Jonah Berger and Katherine L. Milkman (2012), "What Makes Online Content Viral?" *Journal of Marketing Research*, 49 (2), 192–205. doi.org/10.1509/jmr.10.0353
43 Angie Drobnic Holan and Linda Qiu (2015), "2015 Lie of the Year: The Campaign Misstatements of Donald Trump," *Politifact*, December 21, www.politifact.com/truth-o-meter/article/2015/dec/21/2015-lie-year-donald-trump-campaign-misstatements/; Glenn Kessler, Salvador Rizzo, and Meg Kelly (2021), "Trump's False or Misleading Claims Total 30,573 over 4 Years," *The Washington Post*, January 24, www.washingtonpost.com/politics/2021/01/24/trumps-false-or-misleading-claims-total-30573-over-four-years/.
44 The Editorial Board (2016), "Facebook and the Digital Virus Called Fake News," *New York Times*, November 19, www.nytimes.com/2016/11/20/opinion/sunday/facebook-and-the-digital-virus-called-fake-news.html?_r=0.
45 Robert Kozinets, Anthony Patterson, and Rachel Ashman (2017), "Networks of Desire: How Technology Increases Our Passion to Consume," *Journal of Consumer Research*, 43 (5), 659–82. doi.org/10.1093/jcr/ucw061
46 Craig Silverman (2016), "This Analysis Shows how Fake Election News Stories Outperformed Real News on Facebook," *BuzzFeed News*, November 16, www.buzzfeed.com/craigsilverman/viral-fake-election-news-outperformed-real-news-on-facebook?utm_term=.gymy3e3RoW#.foABpvpJLa.
47 Amy Mitchell, Jeffrey Gottfried, Jocelyn Kiley and Katerina Eva Matsa (2014), "Section 1: Media Sources: Distinct Favorites Emerge on the Left and Right," *Pew Research Center*, October 21, www.journalism.org/2014/10/21/section-1-media-sources-distinct-favorites-emerge-on-the-left-and-right/.
48 Rober Schroeder (2016), "Trump Has Gotten nearly $3 Billion in 'Free' Advertising," *MarketWatch*, May 6, www.marketwatch.com/story/trump-has-gotten-nearly-3-billion-in-free-advertising-2016-05-06.

49 Reporters without Borders (2023), "2023 World Press Freedom Index," https://rsf.org/en/index.
50 Glenn Kessler and Meg Kelly (2018), "President Trump Made 2,140 False or Misleading Claims in his First Year," *The Washington Post*, January 20, www.washingtonpost.com/news/fact-checker/wp/2018/01/20/president-trump-made-2140-false-or-misleading-claims-in-his-first-year/?noredirect=on&utm_term=.2e8d815fdd7b
51 Zoey Chen and Jonah Berger (2016), "How Content Acquisition Method Affects Word of Mouth," *Journal of Consumer Research*, 43 (1), 86–102. doi.org/10.1093/jcr/ucw001; Ana Babić Rosario, Francesca Sotgiu, Kristine de Valck, Tammo H. A. Bijmolt (2016), "The Effect of Electronic Word of Mouth on Sales: A Meta-Analytic Review of Platform, Product, and Metric Factors," *Journal of Marketing Research*, 53 (3), 297–318. doi.org/10.1509/jmr.14.0380. For a broader treatment of memes, see Susan Blackmore (1999), *The Meme Machine*. Oxford, UK: Oxford University Press.
52 Jonathan Gottschall (2012), *The Storytelling Animal: How Stories Make Us Human*, New York, NY: Mariner.
53 Nassim Nicholas Taleb (2010), *The Black Swan: The Impact of the Highly Improbable*. New York, NY: Random House.
54 Tehila Kogut and Ilana Ritov (2005), "The 'Identified Victim' Effect: An Identified Group, or Just a Single Individual?" *Journal of Behavioral Decision Making*, 18 (3), 157–67. doi.org/10.1002/bdm.492; Deborah A. Small, George Loewenstein, and Paul Slovic (2007), "Sympathy and callousness: The Impact of Deliberative Thought on Donations to Identifiable and Statistical Victims," *Organizational Behavior and Human Decision Processes*, 102 (2), 143–53. doi.org/10.1016/j.obhdp.2006.01.005
55 Richard H. Thaler and Cass R. Sunstein (2008), *Nudge: Improving Decisions about Health, Wealth, and Happiness*. New York, NY: Penguin.
56 Daniel Gardner (2008), *The Science of Fear*. New York, NY: Dutton.
57 Steven Pinker (2011), *The Better Angels of our Nature: Why Violence Has Declined*. New York, NY: Viking. See also Steven Pinker (2018), *Enlightenment Now: The Case for Reason, Science, Humanism, and Progress*. New York, NY: Viking.
58 Daniel Gardner (2008), *The Science of Fear*. New York, NY: Dutton.
59 Julie Barzilay, Laura Johnson, and Gillian Mohney (2016), "Why the CDC Hasn't Launched a Comprehensive Gun Study in 15 Years," *ABC News*, June 16, http://abcnews.go.com/Health/cdc-launched-comprehensive-gun-study-15-years/story?id=39873289.
60 World Health Organization (2017), "Measles," www.who.int/mediacentre/factsheets/fs286/en/
61 Centers for Disease Control and Prevention (2017), "Global Diarrhea Burden," www.cdc.gov/healthywater/global/diarrhea-burden.html
62 National Geographic Channel (2015), "Shark Attack Facts," http://natgeotv.com/ca/human-shark-bait/facts.
63 Reported in Daniel Kahneman (2011), *Thinking, Fast and Slow*. New York, NY: Farrar, Straus, and Giroux.
64 Daniel Gardner (2008), *The Science of Fear*. New York, NY: Dutton.
65 Olga Hubard (2014), "Concepts as Context: Thematic Museum Education and its Influence on Meaning Making," *The International Journal of Art & Design Education*, 33 (1), 103–15. doi.org/10.1111/j.1476-8070.2014.12001.x

66 Nicolas Bourriaud (2002), *Relational Aesthetics*, Dijon, France: Les Presses du Réel; Stewart Martin (2007), "Critique of Relational Aesthetics," *Third Text*, 21 (4), 369–86. doi.org/10.1080/09528820701433323
67 Semir Zeki (2001), "Artistic Creativity and the Brain," *Science*, 293 (5527), 51–2. DOI: 10.1126/science.1062331
68 Jean Robertson and Craig McDaniel (2010), *Themes of Contemporary Art: Visual Art after 1980*, p. 293. New York, NY: Oxford University Press.
69 Smith, Terry (2009), *What Is Contemporary Art*, p. 91. Chicago, IL: The University of Chicago Press.
70 Joan Gibbons (2005), *Art and Advertising*, p. 22. New York, NY: I. B. Tauris.
71 Lucy Lippard quoted in Cynthia Freeland (2001), *But Is It Art?*, p. 19, New York, NY: Oxford University Press.
72 Peter Timms (2004), *What's Wrong with Contemporary Art?*, p. 77. Sydney, Australia: New South Wales University Press.
73 Peter Timms (2004), *What's Wrong with Contemporary Art?*, p. 162. Sydney, Australia: New South Wales University Press.
74 Steven Pinker (2002), *The Blank Slate: The Modern Denial of Human Nature*. New York, NY: Viking.
75 For a general discussion of this phenomenon, see Steven Pinker (2018), *Enlightenment Now: The Case for Reason, Science, Humanism, and Progress*. New York, NY: Viking.
76 Alan D. Sokal (1996), "Transgressing the Boundaries: Toward a Transformative Hermeneutics of Quantum Gravity," *Social Text*, 46/47 (Spring – Summer), 217–52.

5 DISENTANGLING THE MUSES

1 Gilbert K. Chesterton (1928/1991), *The Collected Works of G. K. Chesterton: The Illustrated London News, 1926–1928*. San Francisco, CA: Ignatius Press.
2 H. L. Mencken (1949), *A Mencken Chrestomathy*. New York, NY: Knopf.
3 Noël Carroll (2000), *Theories of Art Today*. Madison, WI: The University of Wisconsin Press; Berys Gaut and Dominic McIver Lopes, eds. (2007), *The Routledge Companion to Aesthetics*. New York, NY: Routledge.
4 Daniel E. Berlyne (1974), *Studies in the New Experimental Aesthetics: Steps toward an Objective Psychology of Aesthetic Appreciation*, Washington, DC: Hemisphere; Henrik Hagtvedt, Reidar Hagtvedt, and Vanessa M. Patrick (2008), "The Perception and Evaluation of Visual Art," *Empirical Studies of the Arts*, 26 (2), 197–218. doi.org/10.2190/EM.26.2.d; Henrik Hagtvedt and Vanessa M. Patrick (2011), "Fine Arts," in *Encyclopedia of Consumer Culture*, Dale Southerton, ed. Los Angeles, CA: Sage; Richard G. Tansey and Fred S. Kleiner (1996), *Gardner's Art through the Ages*. Orlando, FL: Harcourt Brace.
5 Ellen Dissanayake (1995), *Homo Aestheticus: Where Art Comes From and Why*, Seattle, WA: University of Washington Press; Denis Dutton (2007), "Aesthetic Universals," in *The Routledge Companion to Aesthetics*, Berys Gaut and Dominic McIver Lopes, eds. New York, NY: Routledge.
6 James R. Averill, Petra Stanat, and Thomas A. More (1998), "Aesthetics and the Environment," *Review of General Psychology*, 2 (2), 153–74; Gitte Lindgaard and T. W. Allan Whitfield (2004), "Integrating Aesthetics Within an Evolutionary and Psychological Framework," *Theoretical Issues in Ergonomics Science*, 5 (1), 73–90. doi.org/10.1037/1089-2680.2.2.153

7 Ellen Dissanayake (1995), *Homo Aestheticus: Where Art Comes From and Why*, Seattle, WA: University of Washington Press; Ellen Dissanayake (2000), *Art and Intimacy: How the Arts Began*, Seattle, WA: University of Washington Press; Ellen Dissanayake (2007), "What Art Is and What Art Does: An Overview of Contemporary Evolutionary Hypotheses," in *Evolutionary and Neurocognitive Approaches to Aesthetics, Creativity, and the Arts*, pp. 1–14, Colin Martindale, Paul Locher, and Vladimir M. Petrov, eds. Amityville, NY: Baywood Publishing Company, Inc; Denis Dutton (2007), "Aesthetic Universals," in *The Routledge Companion to Aesthetics*, Berys Gaut and Dominic McIver Lopes, eds. New York, NY: Routledge; Denis Dutton (2009), *The Art Instinct*, New York: Bloomsbury Press.
8 Alexander Baumgarten (1735/1954), *Reflections on Poetry*, Berkeley, CA: University of California Press.
9 Immanuel Kant (1790/2007), *Critique of Judgement*, New York, NY: Oxford University Press.
10 Henrik Hagtvedt (2022), "A Brand (New) Experience: Art, Aesthetics, and Sensory Effects," *Journal of the Academy of Marketing Science*, 50 (3), 425–8.
11 Simon Lacey, Henrik Hagtvedt, Vanessa Patrick, Amy Anderson, Randall Stilla, Gopikrishna Deshpande, Xiaoping Hu, João R. Sato, Srinivas Reddy, and Krish Sathian (2011), "Art for Reward's Sake: Visual Art Recruits the Ventral Striatum," *NeuroImage*, 55 (1), 420–33. doi.org/10.1016/j.neuroimage.2010.11.027
12 Alice Yoo (2011), "Riveting Story Behind that Striking Sculpture," *My Modern Met*, June 30, https://mymodernmet.com/riveting-story-behind-that/.
13 Noël Carroll (2000), *Theories of Art Today*. Madison, WI: The University of Wisconsin Press; Jean Robertson and Craig McDaniel (2010), *Themes of Contemporary Art: Visual Art after 1980*. New York, NY: Oxford University Press.
14 Eric Felten (2012), "Is It Art? Increasingly, Nowadays, That's a Judicial Decision," *Wall Street Journal*, June 1, U.S. edition.
15 For a discussion on the identity of objects, see Lance J. Rips, Sergey Blok, and George Newman (2006), "Tracing the Identity of Objects," *Psychological Review*, 113 (1), 1–30. doi.org/10.1037/0033-295X.113.1.1
16 Tracy Zwick (2013), "Sotheby's Wins in Dispute with Jancou Gallery over Cady Noland Artwork," *ArtNews*, August 29.
17 Sol LeWitt (1967), "Paragraphs on Conceptual Art," *Artforum*, 5 (10), 79–83.
18 Amy Whitaker (2009), *Museum Legs*. Tucson, AZ: Holartbooks.
19 National Endowment for the Arts, www.govinfo.gov/content/pkg/GOVMAN-2006-06-01/pdf/GOVMAN-2006-06-01-Pg457.pdf.
20 Henrik Hagtvedt and Kathleen D. Vohs (2022), "Viewing Challenging Art Lends Meaning to Life by Stimulating Integrative Complexity," *The Journal of Positive Psychology*, 17 (6), 876–87. doi.org/10.1080/17439760.2021.1975159
21 Steven Pinker (2011), *The Better Angels of our Nature: Why Violence Has Declined*. New York, NY: Viking.
22 Dore Ashton (1972), *Picasso on Art*, New York, NY: Viking.

6 AFTERWORD

1 Friedrich Nietzche (1889/2016), *Twilight of the Idols: How to Philosophize with a Hammer*. Scotts Valley, CA: CreateSpace.

2 Leo Tolstoy (1902/1988), "What Is Religion and of What Does Its Essence Consist?" *Leo Tolstoy: A Confession and Other Writings*, London, UK: Penguin.
3 Arnold Hauser (1999), *The Social History of Art*, London, UK: Routledge.
4 Wesley M. Shrum (1996), *Fringe and Fortune: The Role of Critics in High and Popular Art*, Princeton, NJ: Princeton University Press.
5 James A. Gould, ed. (1992), *Classic Philosophical Questions*, p. 221. New York, NY: Columbia University Press.
6 For extended reading, see Berys Gaut and Dominic McIver Lopes (2007), *The Routledge Companion to Aesthetics*, New York: Routledge. doi.org/10.4324/9780203813034. I here refer to several chapters, including *Plato* by Christopher Janaway; *Aristotle* by Nickolas Pappas; *Empiricism: Hutcheson and Hume* by James Shelley; *Kant* by Donald W. Crawford; *Hegel* by Michael Inwood; *Idealism: Schopenhauer, Schiller and Schelling* by Dale Jacquette; *Nietzsche* by Ruben Berrios and Aaron Ridley; *Formalism* by Noël Carroll; *Pragmatism: Dewey* by Richard Shusterman; *Expressivism: Croce and Collingwood* by Gordon Graham; *Heidegger* by Thomas E. Wartenberg; *Postmodernism: Barthes and Derrida* by David Novitz.
7 Plato (approximately 380 BCE/2008), *Republic*, New York: Oxford University Press.
8 For a different take on Plato's views, see R. G. Collingwood (1958), *The Principles of Art*, New York: Oxford University Press.
9 Aristotle (approximately 335 BCE/1997), *Poetics*, London: Penguin.
10 Immanuel Kant (1790/2007), *Critique of Judgement*, New York: Oxford University Press; Thomas E. Wartenberg (2002), *The Nature of Art*, Belmont, CA: Wadsworth/Thomson.
11 Immanuel Kant (1781/2008), *Critique of Pure Reason*, London: Penguin.
12 Friedrich Nietzsche (1872/1967), *The Birth of Tragedy*, New York, NY: Vintage; cited in Ruben Berrios and Aaron Ridley (2007), "Nietzsche," in *The Routledge Companion to Aesthetics*, ed. Berys Gaut and Dominic McIver Lopes, New York, NY: Routledge.
13 Leo Tolstoy (1898/1995), *What Is Art?*, London: Penguin.
14 Adorno, Theodor (2001), *The Culture Industry*, London: Routledge.
15 Cited in Tomas E. Wartenberg (2002), *The Nature of Art*, Belmont, CA: Wadsworth/Thomson.
16 George Dickie (1974), *Art and the Aesthetic: An Institutional Analysis*, New York: Cornell University Press.
17 John Dewey (1934/2005), *Art as Experience*, New York: Perigee; Dewey, John (1989), "Having an Experience," in *John Dewey: The Later Works, 1925–1953: Art as Experience*, ed. Jo Ann Boydston, Carbondale: Southern Illinois University Press, 42–63.
18 Clive Bell (2007), *Art*, Charleston, SC: BiblioBazaar.
19 Noël Carroll (2007), "Formalism," in *The Routledge Companion to Aesthetics*, ed. Berys Gaut and Dominic McIver Lopes, New York: Routledge.
20 R. G. Collingwood (1958), *The Principles of Art*, New York: Oxford University Press.
21 Ellen Dissanayake (2000), *Art and Intimacy: How the Arts Began*, Seattle, WA: University of Washington Press; Dissanayake, Ellen (2007), "What Art Is and What Art Does: An Overview of Contemporary Evolutionary Hypotheses,"

in *Evolutionary and Neurocognitive Approaches to Aesthetics, Creativity, and the Arts*, pp. 1–14, ed. C. Martindale, P. Locher, and V. M. Petrov, Amityville, NY: Baywood Publishing Company, Inc.
22 Ellen Dissanayake (1995), *Homo Aestheticus: Where Art Comes From and Why*, Seattle, WA: University of Washington Press, p. 184.
23 Nicolas Bourriaud (1998), *Relational Aesthetics*, Dijon, France: Les Presses du Réel.
24 Denis Dutton (2007), "Aesthetic Universals," in *The Routledge Companion to Aesthetics*, ed. Berys Gaut and Dominic McIver Lopes, New York, NY: Routledge; Dutton, Denis (2009), *The Art Instinct*, New York, NY: Bloomsbury Press.
25 Noël Carroll (2000), "Introduction," in *Theories of Art Today*, ed. Noël Carroll, Madison, WI: University of Wisconsin Press.
26 Stephen Davies (2007), "Definitions of Art," in *The Routledge Companion to Aesthetics*, ed. Berys Gaut and Dominic McIver Lopes, New York, NY: Routledge; George Dickie (1984), *The Art Circle*, New York, NY: Haven.
27 Noël Carroll (2007), "Formalism," in *The Routledge Companion to Aesthetics*, ed. Berys Gaut and Dominic McIver Lopes, New York, NY: Routledge.

REFERENCES

Adam, Georgina (2014), *Big Bucks: The Explosion of the Art Market in the 21st Century*. Surrey: Lund Humphries.
Adams, Douglas (1980/2008), *The Restaurant at the End of the Universe*. New York, NY: Del Rey.
Adorno, Theodor (2001), *The Culture Industry*. London: Routledge.
Advertising Age, Special Supplement (1999), *The Advertising Century*. Chicago, IL: Crain Communicationss.
Ahmed, Sumaiya and Ashish Sinha (2016), "When It Pays to Wait: Optimizing Release Timing Decisions for Secondary Channels in the Film Industry." *Journal of Marketing*, 80 (4), 20–38. doi.org/10.1509/jm.15.0484
Altheide, David L. and John M. Johnson (1977), "Counting Souls: A Study of Counseling at Evangelical Crusades," *The Pacific Sociological Review*, 20 (3), 323–48. doi.org/10.2307/1388912
Amabile, Teresa M (1988), "A Model of Creativity and Innovation in Organizations," *Research in Organizational Behavior*, 10, 123–67.
Amaldoss, Wilfred and Sanjay Jain (2005), "Conspicuous Consumption and Sophisticated Thinking," *Management Science*, 51 (10), 1449–66. doi.org/10.1287/mnsc.1050.0399
Aristotle (ca 335 BCE/1997), *Poetics*. London: Penguin.
Artnet News (2016), "The Artnet News Index: The World's Top 100 Art Collectors for 2016," June 13. https://news.artnet.com/art-world/artnet-news-index-top-100-collectors-part-one-513776
Asch, Solomon E. (1952), *Social Psychology*. Englewood Cliffs, NJ: Prentice-Hall.
Asch, Solomon E. (1956), "Studies of Independence and Conformity: A Minority of One against a Unanimous Majority." *Psychological Monographs: General and Applied*, 70 (9), 1–70. doi.org/10.1016/0022-1031(80)90070-0
Ashton, Dore (1972), *Picasso on Art*. New York, NY: Viking.
Averill, James R., Petra Stanat, and Thomas A. More (1998), "Aesthetics and the Environment," *Review of General Psychology*, 2 (2), 153–74.
Banerjee, Abhijit V. (1992), "A Simple Model of Herd Behavior," *Quarterly Journal of Economics*, 107 (3), 797–817. doi.org/10.2307/2118364

Barone, Michael J. and Robert D. Jewell (2013), "The Innovator's License: A Latitude to Deviate from Category Norms," *Journal of Marketing*, 77 (1), 120–34. doi.org/10.1509/jm.10.0145

Barzilay, Julie, Laura Johnson, and Gillian Mohney (2016), "Why the CDC Hasn't Launched a Comprehensive Gun Study in 15 Years," *ABC News*, June 16, http://abcnews.go.com/Health/cdc-launched-comprehensive-gun-study-15-years/story?id=39873289.

Baumgarten, Alexander (1735/1954), *Reflections on Poetry*. Berkeley, CA: University of California Press.

Baumgarth, Carsten and Daragh O'Reilly (2014), "Brands in the Arts and Culture Sector," *Arts Marketing: An International Journal*, 4 (1/2), 2–9. doi.org/10.1108/AM-08-2014-0028

BBC News (2004), "Duchamp's Urinal Tops Art Survey." http://news.bbc.co.uk/2/hi/entertainment/4059997.stm.

Beard, Mary (2015), *SPQR: A History of Ancient Rome*. New York, NY: Liveright Publishing.

Beard, Mary and John Henderson (2001), *Classical Art: From Greece to Rome*. Oxford, UK: Oxford University Press.

Bearden, William O., Richard G. Netemeyer, and Jesse E. Teel (1989), "Measurement of Consumer Susceptibility to Interpersonal Influence," *Journal of Consumer Research*, 15 (4), 473–81. doi.org/10.1086/209186

Bell, Clive (2007), *Art*. Charleston, SC: BiblioBazaar.

Bellezza, Silvia, Francesca Gino, and Anat Keinan (2014), "The Red Sneakers Effect: Inferring Status and Competence from Signals of Nonconformity," *Journal of Consumer Research*, 41 (1), 35–54. doi.org/10.1086/674870

Bergenstock, Donna J. and James M. Maskulka (2001), "The De Beers Story: Are Diamonds Forever?" *Business Horizons*, 44 (3), 37–44. doi.org/10.1016/S0007-6813(01)80033-1

Berger, Jonah (2013), *Contagious: Why Things Catch On*. New York, NY: Simon & Schuster.

Berger, Jonah and Katherine L. Milkman (2012), "What Makes Online Content Viral?" *Journal of Marketing Research*, 49 (2), 192–205. doi.org/10.1509/jmr.10.0353

Berger, Jonah and Morgan Ward (2010), "Subtle Signals of Inconspicuous Consumption," *Journal of Consumer Research*, 37 (4), 555–69. doi.org/10.1086/655445

Berlyne, Daniel E. (1971), *Aesthetics and Psychobiology*. New York, NY: Appleton-Century-Crofts.

Berlyne, Daniel E. (1974), *Studies in the New Experimental Aesthetics: Steps toward an Objective Psychology of Aesthetic Appreciation*. Washington, DC: Hemisphere.

Bernstein, Jacob (2019), "Mary Boone Is Not Done," *New York Times*, March 29, www.nytimes.com/2019/03/29/style/mary-boone-tax-evasion.html

Berrios, Ruben and Aaron Ridley (2007), "Nietzsche," in *The Routledge Companion to Aesthetics*, Berys Gaut and Dominic McIver Lopes, eds. New York, NY: Routledge.

Bikhchandani, Sushil, David Hirshleifer, and Ivo Welch (1998), "Learning from the Behavior of Others: Conformity, Fads, and Informational Cascades," *Journal of Economic Perspectives*, 12 (3), 151–70. dx.doi.org/10.1257/jep.12.3.151

Bishop, Morris (2001), *The Middle Ages*. Boston, MA: Mariner Books.
Blackmore, Susan (1999), *The Meme Machine*. Oxford, UK: Oxford University Press.
Bourdieu, Pierre (1984), *Distinction: A Social Critique of the Judgment of Taste*. Cambridge, MA: Harvard University Press.
Bourriaud, Nicolas (1998), *Relational Aesthetics*, Dijon, France: Les Presses du Réel.
Bourriaud, Nicolas (2002), *Relational Aesthetics*, Dijon, France: Les Presses du Réel.
Botti, Simona (2000), "What Role for Marketing in the Arts? An Analysis of Arts Consumption and Artistic Value," *International Journal of Arts Management*, 2 (3), 14–27.
Bublitz, Melissa G., Tracy Rank-Christman, Luca Cian, Xavier Cortada, Adriana Madzharov, Vanessa M. Patrick, Laura A. Peracchio, et al. (2019), "Collaborative Art: A Transformational Force within Communities," *Journal of the Association for Consumer Research*, 4 (4), 313–31. doi.org/10.1086/705023
Budge, Kylie (2017), "Objects in Focus: Museum Visitors and Instagram," *Curator: The Museum Journal*, 60 (1), 67–85. doi.org/10.1111/cura.12183
Buechel, Eva C. and Chris Janiszewski (2014), "A Lot of Work or a Work of Art: How the Structure of a Customized Assembly Task Determines the Utility Derived from Assembly Effort," *Journal of Consumer Research*, 40 (5), 960–72. doi.org/10.1086/673846
Burns, Charlotte (2015), "Eric Fischl Leaving Mary Boone Gallery after 30 Years," *The Art Newspaper*, 22 May, http://theartnewspaper.com/market/art-market-news/eric-fishl-leaving-mary-boone-gallery-after-30-years/.
Cabanne, Pierre (1971), *Dialogues with Marcel Duchamp*. New York, NY: Viking.
Carroll, Noël (2000a), "Introduction," in *Theories of Art Today*, Noël Carroll, ed. Madison: University of Wisconsin Press.
Carroll, Noël (2000b), *Theories of Art Today*. Madison: The University of Wisconsin Press.
Carroll, Noël (2007), "Formalism," in *The Routledge Companion to Aesthetics*, Berys Gaut and Dominic McIver Lopes, eds. New York, NY: Routledge.
Centers for Disease Control and Prevention (2017), "Global Diarrhea Burden," www.cdc.gov/healthywater/global/diarrhea-burden.html.
Cetinic, Eva and James She (2022), "Understanding and Creating art with AI: Review and Outlook," *ACM Transactions on Multimedia Computing, Communications, and Applications (TOMM)*, 18 (2), 1–22. doi.org/10.1145/3475799
Chan, Cindy, Jonah Berger, and Leaf Van Boven (2012), "Identifiable But Not Identical: Combining Social Identity and Uniqueness Motives in Choice," *Journal of Consumer Research*, 39 (3), 561–73. doi.org/10.1086/664804
Chen, Yi-Fen (2011), "Auction Fever: Exploring Informational Social Influences on Bidder Choices," *Cyber Psychology, Behavior & Social Networking*, 14 (7/8), 411–16. doi.org/10.1089/cyber.2009.0355
Chen, Yu (2009), "Possession and Access: Consumer Desires and Value Perceptions Regarding Contemporary Art Collection and Exhibit Visits," *Journal of Consumer Research*, 35 (6), 925–40. doi.org/10.1086/593699
Chen, Zoey and Jonah Berger (2016), "How Content Acquisition Method Affects Word of Mouth," *Journal of Consumer Research*, 43 (1), 86–102. doi.org/10.1093/jcr/ucw001
Chernev, Alexander and David Gal (2010), "Categorization Effects in Value Judgments: Averaging Bias in Evaluating Combinations of Vices and Virtues," *Journal of Marketing Research*, 47 (4), 738–47. doi.org/10.1509/jmkr.47.4.73

References

Chesterton, Gilbert K. (1928/1991), *The Collected Works of G. K. Chesterton: The Illustrated London News, 1926–1928*. San Francisco, CA: Ignatius Press.

Chiang, Thomas C. and Dazhi Zheng (2010), "An Empirical Analysis of Herd Behavior in Global Stock Markets," *Journal of Banking & Finance*, 34 (8), 1911–21. doi.org/10.1016/j.jbankfin.2009.12.014

Chong, Derrick (2005), "Stakeholder Relationships in the Market for Contemporary Art," in *Understanding International Art Markets and Management*, Iain Robertson, ed, p. 93. New York, NY: Routledge.

Christie's (2014) Live Auction 3495., www.christies.com/lotfinder/paintings/on-kaw ara-may-1-1987-5792580-details.aspx?from=salesummary&intObjectID=5792 580&sid=3a727442-f273-4556-96ce-a711099c12dc.

Cialdini, Robert B. (1984), *Influence: The Psychology of Persuasion*. New York, NY: Harper.

Cohn, Gabe (2018), "AI Art at Christie's Sells for $432,500," *New York Times*, October 25.

Colbert, François (2014), "The Arts Sector: A Marketing Definition," *Psychology & Marketing*, 31 (8), 563–65. doi.org/10.1002/mar.20717

Colbert, François and Yannik St-James (2014), "Research in Arts Marketing: Evolution and Future Directions," *Psychology & Marketing*, 31 (8), 566–75. doi.org/10.1002/mar.20718

Collingwood, R. G. (1958), *The Principles of Art*. New York: Oxford University Press.

Crow, Kelly (2011), "The Gagosian Effect," *The Wall Street Journal*, April 1, www.wsj.com/articles/SB10001424052748703712504576232791179823226.

Crow, Kelly (2016), "Billionaire Ken Griffin Paid $500 Million for Pollock, De Kooning Paintings," *The Wall Street Journal*, February 25, www.wsj.com/artic les/billionaire-ken-griffin-paid-500-million-for-pollock-de-kooning-paintings-145 5902545.

Crutchfield, Richard S. (1955). "Conformity and Character." *American Psychologist*, 10 (5), 191–8. doi.org/10.1037/h0040237

Dahl, Darren W. and C. Page Moreau (2007), "Thinking Inside the Box: Why Consumers Enjoy Constrained Creative Experiences," *Journal of Marketing Research*, 44 (3), 357–69. doi.org/10.1509/jmkr.44.3.357

Davies, Stephen (2007), "Definitions of Art," in *The Routledge Companion to Aesthetics*, Berys Gaut and Dominic McIver Lopes, eds. New York, NY: Routledge.

Dawkins, Richard (1976), *The Selfish Gene*. Oxford, UK: Oxford University Press

Dellaert, Benedict G. C. and Stefan Stremersch (2005), "Marketing Mass-Customized Products: Striking a Balance Between Utility and Complexity," *Journal of Marketing Research*, 42 (2), 219–27. doi.org/10.1509/jmkr.42.2.219.62293

Deprez, Esmé E. (2014), "Why Starving Artists Still Prefer To Starve in New York," *BloombergBusiness*, May 21, www.bloomberg.com/news/articles/2014-05-21/ patti-smith-s-advice-rebuffed-as-new-york-draws-artists

Dewey, John (1934/2005), *Art as Experience*. New York, NY: Perigee.

Dewey, John (1989), "Having an Experience," in *John Dewey: The Later Works, 1925–1953: Art as Experience*, Jo Ann Boydston, ed., pp. 42–63. Carbondale: Southern Illinois University Press.

Dholakia, Ruby Roy, Jingyi Duan, and Nikhilesh Dholakia (2015), "Production and Marketing of Art in China: Traveling the Long, Hard Road from Industrial Art to High Art," *Arts and the Market*, 5 (1), 25–44. doi.org/10.1108/AM-10-2013-0023

Dholakia, Utpal M. and Kerry Soltysinski (2001), "Coveted or Overlooked? The Psychology of Bidding for Comparable Listings in Digital Auctions," *Marketing Letters*, 12 (3), 225–37. doi.org/10.1023/A:1011164710951

Diamond, Jared (1999), *Guns, Germs, and Steel*. New York, NY: Norton.

Dickie, George (1974), *Art and the Aesthetic: An Institutional Analysis*. New York: Cornell University Press.

Dickie, George (1984), *The Art Circle*. New York, NY: Haven.

Dissanayake, Ellen (1995), *Homo Aestheticus: Where Art Comes From and Why*. Seattle: University of Washington Press.

Dissanayake, Ellen (2000), *Art and Intimacy: How the Arts Began*. Seattle: University of Washington Press.

Dissanayake, Ellen (2007), "What Art Is and What Art Does: An Overview of Contemporary Evolutionary Hypotheses," in *Evolutionary and Neurocognitive Approaches to Aesthetics, Creativity, and the Arts*, Colin Martindale, Paul Locher, and Vladimir M. Petrov, eds., pp. 1–14. Amityville, NY: Baywood Publishing.

Du, Rex Yuxing, Ye Hu, and Sina Damangir (2015), "Leveraging Trends in Online Searches for Product Features in Market Response Modeling," *Journal of Marketing*, 79 (1), 29–43. doi.org/10.1509/jm.12.0459

Dutton, Denis (2007), "Aesthetic Universals," in *The Routledge Companion to Aesthetics*, Berys Gaut and Dominic McIver Lopes, eds. New York, NY: Routledge.

Dutton, Denis (2009), *The Art Instinct*. New York, NY: Bloomsbury Press.

Ertug, Gokhan, Tamar Yogev, Yonghoon G. Lee, and Peter Hedström (2016), "The Art of Representation: How Audience-Specific Reputations Affect Success in the Contemporary Art Field," *Academy of Management Journal*, 59 (1), 113–34. doi.org/10.5465/amj.2013.0621

Evans, Martin (2014), "Tate Accused of Conflict of Interest Over Exhibition of Trustee's Work," *The Telegraph*, January 3, www.telegraph.co.uk/culture/10549967/Tate-accused-of-conflict-of-interest-over-exhibition-of-trustees-work.html

Farago, Jason (2019), "A (Grudging) Defense of the $120,000 Banana," *New York Times*, December 8, www.nytimes.com/2019/12/08/arts/design/a-critics-defense-of-cattelan-banana-.html

Felten, Eric (2012), "Is It Art? Increasingly, Nowadays, That's a Judicial Decision," *Wall Street Journal*, June 1, U.S. edition.

Festinger, Leon, Henry W. Riecken, and Stanley Schachter (1956/2008), *When Prophecy Fails*. London, UK: Pinter & Martin.

Findlay, Michael (2014), *The Value of Art*. New York, NY: Prestel.

Fischl, Eric and Robert Berlind (2014), "Art in Conversation," *The Brooklyn Rail*, July, https://brooklynrail.org/2014/07/art/eric-fischl-with-robert-berlind

Fontevecchia, Agustino (2013), "Hedge Fund Billionaire Steve Cohen's $155M Picasso Isn't His First Multi-Million Piece Of Art," March 26, www.forbes.com/sites/afontevecchia/2013/03/26/hedge-fund-billionaire-steve-cohens-155m-picasso-isnt-his-first-multi-million-piece-of-art/#45d980965030

Fornell, Claes, Forrest V. Morgeson III, and G. Tomas M. Hult (2016), "Stock Returns on Customer Satisfaction Do Beat the Market: Gauging the Effect of a Marketing Intangible," *Journal of Marketing*, 80 (5), 92–107. doi.org/10.1509/jm.15.0229

Fraiberger, Samuel P., Roberta Sinatra, Magnus Resch, Christoph Riedl, and Albert-László Barabási (2018), "Quantifying Reputation and Success in Art," *Science*, 362 (6416), 825–9. doi.org/aau7224

Frankl, Paul and Paul Crossley (2000), *Gothic Architecture*. New Haven, CT: Yale University Press.

Freeland, Cynthia (2001), *But Is It Art?*, p. 19, New York, NY: Oxford University Press.

Gardner, Daniel (2008), *The Science of Fear*. New York, NY: Dutton.

Gaut, Berys and Dominic McIver Lopes, eds. (2007), *The Routledge Companion to Aesthetics*. New York, NY: Routledge.

Ghorashi, Hannah (2015), "Louis Vuitton Ends Its 13-Year Relationship with Takashi Murakami," *ArtNews*, July, www.artnews.com/2015/07/21/louis-vuitton-ends-its-13-year-relationship-with-takashi-murakami/

Gibbons, Joan (2005), *Art and Advertising*. New York, NY: I.B. Tauris.

Gillespie, Brian, Mark Mulder, and Manja Leib (2016), "Who's Laughing Now? The Effect of Simulated Laughter on Consumer Enjoyment of Television Comedies and the Laugh-Track Paradox," *Journal of the Association of Consumer Research*, 1 (4), 592–606. dx.doi.org/10.1086/688220

Gottschall, Jonathan (2012), *The Storytelling Animal: How Stories Make Us Human*. New York, NY: Mariner.

Gould, James A. ed. (1992), *Classic Philosophical Questions*. New York, NY: Columbia University Press.

Gran, Anne-Britt and Donatella De Paoli (2005), *Kunst og Kapital: Nye Forbindelser Mellom Kunst, Estetikk og Næringsliv*. Oslo, Norway: Pax Forlag.

Green, Donna H., Donald W. Barclay, and Adrian B. Ryans (1995), "Entry Strategy and Long-Term Performance: Conceptualization and Empirical Examination," *Journal of Marketing*, 59 (4), 1–16. doi.org/10.1177/002224299505900040

Grewal, Dhruv and Michael Levy (2021), *Marketing*, 8th edition. New York, NY: McGraw Hill.

Haden-Gues, Anthony (1982), "The New Queen of the Art Scene," *New York Magazine*, April 19.

Hagtvedt, Henrik (2019), "Shared Aesthetics: A Commentary on Collaborative Art," Journal of the Association for Consumer Research, 4 (4), 336. doi.org/10.1086/705024

Hagtvedt, Henrik (2020), "Art and Aesthetics," in Research Handbook on Luxury Branding, Felicitas Morhart, Sandor Czellar, and Keith Wilcox, eds, pp. 171–89. Cheltenham, UK: Edward Elgar Publishing. doi.org/10.4337/9781786436351.00022

Hagtvedt, Henrik (2022a), "Art and Aesthetics in the Future of Luxury," in The Future of Luxury Brands, Annamma Joy, ed, pp. 115–34. Boston, MA: De Gruyter. doi.org/10.1515/9783110732757-006

Hagtvedt, Henrik (2022b), "A Brand (New) Experience: Art, Aesthetics, and Sensory Effects," editorial, *Journal of the Academy of Marketing Science*, 50 (3), 425–28. doi.org/10.1007/s11747-021-00833-8

Hagtvedt, Henrik (2023), "Aesthetics in Marketing," *Foundations and Trends in Marketing*, 18 (2), 94–175. dx.doi.org/10.1561/1700000082

Hagtvedt, Henrik, Reidar Hagtvedt, and Vanessa M. Patrick (2008), "The Perception and Evaluation of Visual Art," *Empirical Studies of the Arts*, 26 (2), 197–218. doi.org/10.2190/EM.26.2.d

Hagtvedt, Henrik and Vanessa M. Patrick (2008a), "Art and the Brand: The Role of Visual Art in Enhancing Brand Extendibility," *Journal of Consumer Psychology*, 18 (July), 212–22. doi.org/10.1016/j.jcps.2008.04.010

Hagtvedt, Henrik and Vanessa M. Patrick (2008b), "Art Infusion: The Influence of Visual Art on the Perception and Evaluation of Consumer Products," *Journal of Marketing Research*, 45 (June), 379–89. doi.org/10.1509/jmkr.45.3.379

Hagtvedt, Henrik and Vanessa M. Patrick (2009), "The Broad Embrace of Luxury: Hedonic Potential as a Driver of Brand Extendibility," *Journal of Consumer Psychology*, 19 (4), 608–18. doi.org/10.1016/j.jcps.2009.05.007

Hagtvedt, Henrik and Vanessa M. Patrick (2011a), "Fine Arts," in *Encyclopedia of Consumer Culture*, Dale Southerton, ed. Los Angeles, CA: Sage.

Hagtvedt, Henrik and Vanessa M. Patrick (2011b), "Turning Art into Mere Illustration: Concretizing Art Renders Its Influence Context Dependent," *Personality and Social Psychology Bulletin*, 37 (12), 1624–32. doi.org/10.1177/0146167211415631

Hagtvedt, Henrik and Kathleen D. Vohs (2017) "Art Enhances Meaning by Stimulating Integrative Complexity and Aesthetic Interest," Behavioral and Brain Sciences, 40, 30–1. doi:10.1017/S0140525X17001728

Hagtvedt, Henrik and Kathleen D. Vohs (2022), "Viewing Challenging Art Lends Meaning to Life by Stimulating Integrative Complexity," Journal of PositivePsychology, 17 (6), 876–87. doi.org/10.1080/17439760.2021.1975159

Hall, Donald and Pat Corrington Wykes (1990), *Anecdotes of Modern Art*. New York, NY: Oxford University Press.

Han, Young Jee, Joseph C. Nunes, and Xavier Drèze (2010), "Signaling Status with Luxury Goods: The Role of Brand Prominence," *Journal of Marketing*, 74 (4), 15–30. doi.org/10.1509/jmkg.74.4.015

Hanson, Ward A. and Daniel S. Putler (1996), "Hits and Misses: Herd Behavior and Online Product Popularity," *Marketing Letters*, 7 (4), 297–305. doi.org/10.1007/BF00435537

Harlow, George E. (1997), "Following the History of Diamonds," in *The Nature of Diamonds*, George E. Harlow, ed. Cambridge, UK: Cambridge University Press.

Harrell, Eben and Frances Perraudin (2010), "Cultural Assets: Banks Stock Up on Art," *Time*, October 24, www.time.com/time/magazine/article/0,9171,2024 218,00.html.

Hauser, Arnold (1999), *The Social History of Art*. London, UK: Routledge.

Heckert, Druann Maria (1989), "The Relativity of Positive Deviance: The Case of the French Impressionists," *Deviant Behavior*, 10 (2), 131–44. doi.org/10.1080/01639625.1989.9967806

Hildebrand, Christian, Gerald Haubl, and Andreas Herrmann (2014), "Product Customization via Starting Solutions," *Journal of Marketing Research*, 51 (6), 707–25. doi.org/10.1509/jmr.13.0437

Hirschman, Elizabeth C. (1983), "Aesthetics, Ideologies and the Limits of the Marketing Concept," *Journal of Marketing*, 47 (Summer), 45–55. doi.org/10.1177/002224298304700306

Hoffman, Barry (2002), *The Fine Art of Advertising*. New York, NY: Stewart, Tabori and Chang.

Holan, Angie Drobnic and Linda Qiu (2015), "2015 Lie of the Year: The Campaign Misstatements of Donald Trump," *Politifact*, December 21, www.politifact.com/truth-o-meter/article/2015/dec/21/2015-lie-year-donald-trump-campaign-missta tements/.

Hopkins, David (2000), *After Modern Art: 1945–2000*. Oxford, UK: Oxford University Press.
Horowitz, Noah (2011), *Art of the Deal: Contemporary Art in a Global Financial Market*. Princeton, NJ: Princeton University Press.
Hoyer, Wayne D. and Nicola E. Stokburger-Sauer (2012), "The Role of Aesthetic Taste in Consumer Behavior," *Journal of the Academy of Marketing Science*, 40 (1), 167–80. doi.org/10.1007/s11747-011-0269-y
Hubard, Olga (2014), "Concepts as Context: Thematic Museum Education and its Influence on Meaning Making," *International Journal of Art & Design Education*, 33 (1), 103–15. doi.org/10.1111/j.1476-8070.2014.12001.x
Hugo, Victor (1831/1978), *Notre-Dame de Paris*. London, UK: Penguin.
Huh, Young Eun, Joachim Vosgerau, and Carey K. Morewedge (2014), "Social Defaults: Observed Choices Become Choice Defaults," *Journal of Consumer Research*, 41 (3), 746–60. doi.org/10.1086/677315
IBISWorld (2019), "Global Movie Production & Distribution Industry: Market Research Report," September, www.ibisworld.com/global/market-research-reports/global-movie-production-distribution-industry/.
Iyengar, Sheena (2010), *The Art of Choosing*. New York, NY: Twelve.
Jacobson, Robert and David A. Aaker (1987 "The Strategic Role of Product Quality," *Journal of Marketing*, 51 (4), 31–44. doi.org/10.1177/002224298705100404
Jeffri, Joan (2005), "Managing Uncertainty: The Visual Art Market for Contemporary Art in the United States," in *Understanding International Art Markets and Management*, Iain Robertson, ed. New York, NY: Routledge.
Jenkins, Peter (1991), *Modern Painters*, 4 (2), 75.
Joy, Annamma and John F. Sherry (2003), "Disentangling the Paradoxical Alliances between Art Market and Art World," *Consumption, Markets and Culture*, 6 (3), 155–81. doi.org/10.1080/1025386032000153759
Jung, Minah H., Hannah Perfecto, and Leif D. Nelson (2016), "Anchoring in Payment: Evaluating a Judgmental Heuristic in Field Experimental Settings," *Journal of Marketing Research*, 53 (3), 354–68. doi.org/10.1509/jmr.14.0238
Kahneman, Daniel (2011), *Thinking, Fast and Slow*. New York, NY: Farrar, Straus, and Giroux.
Kant, Immanuel (1790/2007), *Critique of Judgement*. New York, NY: Oxford University Press.
Kant, Immanuel (1781/2008), *Critique of Pure Reason*. London: Penguin.
Kapferer, Jean-Noël (1997), "Managing Luxury Brands," *Journal of Brand Management*, 4 (4), 251–59.
Kapferer, Jean-Noël (2014), "The Future of Luxury: Challenges and Opportunities," *Journal of Brand Management*, 21 (9), 716–26. doi.org/10.1057/bm.2014.32
Kessler, Glenn and Meg Kelly (2018), "President Trump Made 2,140 False or Misleading Claims in his First Year," *The Washington Post*, January 20, www.washingtonpost.com/news/fact-checker/wp/2018/01/20/president-trump-made-2140-false-or-misleading-claims-in-his-first-year/?noredirect=on&utm_term=.2e8d815fdd7b
Kester, Grant H. (2011). *The One and The Many: Contemporary Collaborative Art in a Global Context*. Durham, NC: Duke University Press.
Kim, Sara and Aparna A. Labroo (2011), "From Inherent Value to Incentive Value: When and Why Pointless Effort Enhances Consumer Preference," *Journal of Consumer Research*, 38 (4), 712–42. doi.org/10.1086/660806

King, Ross (2000), *Brunelleschi's Dome: How a Renaissance Genius Reinvented Architecture*. New York, NY: Bloomsbury.
Kogut, Tehila and Ilana Ritov (2005), "The 'Identified Victim' Effect: An Identified Group, or Just a Single Individual?" *Journal of Behavioral Decision Making*, 18 (3), 157–67. doi.org/10.1002/bdm.492
Kotler, Philip and Kevin Lane Keller (2015), *Marketing Management*, 15th edition. New York, NY: Pearson.
Kotler, Philip and William Mindak (1978), "Marketing and Public Relations," *Journal of Marketing*, 42 (4), 13–20. doi.org/10.1177/002224297804200402
Kozinets, Robert, Anthony Patterson, and Rachel Ashman (2017), "Networks of Desire: How Technology Increases Our Passion to Consume," *Journal of Consumer Research*, 43 (5), 659–82. doi.org/10.1093/jcr/ucw061
Labroo, Aparna A., Soraya Lambotte, and Yan Zhang (2009), "The "Name-Ease" Effect and Its Dual Impact on Importance Judgments," *Psychological Science*, 20 (12), 1516–22. doi.org/10.1111/j.1467-9280.2009.02477.x.
Lacey, Simon, Henrik Hagtvedt, Vanessa Patrick, Amy Anderson, Randall Stilla, Gopikrishna Deshpande, Xiaoping Hu, João R. Sato, Srinivas Reddy, and Krish Sathian (2011), "Art for Reward's Sake: Visual Art Recruits the Ventral Striatum," *NeuroImage*, 55 (1), 420–33. doi.org/10.1016/j.neuroimage.2010.11.027
Landi, Ann (2007), "Top Ten ArtNews Stories: How Jeff Koons Became a Superstar," *ArtNews*, November 1, www.artnews.com/2007/11/01/top-ten-artnews-stories-how-jeff-koons-became-a-superstar/.
Lee, Jaehoon and L. J. Shrum (2012), "Conspicuous Consumption versus Charitable Behavior in Response to Social Exclusion: A Differential Needs Explanation," *Journal of Consumer Research*, 39 (3), 530–44. doi.org/10.1086/664039
LeWitt, Sol (1967). "Paragraphs on Conceptual Art," *Artforum*, 5 (10), 79–83.
Lind, Maria and Olav Velthuis (2012), *Contemporary Art and its Commercial Markets: A Report on Current Conditions and Future Scenarios*. Berlin, Germany: Sternberg Press.
Lindgaard, Gitte and T. W. Allan Whitfield (2004), "Integrating Aesthetics Within an Evolutionary and Psychological Framework," *Theoretical Issues in Ergonomics Science*, 5 (1), 73–90. doi.org/10.1037/1089-2680.2.2.153
Lindstrom, Martin (2011), *Brandwashed: Tricks Companies Use to Manipulate Our Minds and Persuade Us to Buy*. New York, NY: Crown Business.
Litman, Jordan A. (2005), "Curiosity and the Pleasures of Learning: Wanting and Liking New Information," *Cognition and Emotion*, 19 (6), 793–814. doi.org/10.1080/02699930541000101
Loewenstein, George (1994), "The Psychology of Curiosity: A Review and Interpretation," *Psychological Bulletin*, 116 (1), 75–98. doi.org/10.1037/0033-2909.116.1.75
Lukas, Bryan A., Gregory J. Whitwell, and Jan B. Heide (2013), "Why Do Customers Get More Than They Need? How Organizational Culture Shapes Product Capability Decisions," *Journal of Marketing*, 77 (1), 1–12. doi.org/10.2307/41714526
Lydiate, Henry (2008), "Authorship and Authentication," in *The Art Business*, Iain Robertson and Derrick Chong, eds., p. 151. New York, NY: Routledge.
Martin, Stewart (2007), "Critique of Relational Aesthetics," *Third Text*, 21 (4), 369–86. doi.org/10.1080/09528820701433323

Martin, Thomas R. (1996), *Ancient Greece: From Prehistoric to Hellenistic Times*. New Haven, CT: Yale University Press.
Martorella, Rosanne (1990), *Corporate Art*. New Brunswick, NJ: Rutgers University Press.
Martorella, Rosanne, ed. (1996), *Art and Business: An International Perspective on Sponsorship*. Westport, CT: Praeger.
McAndrew, Clare (2018), *The Art Market 2019*. Switzerland: Art Basel and UBS.
McAndrew, Clare (2019), *The Art Market 2019*. Switzerland: Art Basel and UBS.
McAndrew, Clare (2024), *The Art Basel & UBS Art Market Report 2024 by Arts Economics*. Switzerland: Art Basel and UBS.
Mele, Christopher (2016), "Is It Art? Eyeglasses on Museum Floor Began as Teenagers' Prank," *New York Times*, May 30, www.nytimes.com/2016/05/31/arts/sfmoma-glasses-prank.html?_r=1.
Mencken, H. L. (1949), *A Mencken Chrestomathy*. New York, NY: Knopf.
Milgram, Stanley (1963), "Behavioral Study of Obedience," *Journal of Abnormal and Social Psychology*, 67 (4), 371–8.
Milgram, Stanley (1974/2009), *Obedience to Authority: An Experimental View*. New York, NY: Harper Perennial.
Miller, Geoffrey (2009), *Spent*. New York, NY: Viking.
Milner, Catherine (2002), "The Tate Values Excrement More Highly than Gold," *The Telegraph*, June 30, www.telegraph.co.uk/news/uknews/1398798/The-Tate-values-excrement-more-highly-than-gold.html.
Mitchell, Amy, Jeffrey Gottfried, Jocelyn Kiley and Katerina Eva Matsa (2014), "Section 1: Media Sources: Distinct Favorites Emerge on the Left and Right," Pew Research Center, October 21, www.journalism.org/2014/10/21/section-1-media-sources-distinct-favorites-emerge-on-the-left-and-right/.
Moody, Eric (2005), "The Success and Failure of International Arts Management: The Profitable Evolution of a Hybrid Discipline," in *Understanding International Art Markets and Management*, Iain Robertson, ed., p. 78. New York, NY: Routledge.
Moulard, Julie Guidry, Dan Hamilton Rice, Carolyn Popp Garrity, and Stephanie M. Mangus (2014), "Artist Authenticity: How Artists' Passion and Commitment Shape Consumers' Perceptions and Behavioral Intentions across Genders," *Psychology & Marketing*, 31 (8), 576–90. doi.org/10.1002/mar.20719
Muñiz, Jr, Albert M., Toby Norris, and Gary Alan Fine (2014), "Marketing Artistic Careers: Pablo Picasso as Brand Manager," *European Journal of Marketing*, 48 (1/2), 68–88. doi.org/10.1108/EJM-01-2011-0019
Muniz, Jr., Albert M., and Thomas C. O'Guinn (2001), "Brand Community," *Journal of Consumer Research*, 27 (4), 412–32. doi.org/10.1086/319618
Myers, Marc (2015), "The Guggenheim Show 'Silence' Spans Kawara's Career," *Wall Street Journal*, January 30, www.wsj.com/articles/the-guggenheim-show-silence-spans-on-kawaras-career-1422655735
National Geographic Channel (2015), "Shark Attack Facts," http://natgeotv.com/ca/human-shark-bait/facts
Newman, George E. and Paul Bloom (2012), "Art and Authenticity: The Importance of Originals in Judgments of Value," *Journal of Experimental Psychology: General*, 141 (3), 558–69. doi.org/10.1037/a0026035
Nietzsche, Friedrich (1872/1967), *The Birth of Tragedy*, New York, NY: Vintage.

Nietzche, Friedrich (1889/2016), *Twilight of the Idols: How to Philosophize with a Hammer*. Scotts Valley, CA: CreateSpace.
Norton, Louise (1917), "The Richard Mutt Case," *The Blind Man*, 2 (May), 5.
Nueno, Jose Luis and John A. Quelch (1998), "The Mass Marketing of Luxury," *Business Horizons*, 41 (6), 61–8. doi.org/10.1016/S0007-6813(98)90023-4
O'Hara, Frank (1965), *Robert Motherwell*. Garden City, NY: Doubleday.
Ordabayeva, Nailya and Pierre Chandon (2011), "Getting Ahead of the Joneses: When Equality Increases Conspicuous Consumption among Bottom-Tier Consumers," *Journal of Consumer Research*, 38 (1), 27–41. doi.org/10.1086/658165
O'Reilly, Daragh and Finola Kerrigan (2010), *Marketing the Arts: A Fresh Approach*. New York, NY: Routledge.
Patrick, Vanessa M. and Henrik Hagtvedt (2011), "Advertising with Art: Creative Visuals," in *Encyclopedia of Creativity*, 2nd edition, Mark Runco and Steven Pritzker, eds. San Diego: Elsevier. doi.org/10.1016/B978-0-12-375038-9.00003-0
Patrick, Vanessa M. and Henrik Hagtvedt (2009), "Luxury Branding," in *Handbook of Brand Relationships*, Joseph Priester, Deborah J. MacInnis, and C. Whan Park, eds. New York, NY: Society for Consumer Psychology and M.E. Sharpe.
Peter, Drucker F. (1998), "The Discipline of Innovation," *Harvard Business Review*, 76 (6), 149–57.
Pettijohn, Linda S., Douglas W. Mellott, and Charles E. Pettijohn (1992), "The Relationship between Retailer Image and Brand Image," *Psychology & Marketing*, 9 (4), 311–28. doi.org/10.1002/mar.4220090405
Phillips (2010), www.phillips.com/detail/Felix-Gonzalez-Torres/NY010710/4.
Pinker, Steven (1997), *How the Mind Works*. New York, NY: Norton.
Pinker, Steven (2002), *The Blank Slate: The Modern Denial of Human Nature*. New York, NY: Viking.
Pinker, Steven (2007), *The Stuff of Thought: Language as a Window into Human Nature*. New York, NY: Penguin.
Pinker, Steven (2011), *The Better Angels of our Nature: Why Violence Has Declined*. New York, NY: Viking.
Pinker, Steven (2018), *Enlightenment Now: The Case for Reason, Science, Humanism, and Progress*. New York, NY: Viking.
Plato (ca 380 BCE/2008), *Republic*. New York: Oxford University Press.
Plumb, J. H. (1991), *The Penguin Book of the Renaissance*. London, UK: Penguin Books.
Pogrebin, Robin (2022), "Warhol's 'Marilyn,' at $195 Million, Shatters Auction Record for an American Artist," New York Times, May 9.
Postrel, Virginia (2003), *The Substance of Style: How the Rise of Aesthetic Value Is Remaking Commerce, Culture, and Consciousness*. New York, NY: Harper.
Preece, Chloe (2015), "The Authentic Celebrity Brand: Unpacking Ai Weiwei's Celebritised Selves," *Journal of Marketing Management*, 31 (5/6), 616–45. doi.org/10.1080/0267257X.2014.1000362
Preece, Chloe and Finola Kerrigan (2015), "Multi-Stakeholder Brand Narratives: An Analysis of the Construction of Artistic Brands," *Journal of Marketing Management*, 31 (11/12), 1207–30. doi.org/10.1080/0267257X.2014.997272
President's Committee on the Arts and Humanities (2017), www.pcah.gov/partners-friends.
Ramage, Nancy H. and Andrew Ramage (2015), *Roman Art: Romulus to Constantine*. Upper Saddle River, NJ: Pearson.

Reber, Rolf, Norbert Schwarz, and Piotr Winkielman, (2004), "Processing Fluency and Aesthetic Pleasure: Is Beauty in the Perceiver's Processing Experience?" *Personality and Social Psychology Review*, 8 (4), 364–82. doi.org/10.1207/s15327957pspr0804_3

"Record per 'Merda d' Artista' di Manzoni: 275mila euro per la Scatoletta n. 69," (2016), *La Stampa*, December 8, www.lastampa.it/cultura/2016/12/08/news/record-per-merda-d-artista-di-manzoni-275mila-euro-per-la-scatoletta-n-69-1.34752641

Reporters without Borders (2023), "2023 World Press Freedom Index," https://rsf.org/en/index

Reynolds, Christopher (2006), "Geffen's Other Dream Works," *Los Angeles Times*, November 10, http://articles.latimes.com/2006/nov/10/entertainment/et-geffen10

Reynolds, William H. (1968), "Cars and Clothing: Understanding Fashion Trends," *Journal of Marketing*, 32 (3), 44–9. doi.org/10.1177/002224296803200308

Rips, Lance J., Sergey Blok, and George Newman (2006), "Tracing the Identity of Objects," *Psychological Review*, 113 (1), 1–30. doi.org/10.1037/0033-295X.113.1.1

Robertson, Jean and Craig McDaniel (2010), *Themes of Contemporary Art: Visual Art after 1980*. New York, NY: Oxford University Press.

Rodner, Victoria L. and Chloe Preece (2016), "Painting the Nation: Examining the Intersection between Politics and the Visual Arts Market in Emerging Economies," *Journal of Macromarketing*, 36 (2), 128–48. doi.org/10.1177/0276146715574775

Rodner, Victoria L. and Chloe Preece (2015), "Tainted Museums: 'Selling Out' Cultural Institutions," *International Journal of Nonprofit & Voluntary Sector Marketing*, 20 (2), 189–209. doi.org/10.1002/nvsm.1527

Rodner, Victoria L. and Finola Kerrigan (2014), "The Art of Branding – Lessons from Visual Artists," *Arts Marketing: An International Journal*, 4 (1/2), 101–18. doi.org/10.1108/AM-02-2014-0013

Rosario, Ana Babić, Francesca Sotgiu, Kristine de Valck, and Tammo H. A. Bijmolt (2016), "The Effect of Electronic Word of Mouth on Sales: A Meta-Analytic Review of Platform, Product, and Metric Factors," *Journal of Marketing Research*, 53 (3), 297–318. doi.org/10.1509/jmr.14.0380

Russell, John (1999), "Leo Castelli, Influential Art Dealer, Dies at 91," *The New York Times*, August 23, www.nytimes.com/1999/08/23/arts/leo-castelli-influential-art-dealer-dies-at-91.html

Ryan, Annmarie and Keith Blois (2016), "Assessing the Risks and Opportunities in Corporate Art Sponsorship Arrangements Using Fiske's Relational Models Theory," *Arts and the Market*, 6 (1), 33–51. doi.org/10.1108/AAM-02-2014-0010

Saad, Gad (2007), *The Evolutionary Bases of Consumption*. Mahwah, NJ: Lawrence Erlbaum Associates.

Sabin, Robert, ed. (1964), *The International Cyclopedia of Music and Musicians*. New York, NY: Dodd, Mead.

Schnugg, Claudia and Johannes Lehner (2016), "Communicating Identity or Status? A Media Analysis of Art Works Visible in Photographic Portraits of Business Executives," *International Journal of Arts Management*, 18 (2), 63–74.

Schroeder, Jonathan E. (2005), "The Artist and the Brand," *European Journal of Marketing*, 39 (11/12), 1291–305. doi.org/10.1108/03090560510623262

Schroeder, Rober (2016), "Trump Has Gotten nearly $3 Billion in 'Free' Advertising," *MarketWatch*, May 6, www.marketwatch.com/story/trump-has-gotten-nearly-3-billion-in-free-advertising-2016-05-06

Scott, Maura L., Martin Mende, and Lisa E. Bolton (2013), "Judging the Book by Its Cover? How Consumers Decode Conspicuous Consumption Cues in Buyer-Seller Relationships," *Journal of Marketing Research*, 50 (3), 334–47. doi.org/10.1509/jmr.11.0478

Shafir, Eldar, Peter Diamond, and Amos Tversky (1997), "Money Illusion," *The Quarterly Journal of Economics*, 112 (2), 341–74. doi.org/10.1162/003355397555208

Shakespeare, William (1600/2008), *Henry V*. New York, NY: Oxford University Press.

Shankar, Venkatesh, Gregory S. Carpenter, and Lakshman Krishnamurthi (1999), "The Advantages of Entry in the Growth Stage of the Product Life Cycle: An Empirical Analysis," *Journal of Marketing Research*, 36 (2), 269–76. doi.org/10.1177/00222437990360021

Shimron, Leeor (2023), "NFT Market Meltdown: How Can Investors Best Position Themselves?" *Forbes*, July 11.

Shrum, Wesley M. (1996), *Fringe and Fortune: The Role of Critics in High and Popular Art*. Princeton, NJ: Princeton University Press.

Silverman, Craig (2016), "This Analysis Shows how Fake Election News Stories Outperformed Real News on Facebook," *BuzzFeed News*, November 16, www.buzzfeed.com/craigsilverman/viral-fake-election-news-outperformed-real-news-on-facebook?utm_term=.gymy3e3RoW#.foABpvpJLa.

Silverstein, Michael J. and Neil Fiske (2003), *Trading Up: The New American Luxury*. New York: Portfolio Penguin Group.

Silvia, Paul J. (2005), "Emotional Responses to Art: From Collation and Arousal to Cognition and Emotion," *Review of General Psychology*, 9 (4), 342–57. doi.org/10.1037/1089-2680.9.4.342.

Silvia, Paul J. (2008), "Interest—The Curious Emotion," *Current Directions in Psychological Science*, 17 (1), 57–60. doi.org/10.1111/j.1467-8721.2008.00548

Sjöholm, Jenny and Cecilia Pasquinelli (2014), "Artist Brand Building: Towards a Spatial Perspective," *Arts Marketing: An International Journal*, 4 (1/2), 10–24. doi.org/10.1108/AM-10-2013-0018

Small, Deborah A., George Loewenstein, and Paul Slovic (2007), "Sympathy and Callousness: The Impact of Deliberative Thought on Donations to Identifiable and Statistical Victims," *Organizational Behavior and Human Decision Processes*, 102 (2), 143–53. doi.org/10.1016/j.obhdp.2006.01.005

Smith, Terry (2009), *What Is Contemporary Art*. Chicago, IL: University of Chicago Press.

Sokal, Alan D. (1996), "Transgressing the Boundaries: Toward a Transformative Hermeneutics of Quantum Gravity," *Social Text*, 46/47 (Spring – Summer), 217–52.

Stallabrass, Julian (2004), *Contemporary Art: A Very Short Introduction*. Oxford, UK: Oxford University Press.

Staw, Barry M. (1981), "The Escalation of Commitment to a Course of Action," *Academy of Management Review*, 6 (4), 577–87. doi.org/10.5465/amr.1986.4283111

Steenkamp, Jan-Benedict E. M. and Hans Baumgartner (1992), "The Role of Optimum Stimulation Level in Exploratory Consumer Behavior," *Journal of Consumer Research*, 19 (3), 434–48. doi.org/10.1086/209313

Stephens, Mitchell (2014), *Beyond News: The Future of Journalism*. New York, NY: Columbia University Press.

Stromberg, Matt (2018), "Museum as Selfie Station," *Contemporary Art Review LA*, 11, 18–29.

Sun, Heshan (2013), "A Longitudinal Study of Herd Behavior in the Adoption and Continued Use of Technology," *MIS Quarterly*, 37 (4), 1013–A13. doi.org/10.25300/MISQ/2013/37.4.02

Taleb, Nassim Nicholas (2010), *The Black Swan: The Impact of the Highly Improbable*. New York, NY: Random House.

Tansey, Richard G. and Fred S. Kleiner (1996), *Gardner's Art through the Ages*. Orlando, FL: Harcourt Brace.

Thaler, Richard H. and Cass R. Sunstein (2008), *Nudge: Improving Decisions about Health, Wealth, and Happiness*. New York, NY: Penguin.

The Art Newspaper (2004), "Art Newspaper Readers' Questions," www.saatchi-gallery.co.uk/charlesqa/qa.htm.

The Editorial Board (2016), "Facebook and the Digital Virus Called Fake News," *New York Times*, November 19, www.nytimes.com/2016/11/20/opinion/sunday/facebook-and-the-digital-virus-called-fake-news.html?_r=0.

Thompson, Derek (2017), *Hit Makers: The Science of Popularity in an Age of Distraction*. New York, NY: Penguin.

Thompson, Don (2008), *The $12 Million Stuffed Shark: The Curious Economics of Contemporary Art*. New York, NY: Palgrave Macmillan.

Thompson, Don (2014), *The Supermodel and the Brillo Box: Back Stories and Peculiar Economics from the World of Contemporary Art*. New York, NY: Palgrave Macmillan.

Thornton, Sarah (2008), *Seven Days in the Art World*. New York, NY: Norton.

Timms, Peter (2004), *What's Wrong with Contemporary Art?*, Sydney, Australia: New South Wales University Press.

Tolstoy, Leo (1898/1995), *What Is Art?*, London: Penguin.

Tolstoy, Leo (1902/1988), "What Is Religion and of What Does Its Essence Consist?" in *Leo Tolstoy: A Confession and Other Writings*. London, UK: Penguin.

Twitchell, James B. (2000), *20 Ads that Shook the World: The Century's Most Groundbreaking Advertising and How It Changed Us All*. New York, NY: Three Rivers Press.

Urban, Glen L. and John R. Hauser (2004), ""Listening In" to Find and Explore New Combinations of Customer Needs," *Journal of Marketing*, 68 (2), 72–87. doi.org/10.1509/jmkg.68.2.72.27793

Van Osselaer, Stijn M. J. and Joseph W. Alba (2000), "Consumer Learning and Brand Equity," *Journal of Consumer Research*, 27 (1), 1–16. doi.org/10.1086/314305

Varadarajan, P. Rajan and Anil Menon (1988), "Cause-Related Marketing: A Coalignment of Marketing Strategy and Corporate Philanthropy," *Journal of Marketing*, 52 (3), 58–74. doi.org/10.1177/002224298805200306

Veblen, Thorstein (1899/2007), *The Theory of the Leisure Class*. New York, NY: Oxford University Press.

Velthuis, Olav (2005), *Talking Prices: Symbolic Meaning of Prices on the Market for Contemporary Art*. Princeton, NJ: Princeton University Press.

Velthuis, Olav (2012), "The Contemporary Art Market Between Stasis and Flux," in *Contemporary Art and Its Commercial Markets: A Report on Current Conditions and Future Scenarios*, Maria Lind and Olav Velthuis, eds. Berlin, Germany: Sternberg Press.

Vergne, J.-P. and Tyler Wry (2014), "Categorizing Categorization Research: Review, Integration, and Future Directions," *Journal of Management Studies*, 51 (1), 56–94. doi.org/10.1111/joms.12044

Vigna, Paul (2022), "NFT Sales Are Flatlining," *The Wall Street Journal*, May 3.

Vigneron, Franck and Lester W Johnson (2004), "Measuring Perceptions of Brand Luxury," *Journal of Brand Management*, 11 (6), 484–506. doi.org/10.1057/bm.1997.4

Wade, Nicholas (2006), *Before the Dawn: Recovering the Lost History of Our Ancestors*. New York, NY: Penguin.

Wade, Nicholas (2009), *The Faith Instinct: How Religion Evolved and Why It Endures*. New York, NY: Penguin.

Walmsley, Ben (2019), "The Death of Arts marketing: A Paradigm Shift from Consumption to Enrichment," *Arts and the Market*, 9 (1), 32–49. doi.org/10.1108/AAM-10-2018-0013

Walther, Ingo F. (2013), *Impressionism*. Cologne, Germany: Taschen.

Warhol, Andy (1975), *The Philosophy of Andy Warhol (From A to B and Back Again*. San Diego, CA: Harcourt Brace.

Wartenberg, Thomas E. (2002), *The Nature of Art*. Belmont, CA: Wadsworth/Thomson.

Whitaker, Amy (2009), *Museum Legs*. Tucson, AZ: Holartbooks.

Wilcox, Keith, Hyeong Min Kim, and Sankar Sen (2009), "Why Do Consumers Buy Counterfeit Luxury Brands?" *Journal of Marketing Research*, 46 (2), 247–59. doi.org/10.1509/jmkr.46.2.247

World Health Organization (2017), "Measles," www.who.int/mediacentre/factsheets/fs286/en/.

Yoo, Alice (2011), "Riveting Story Behind that Striking Sculpture," *My Modern Met*, June 30, https://mymodernmet.com/riveting-story-behind-that/.

Zajonc, Robert B. (1980), "Feeling and Thinking: Preferences Need No Inferences," *American Psychologist*, 35 (2), 151–75. doi.org/10.1037/0003-066X.35.2.151

Zeki, Semir (2001), "Artistic Creativity and the Brain," *Science*, 293 (5527), 51–2. doi.org/10.1126/science.1062331

Zwick, Tracy (2013), "Sotheby's Wins in Dispute with Jancou Gallery over Cady Noland Artwork," *ArtNews*, August 29.

Zylinska, Joanna (2020), *AI Art: Machine Visions and Warped Dreams*. London, UK: Open Humanities Press.

INDEX

4-P framework 9, 28

Absolut Vodka campaign 57
Abts, Tomma 54
accessibility of art 31, 48
activism 28
Adam, Georgina 54
Adams, Douglas 1
Adorno, Theodor 108
advertising 46, 57–8, 61, 63–5
Advertising Age 64
aesthetics 15, 86, 91–5, 111; aesthetic pleasure 19, 72, 107; and execution of art 91, 93, 94, 95, 96, 97, 109; and quality of art 91–2, 99
Akhenaten, pharoah 32
Alberti, Leon Battista 106
Alexander the Great 17, 34
American National Endowment for the Arts 34
applauding 68
appreciation of art 2, 59–60, 92, 95, 107
architecture 15, 17–18, 21
Aristotle 106
Armani, Giorgio 61
art *see* appreciation of art; commercial art; conceptual art; contemporary art/contemporary art market; dealers in art; definition of art; fine art; modern art; performance art; postmodernism; theory of art; visual art

Art Basel and UBS Global Art Market Report 12
Art Infusion Effect 58
art market 1, 2–3, 5, 11–14, 103; and architecture 15, 17–18, 21; and defining art 112–13, 114; and marketing acumen 13, 44, 56; and promotion 9, 27–30, 57, 58; and publicity 12, 27–30; and segmentation 30–2, 42; and sponsorship 34–5, 38, 54, 56–7, 60–1, 100; and time 17, 21–4; and value of art 12, 96, 97; *see also* branding; contemporary art/contemporary art market; sponsorship
artification 111
artificial intelligence (AI) 21
artists 2–3, 8, 28; as brands 24–7, 52; and contemporary art market 41–5, 48–9, 52; as icons 101; individual 32; numbers of 44; starving 20, 44
Asch, Solomon E. 66
asthma 85
attention-seeking 28–9, 43, 85, 87–8, 97; *see also* controversy; scandal; shock value
auction houses 27, 49–51; *see also* Christie's auction house; Sotheby's auction house
auctions, one-man 44
audience interaction 94, 109
authentication 44

150 Index

bandwagons 43–4
Bank of America 61
Barratt, Thomas J. 57
Batteux, Abbé 105
BBC news 85
Beardsley, Monroe C. 109
beauty 92, 106, 107, 108
Beccerra, Antonio 88
behavior, herd 65–71, 73–4, 75
Beijing Poly International Auction Co. 51
Bell, Clive 109
Berger, Jonah 77
bestseller lists 67
biases 81–5
Bleuler, Eugen 78
boards of museums 54, 70
Bonhams auction house 51
Bonnard, Pierre 41
Boone, Mary 39, 49
Botticelli, Sandro 24
Bradley, Paige, *Expansion* 94
brand ambassadors 66
brand communities 74
brand equity 25, 34
branding 8, 24–7, 28, 96; and contemporary art market 39, 43, 44, 51, 52; and firms/corporations 34, 57, 60; and social influence 70, 74
brands, artists as 24–7, 52
Brunelleschi, Filippo 30–1
buyers of art 2, 13–14, 41, 43; buyer preference 7, 35; *see also* collectors of art; fashion/trends

capitalism 108
Carroll, Noël 110, 112, 113
Cassatt, Mary 41
Castelli, Leo 47, 49
categorization of art 94, 96, 97, 113
Cattelan, Maurizio 15, 42
celebrities 76, 98
celebrity status of dealers 46
certificates, signed 96
Cézanne, Paul 41
Charities Commission 54
chess 72
Chesterton, G. K. 90
child deaths 84
China Guardians Auction Co. 51
Chinese art market 5, 41, 51
Chong, Derrick 55
Christianity 32, 38

Christie's auction house 51; sales at 11, 21, 27, 40–1
Christo and Jeanne-Claude 12
Cialdini, Robert B. 69, 71
classification of art 10–11, 13, 40, 96
co-creation 32–3
Cohen, Steve 40, 55
collaboration 33, 42
collectors of art 43–4, 55–6, 70, 88, 100; and dealers in art 46, 48, 56; and fairs 51, 52; and firms/corporations 56–7, 60; and museums 54, 100
Collingwood, R. G. 110
color 72–3
Color Association of America 72–3
commercial art 5
commercialization 33, 42, 64, 86, 101
commissioning of art 13, 32, 35, 57; and marketing 4, 27–8; public commissioning 27–8, 34
commoditization 108
compatibility 21
complacency 62
conceptual art 3, 10–11, 14, 22; and aesthetics 93–4, 95–6, 97; and narratives 85, 86–7; and skill/technical mastery 94, 96
concrete 18
confirmation bias 79
conflation of art 95–7
conformity/nonconformity 36–7, 65–71
consensus 16, 67, 70
consignment arrangements 48–9
consumer products: art used in marketing of 25, 33, 57, 58–60; and herd behaviour 65, 67; represented as art 95, 108
consumers 25, 33, 65, 70, 85
consumption, conspicuous 35–8, 73
contemporary art/contemporary art market 39–61, 68; and artists 41–5, 48–9, 52; and attention-seeking 43, 85; and branding 39, 43, 44, 51, 52; and buyers of art 41, 43; and China 41, 51; and critics 8, 45–6, 70, 98; and galleries 46–7, 52; and incentives 46, 48, 50; and meaning 36, 86; and museums 52–4, 87, 99–100; and pricing of art 46, 50; and profitability 44, 50, 54; and publicity 50, 52, 58; and quality of art 14, 16, 43, 45, 53, 86; and skill/technical mastery 43,

45, 86, 94, 96; and social influence 80–1, 85–9; and sponsorship 54, 56–7, 60–1; *see also* collectors of art; conceptual art; dealers in art
contracts 48
controversy 28–30, 34, 101, 102; *see also* attention-seeking; scandal; shock value; Turner Prize
copyright 57
corporations/firms 34, 56–61, 63–5
COVID-19 pandemic 83
craft 10, 15, 24, 93, 105; *see also* skill/technical mastery
creativity 1, 3, 17, 23, 33, 42, 92, 102
Creed, Martin 29
critics of art 8, 45–6, 70, 98; reviewing 46, 67, 109
Crutchfield, Richard 66
culture/tradition 35–6, 64–5, 95, 103; popular culture 42, 57
customer satisfaction 8
customization 32–3

Dadaism 22, 23
Dalí, Salvador 28
danger, overestimation of 84–5
Danto, Arthur 11, 108, 112–13
Dawkins, Richard 75
De Beers 63–5
de Kooning, Willem 41, 47, 55
dealers in art 27, 34, 43, 46–50; and collectors of art 46, 48, 56; and fairs 51, 52; and museums 48, 54, 100
death, accidental 85
definition of art 9–11, 91, 103; and theory of art 108, 109–10, 111–14
democracy 62
Deutsche Bank 60
Dewey, John 109
Diamond, Jared 5
diamonds 63–5
Dickie, George 11, 108, 112–13
disease 84, 85
Dissanayake, Ellen 110
doctors 78
Donatello 23
dress codes 68
Duchamp, Marcel 22, 29, 52; *Fountain* 10, 23, 88
Dutton, Denis 111

education 100
Egyptian art 14–15

Elmgreen and Dragset 87
Emin, Tracey 86, 87
emotion 110
entertainment, art as 20, 97, 108
entrepreneurs 13, 46, 62
ephemerality 23
estimating 67–8
evaluation of art 9, 59, 94–5, 97, 103; *see also* standards, quality
evolution 67, 75–6, 110–11
excellence 3, 9, 20, 93, 101
execution of art 91, 93, 94, 95, 96, 97, 109
exhibiting 27, 28, 43, 54, 99
expertise in art 98–9, 100
exponential growth 72, 76
exposure to marketing 19, 27–30, 70, 100
expression theories 110
expressionists, abstract 23

fads 53, 71–3; *see also* fashion/trends
fairs 51–2
familiarity 19
family resemblances 111–12
fashion industry 72–3
fashion/trends 14, 23, 37, 45, 71–3, 100; *see also* social influence
fear 83, 84
feedback 30
feminism 41
film industry 11–12, 50
Findlay, Michael 46
fine art 12, 86, 105
Fischl, Eric 39
form, significant 109–10, 113
Fox News 79
Frankfurt School 108
freedom, artistic 20, 102, 108, 120
freedom of the press 80
Fry, Roger 110
functionality 62, 63
funding 97, 98; and museums 54, 61, 99–100; public 34, 99–103

Gagosian, Larry 48
galleries 46–7, 52
gallerists *see* dealers in art
Gardner, Daniel 67, 83
Geffen, David 47, 55
genius 16, 18, 20, 45, 113
Gerety, Frances 64
Germany 5

Ghiberti, Lorenzo 30
Gibbons, Joan 87
globalization 41, 51
Gone with the Wind film 50
Gonzales-Torres, Felix 29–30
Gopnik, Blake 12, 100
gossip 76
Gothic architecture 18, 21
Goya, Francisco, *Maja Desnuda* 28
Graham, Billy 70
Graham, William 57
Grasse, Pierre-Paul 65
Greece, Ancient 14–15, 17, 27–8, 77, 106
Green Art Gallery, Dubai 3–4
Greene, Brian 37
Griffin, Ken 55
group cohesiveness 73–4
groupthink 67
Guerrilla Girls 28
Guggenheim museum 26, 53, 61
gullibility 11
gun violence 83, 84

handbags 8
happiness and art 103
Hegel, G. W. F. 107
Heidegger, Martin 107
Hesiod 1
Hirst, Damien 11, 16, 26, 44, 56, 96
historical knowledge 23
Hodges, Jim, *No-One Ever Leaves* 51
Horowitz, Noah 52
Hugo, Victor 62
Hume, David 107
hunter-gatherers 67, 69, 74, 81
Hutcheson, Francis 106–7

iconicity of artists 23–4, 101
ideas 16, 17, 76–7, 97
identity/image creation 34, 60
Illustrated London News 57
imitation 70, 106
imperial measurement system 62
Impressionism 19–20, 27
incentives 75, 99–102; and contemporary art market 46, 48, 50
individuality 111
inflation 50, 64
ING corporation 60
innovation 17–21, 33, 62; technological 5
instinct 111

institutions: cultural 105–6, 107–8; public 100. *see also* museums
investment 34, 62, 73–5
Iyengar, Sheena 73

Jancou, Marc 97
Jeffri, Joan 41, 46
jewelry 23, 46, 63–5
Johns, Jasper, *Target with Plaster Casts* 47
Jonestown Massacre 69, 73
journals/publications about art 46
JPMorgan Chase 60

Kant, Immanuel 92, 107
Kapoor, Anish, *Cloud Gate* 94
Kawara, On 26–7
Khan, Genghis 76
Koons, Jeff 11, 13, 16, 29, 44, 86; and branding 25, 26

laughter, simulated 68
Lebanon 82
legal action 96, 97
Leonardo da Vinci 18, 27, 40–1, 106
LeWitt, Sol 96, 97
life events of artists 28
Lindstrom, Martin 65, 66
London 5
Lorenzo de' Medici 21, 38
Louvre 60
love, everlasting 63, 64
loyalty 49
Lysippos 34

Manet, Édouard, *Déjeuner sur l'herbe* 28
Manzoni, Piero 11, 15
Mapplethorpe, Robert 29, 87
Marco d'Agrate 94
market, primary and secondary 47, 49–50
marketing 2–3, 7–38, 63–5; and commissioning of art 4, 27–8; of consumer products 25, 33, 57, 58–60; exposure to 19, 27–30, 70, 100; and Koons 11, 13, 16, 25, 26, 29; marketing acumen 13, 44, 56; and meaning 23, 25, 26, 36; and needs and desires 7, 8, 13–14; and perception 8, 17, 35, 36, 58–9; and quality of art 9–10, 14–16, 20, 25, 27, 28; and reality 8, 17; and skill/

technical mastery 2, 3, 15, 16, 23, 28, 38; and stunts 12, 28; *see also* branding; consumption, conspicuous; sponsorship; time
Marxism 108
Masaccio 18, 23
Matisse, Henri 65
meaning 103, 120; and aesthetics 95, 97, 109; and contemporary art 36, 86; hidden 23, 26, 81; and marketing 23, 25, 26, 36; and social influence 78, 81, 86
memes 75–7; and narratives 81, 83, 85; and truth 78, 79, 80, 81
Mencken, H. L. 90
Michelangelo 13, 24, 27–8, 41
Middle Ages 18, 38
Milgram shock experiment 69
Millais, John Everett, *Child's World* (later *Bubbles*) 57
Millennium Gate Museum, Atlanta 61
Miller, Geoffrey 7–8
modern art 10, 40, 113
money 1; *see also* marketing; pricing
Montclair Art Museum, New Jersey 61
Moody, Eric 45
Motherwell, Robert 12
Murakami, Takashi 29, 42, 44
Muses 1–2
Museum Kunst Palast, Düsseldorf 87
Museum of Modern Art, New York (MoMA) 11, 26, 53
museums: boards of museums 54, 70; and collectors of art 54, 100; and contemporary art market 52–4, 87, 99–100; and dealers in art 48, 54, 100; and funding 54, 61, 99–103; and pricing of art 54, 101; and quality of art 53, 74–5, 99, 101; and social influence 70, 74–5, 87; and sponsorship 54, 60–1, 100; and time 53, 101

N. W. Ayer & Son 63–4
Narmer Palette 14
narratives 81–5, 87–9
National Endowment for the Arts 34, 101
National Geographic Channel 84
nature 106, 109
needs and desires 7, 8, 13–14
neuroscience 59
neutrality 34, 53

New York 5
New York magazine 39
news, fake 79
newsworthiness 20, 21, 50, 79, 85
Nietzsche, Friedrich 105, 107
Noland, Cady, *Cowboys Milking* 97
non-fungible tokens (NFTs) 71
novelty 23, 33, 45, 94, 111; and innovation 17, 19, 21
nudging 43, 75; *see also* behaviour, herd

obscenity 87–8; *see also* attention-seeking; controversy; scandal
Ofili, Chris 54
outsourcing 16, 26, 44

paintings 12, 24, 109
Pantone Color Institute 72
paper-folding 72
Patrick, Vanessa M. 58
patronage 34, 35, 38
Pears soap manufacturer 57
peer groups 66, 69, 101–2
pennies in a jar 67–8
perception 43; and aesthetics 91, 92; and consumption 35, 36; and marketing 8, 17, 35, 36, 58–9; and reality 8, 17; and social influence 65, 66, 67, 84
performance art 87
pharmaceuticals 8
Phidias 27
philanthropy, corporate 34
Phillips auction house 29–30, 51
Phillips, David 71
philosophy of art 91, 106, 107, 108, 109, 112
photography 21, 36
Picasso, Pablo 25, 40, 41, 55, 65, 120
Pierson, Jack, *Almost* 51
Pinault, François 56
Pinker, Steven 89
placement 28
Plato 105, 106
pleasure 19, 72, 105, 106, 107
politics 78–80
Pollock, Jackson 34, 41
Pompidou Museum, Paris 11
pool game 78
popularity 67, 77
positioning 30–2
Post-Impressionism 110
postmodernism 8, 89

154 Index

power, social 35
pranks 53
preference 7, 19, 24, 35
presentation of art 25, 93
pricing: and contemporary art market 46, 50; and museums 54, 101; and social influence 54, 64, 68, 74–5
printmaking 31
product, art as 9–11
product design 25, 30
profitability 8, 37, 64, 90; and contemporary art market 44, 50, 54
promotion 9, 27–30, 57, 58
propaganda 32, 69
provocation 88
publicity 12, 27–30, 50, 52, 58
purchasing power 31, 64–5
purity of art 93

quality of art: and aesthetics 91–2, 99; and artistic vision 16, 36; and branding 25, 27; and contemporary art 14, 16, 43, 45, 53, 86; and marketing 9–10, 14–16, 20, 25, 27, 28; and museums 53, 74–5, 99, 101; and skill/technical mastery 15, 16, 102; and social influence 70, 74–5, 86; and standards 14–15, 70, 107

racism 41
realism in art 15, 38
reality 8–9, 17
religious organizations and cults 69–70, 73, 75, 100
Rembrandt 23–4
Renaissance 18–19, 21, 23, 24, 38
research, scientific 62
retrospectives 54
reviews 46, 67, 109
Reynolds, William H. 63
Richter, Gerhard 16, 25, 40
rings, engagement 63–5
risk 84
rituals 33, 73, 74, 111
road rage 82–3
Robertson, Jean and McDaniel, Craig 86
Rodin, Auguste 34
role of art 107–8
Rome, Ancient 17–18
Rosenthal, Norman 46
Rothko, Mark 40
Ryman, Robert 3

Saatchi, Charles 12, 56, 86
sacrifice 74
San Francisco Museum of Modern Art 53
scandal 20, 28–9, 42, 76; *see also* attention-seeking; controversy
scarcity 33, 64
schizophrenia 77–8
Schnabel, Julian 49
Schopenhauer, Arthur 107
science curriculum 100
Scull, Robert and Ethel 47
sculpture 15, 17
secondhand market 64
segmentation 30–2, 42
Serrano, Andres, *Piss Christ* 34, 87
Shakespeare, William, *Henry V.* 1
shark attacks 83, 84
shock value 19, 43, 97, 102; and social influence 85, 87–8, 89; *see also* attention-seeking; controversy
Sierra, Santiago 87
skill/technical mastery: and aesthetics 92, 94; and conceptual art 94, 96; and contemporary art/contemporary art market 43, 45, 86; and marketing 2, 3, 15, 16, 23, 28, 38; and quality of art 15, 16, 102
Smith, Terry 87
social critique 88–9
social influence 62–89; and branding 70, 74; and contemporary art/contemporary art market 80–1, 85–9; and disease 84, 85; and exponential growth 72, 76; and fashion/trends 14, 23, 37, 45, 71–3, 100; and functionality 62, 63; and herd behaviour 65–71, 73–4, 75; and meaning 78, 81, 86; and memes 75–7, 78, 79, 80, 81, 83, 85; and museums 70, 74–5, 87; and perception 65, 66, 67, 84; and pricing 54, 64, 68, 74–5; and quality of art 70, 74–5, 86; and religion 69–70, 73, 75; and rituals 73, 74; and shock value 85, 87–8, 89; and suicide 69, 71; and tragedy 69, 82
social media 30, 66, 79
Society of Independent Artists 10
Sokal, Alan D. 89
Sotheby's auction house 40, 44, 51, 97
Spector, Buzz, *Toward a Theory of Universal Causality* 86

sponsorship 34–5, 38, 54, 56–7, 60–1, 100
Stallabrass, Julian 61
standards, quality 14–15, 70, 107; of excellence 3, 9, 20, 93, 101
status 36
status value 44, 48, 56; and social influence 65, 74; status as art 108, 109–10, 111, 112, 113
stereotyping 70
stipends 49
stock market 68
stunts 12, 28
style, individual 24–5
suicide 69, 71
sustainability 8

Taleb, Nassim Nicholas 81–2
Tanner, Henry Ossawa 41
targeting 30–2
Tate Gallery 11
Tate Modern 54, 60
teachers of art 98–9
technologies, digital 33, 36, 50–1, 83
termites 65–6
terrorism 83, 84
Thaler, Richard H. and Sunstein, Cass R. 82
theory of art 105–14; and aesthetics 107, 109, 111; and cultural institutions 105–6, 107–8; and definition of art 108, 109–10, 111–14; and significant form 109–10, 113
Thompson, Derek 76
Thompson, Don 47, 51
Thornton, Sarah 49–50, 70
tie wearing 68, 77
time 17, 21–4, 53, 101
Timms, Peter 88
toddler in well story 81–2
Tolstoy, Leo 105, 107–8

tornadoes 85
trade-offs 102–3
traffic accidents 83
tragedy 69, 82
transparency 6
Trump, Donald 79, 80, 81
truth 77–81, 120
Turner Prize 29, 54, 86, 88

UBS corporation 60
United Kingdom art market 41
United States 41, 62

value of art 12, 96, 97
van Gogh, Vincent 28, 34
Veblen, Thorstein 35
Velthuis, Olav 42, 49
viral spread of ideas 76–7
vision, artistic 3, 16, 36
visual art 12
Vitruvius 15
vodka 57
Vollard, Ambroise 48
Vuitton, Louis 42

warfare 22
Warhol, Andy 13, 24, 40, 44; Brillo boxes 95, 96, 108
water, bottled 8
wealth 4, 35–6, 41, 73
Weitz, Morris 108, 111
Werther effect 71
Whitaker, Amy 100
windshields, pitted 82
Wolfe, David 73
word of mouth 30, 77
World Press Freedom Index 80
Wynn, Steve 55–6

Yayoi Kusama: Infinity Mirrors exhibition, Los Angeles 30

Printed in the United States
by Baker & Taylor Publisher Services